fast company

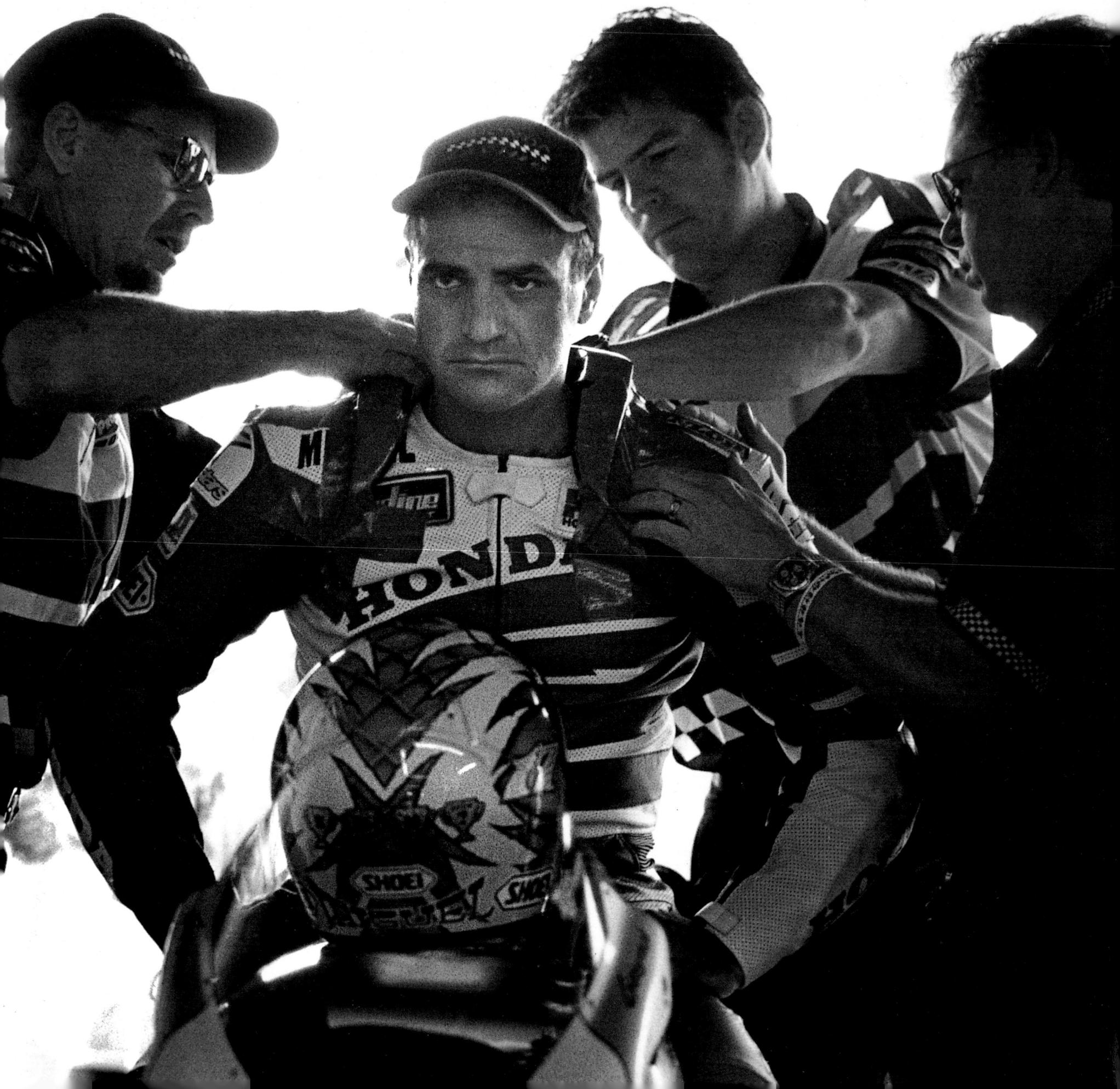

fast company

MOTORCYCLE ROAD RACING'S PIT WARRIORS

jan kral and candace barbot

text by jan ward

LONG WIND PUBLISHING
Ft. Pierce, Florida

also by Jon Kral: *Cracker, Florida's Enduring Cowboys,* ISBN 0-9658128-7-1
Hotbloods: Thoroughbred Horse Racing's Hidden World, ISBN 0-9658128-8-X
Live Steam: Paddlewheel Steamboats on the Mississippi System, ISBN 1-892695-00-6

First Printing, 2001

Designed and Edited by Jon Ward

Library of Congress Cataloging-in-Publication Data

Kral, Jon, 1946-
Barbot, Candace, 1958-
 Fast Company: Motorcycle Road Racing's Pit Warriors
 1. Motorcycles-Racing 2. Motorsports-Motorcycles 3. Transportation
 4. Photography-Artistic I. Kral, Jon II. Barbot, Candace III. Title
Library of Congress Catalog Card Number 00-110742
ISBN 1-892695-01-4

Photographs on pages 1,5,8,11,13,15,16,19,20,24-25,26,28,29,30,31,34-40,42,44,45,48-50,
 52,53,56-58,62-64,66,70,74,75,77,78,80,82,85,88-94,97-100,102-104,109,110,
 112-114,116 and 117 copyright 2000 by Jon Kral
Photographs on pages 2,6,9,14,17,18,21-23,27,32,33,41,43,46,47,51,54,55,59-61,65,67-69,
 71-73,76,79,81,83,84,86,87,95,96,101,105-108,111,115 and 118 copyright 2000 by Candace Barbot
Text copyright 2000 by Jon Ward

Published by Long Wind Publishing
 2208 River Branch Drive
 Ft. Pierce, Florida, 34981
 (561) 595.0268 fax: (561) 595.6246 e-mail: LongWindPub@tctg.com
 www.LongWindPub.com

Printed in Hong Kong

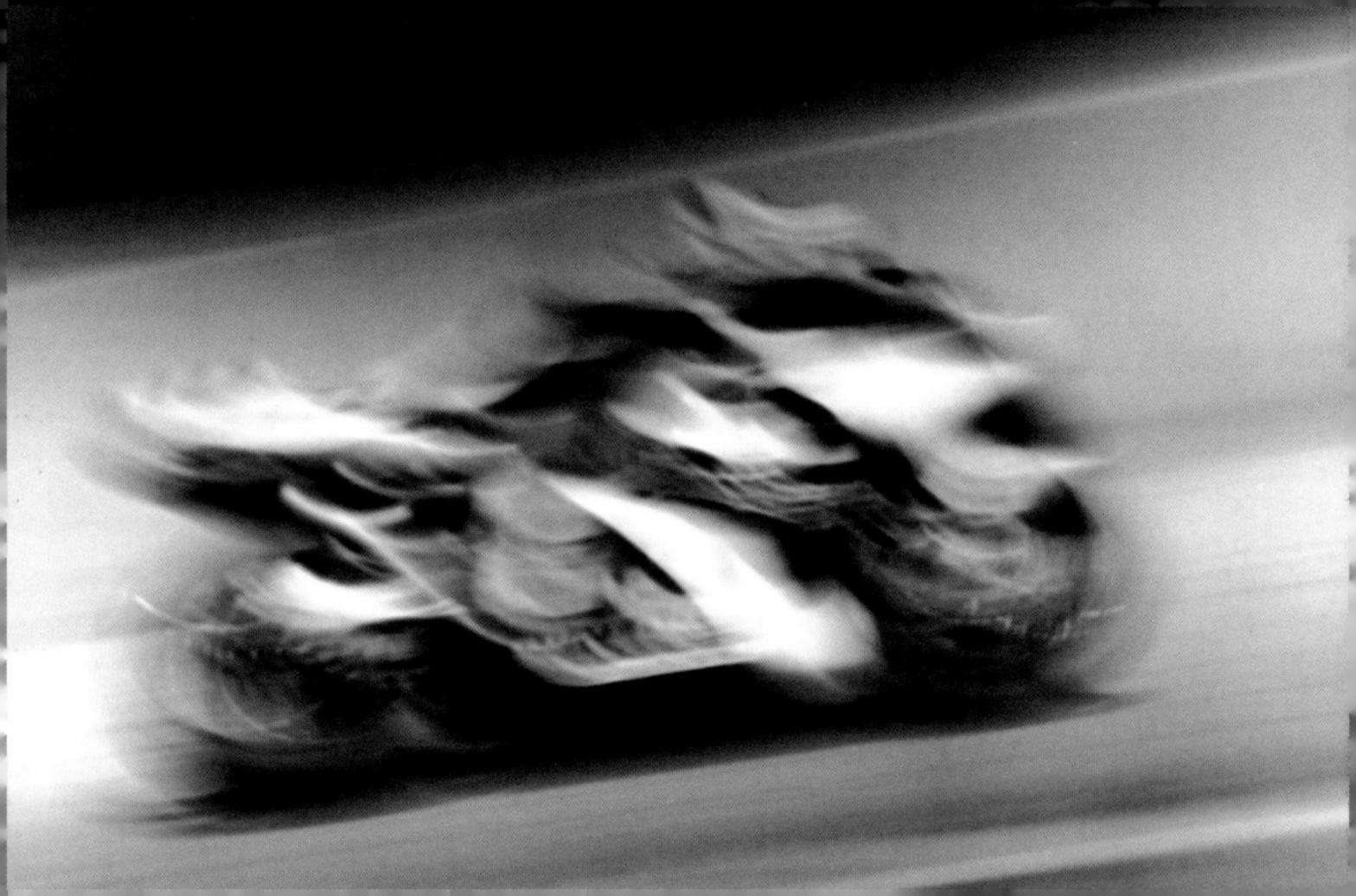

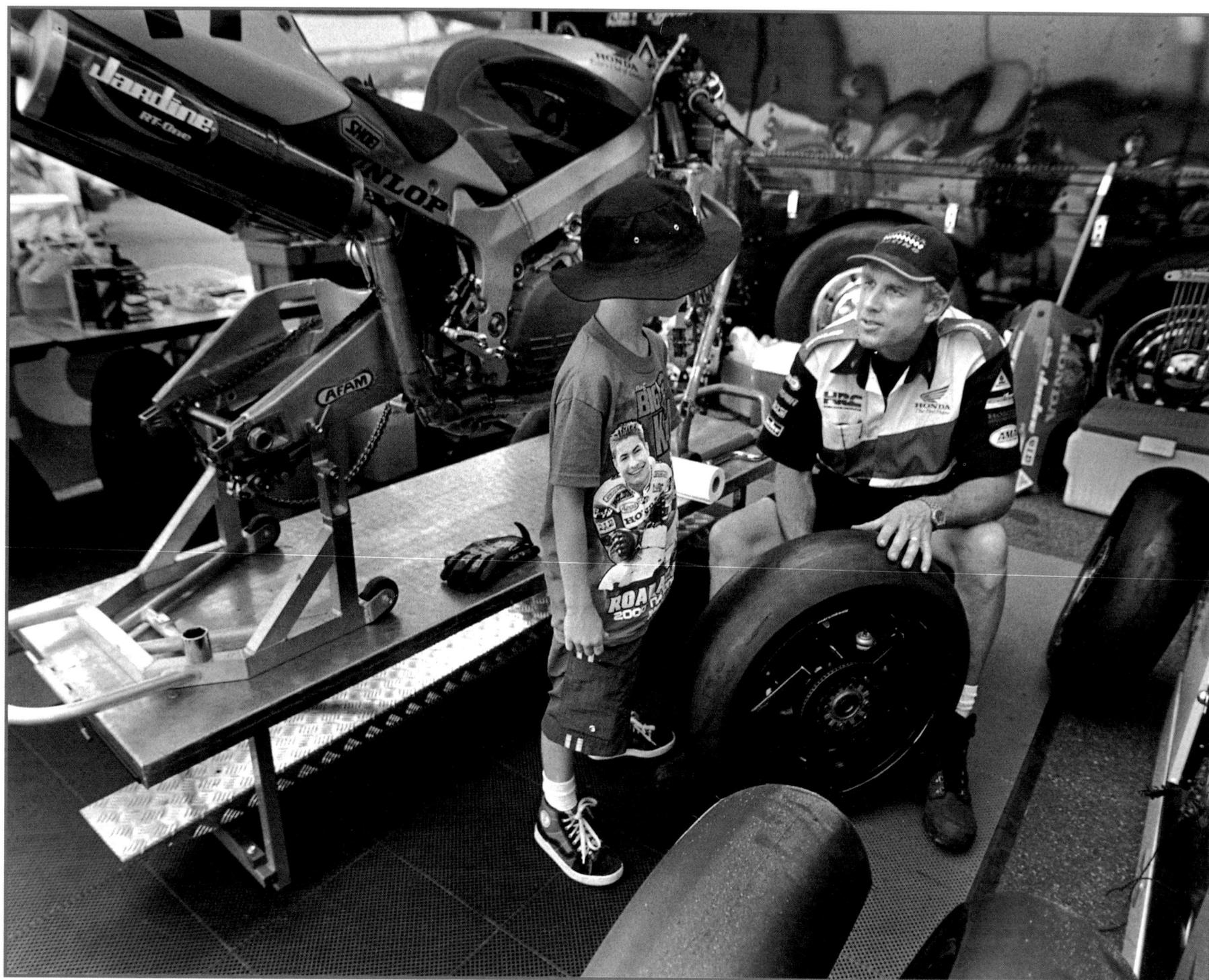

acknowledgments

Safety Specialist Mike Marquez commented that "the hospitality (in motorcycle road racing) is incomparable to any other major sport. Other professional athletes and their fans could definitely learn a thing or two."

Boy, did Jon, Candace and I find that to be true.

Kral and I are both long time bikers, used to sullen attitudes and lots of black leather posturing. We found none of that here.

Candace introduced us to the folks at the Motorcycle Industry Council and their communications arm, Discover Today's Motorcycling (DTM). This book was made possible with their assistance and the help of their industry members. MIC president Tim Buche and DTM director Beverly St. Clair put us in the hands of an able staff who treated us like old friends. Our most heartfelt thanks go to Kim Gallaway, Steff Gunn, Elisabeth Piper, Wendy Wright, Will Hawes, Julie Hernandez and Mike Mount.

Texas-born Gary Christopher of Honda suggested that we do a book just so he could have some Southerners to hang out with at the tracks. Ken Vreeke generously gave us the benefit of his historical perspective. Kawasaki's Bob Moffit contributed valuable industry insights and put us under the tutelage of the media-savvy Sheryl Bussard. Yamaha's Bob Starr showed us the technological future and was an enthusiastic booster.

Kevin Erion offered the Erion Racing paddock as home base at the tracks and gave us complete access to his crews and riders.

Yoshimura Suzuki's Rich Doan went out of his way to give us location information and helpful critiques of the work as it progressed.

We wish that we could thank each and every member of the pit crews, who were our inspiration for this book, individually. You showed us hospitality and demonstrated professional grace under pressure without exception. As Jackson Browne penned in that roadie song, "You guys are the champs."

Thanks to the Miami Herald for giving Jon and Candace some time off to shoot this project.

And special thanks to all of the privateers. We found the indomitable American "can do" spirit in abundance in your paddocks and pits. Male or female, sponsored or ponying up your last hard-earned bucks to go for the gold, we admire you all. Win or lose, you showed the guts to get it done. Keep that shiny side up.

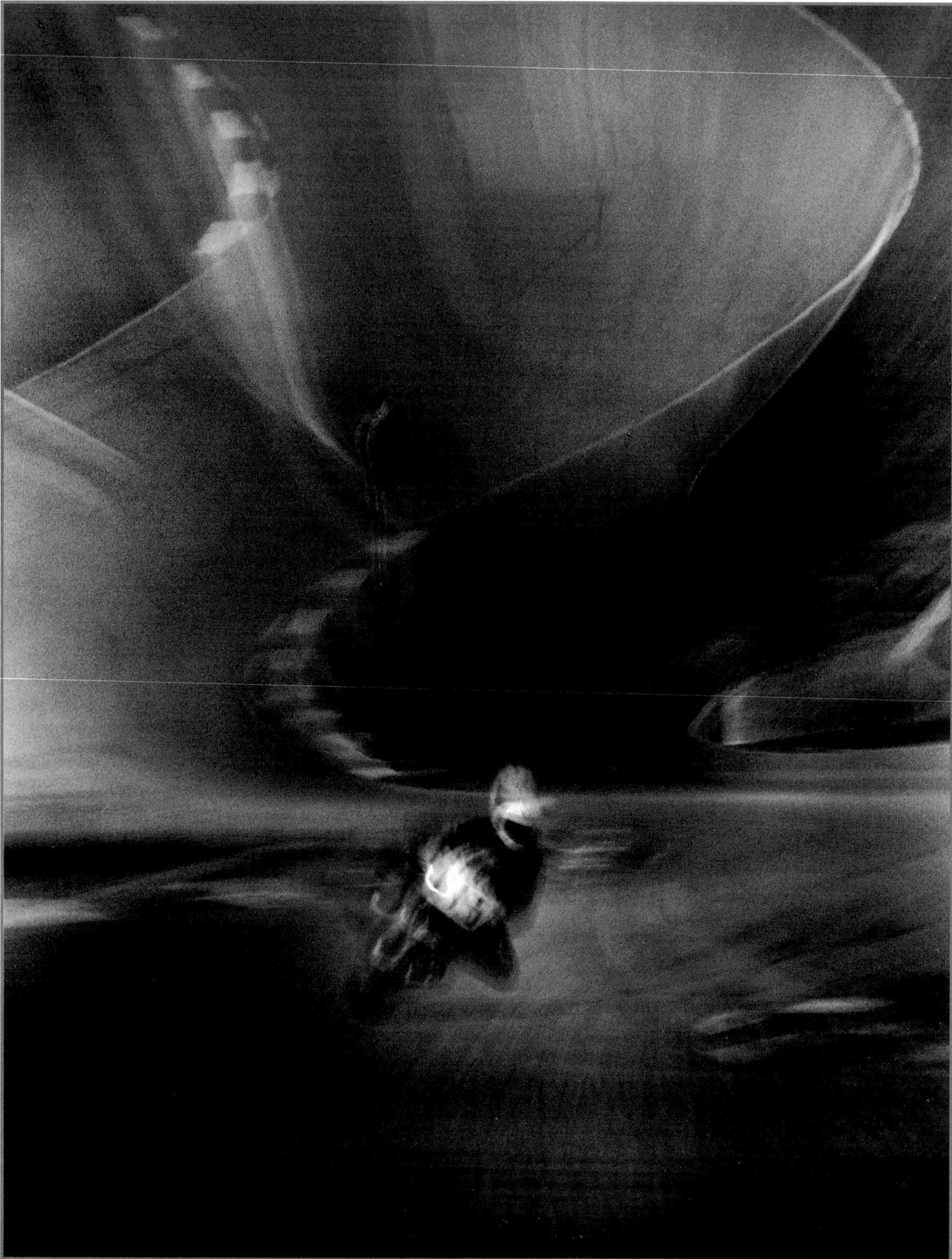

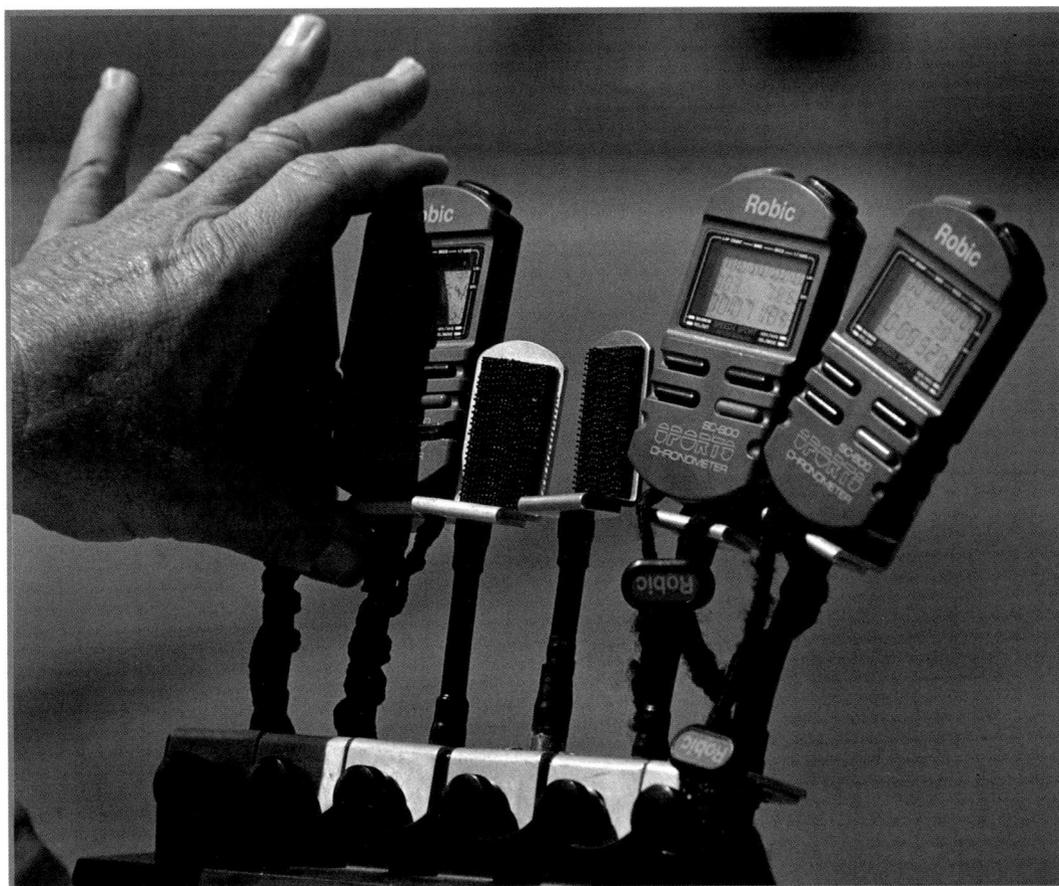

Bike canted over at an impossible angle, moving smoothly through a hairpin esse turn, the racer cocks his head back to look through the curve, knees flared wide, smoking a puck as he really digs in. Another rider, just inches from his shoulder, senses his opportunity and takes a high line through the turn, but the leader rolls on the throttle and nips the interloper's pass in a thrilling mechanical ballet as they both scream into the straightaway at over 140 miles an hour.

This is the motorcycle road racing that you know about.

This would have been the race that you saw from the safety of the stands or on your big screen.

Here's the kind of race that you didn't get to see, as told to me by Rick Hobbs, Crew Chief for the Erion Honda Racing team. It should get you zoned in on the real meaning of the term "racing TEAM."

"My first big-time race was with Vance and Hines. At the time, they were the factory Yamaha roadrace team and I had been hired in the fall of 1992 to work as Jamie James' superbike mechanic.

Jamie crashed at the Dunlop tire test at Daytona in December, injuring himself badly enough that he wouldn't be able to make the first couple of races of the '93 season.

Daytona Bike Week was about six weeks away when I was told that none

other than Eddie Lawson would ride Jamie's bike in the 200. Here I was, a rookie, preparing a bike for a four-time World Champion to ride in one of the biggest races in the world. Talk about being thrown in the deep end!

In any case, Eddie turned out to be a great guy to work with. Basically, he took the bike as it was set up for Jamie and just rode it. After several practice sessions, Eddie was showing us why he was a multi-time world champ. The lap times were coming down, he looked smooth and in control and we were all hoping for great things.

Well, while Eddie looked smooth and in control, back in the garage, things were not quite as smooth. We had some new engine parts that were proving to be not so reliable and we were having overheating problems. Unfortunately, Daytona tends to magnify things into major problems that would be minor annoyances at most other tracks. While we were trying to fix our cooling problem with ductwork and different radiators, the engines were coming out and going back into the bike with a frequency that was scary.

In order to assure reliability in the 200, an engine was shipped from Japan. This engine was to be used in the race only, but we had to test it, so, out came our engine, in went the factory-built engine for one practice, then out it came, and our engine went back in for Sunday morning warm-up.

This meant that we would have to swap engines between the morning warm-up and the race, normally not a big deal, but THIS swap involved changing the entire wire harness, the ignition system, exhaust system and carburetor settings.

As soon as the warm-up session ended, Ron Foster and I started doing all of the necessary things to change all the systems and the engine. Everything went pretty smoothly and we were all back together with about an hour to spare before the race.

Then, we started the bike, and. . . uh, oh. It wouldn't run on all four cylinders. Panic !

Ron and I checked everything that we had done, starting with the wiring and ignition systems, while Eddie suited up and went out to the grid. Here we were, thirty minutes before the race, bike not running and a bunch of very nervous, cigarette-smoking Japanese Yamaha executives in a tight circle around the bike and a sweating Ron and me. We had NO idea why the bike would not run.

Meanwhile, Eddie was out at the grid with no motorcycle, surrounded by all of his competitors sitting on theirs. Incredibly, we could hear him being interviewed on the PA, just as calm and cool as could be.

Closing on fifteen minutes before the start of the race, we found the problem. One side of the rack of carburetors had not fully seated in the manifolds because of interference with a coolant pipe. Hurrah! A simple (but careful!) hammer blow to the offending pipe created enough clearance, we jammed the carburetors in place, tightened everything and got the bike out to the grid just in time for the parade lap.

Eddie never batted an eye, just climbed aboard, nailed the start and went on to win the race. No problem.

I was still in a daze until we started walking towards the Victory Circle. I then realized our efforts had helped win the 1993 Daytona 200, my first taste of victory at that level of competition.

After all of that work and tension, that first victory was so sweet it was addictive. I'm still chasing that addiction today and probably for years to come."

Sounds simple, right? It's not.

"I think perhaps the most meaningful aspect of our annual marketing efforts through racing does not simply come from the dollars we invest or the potential sales impact for us as a company, but rather from the respect and admiration we all reach for the personalities directly involved." commented Bob Starr, Corporate Communications Manager for the Yamaha Motorsports Group. "As our technology continues to evolve, The Team moves with it. When we are successful, we choose to acknowledge The Team, as opposed to 'The Bike'. I believe that this book captures the personalities and this Team effort that's so important perhaps more than any prior effort."

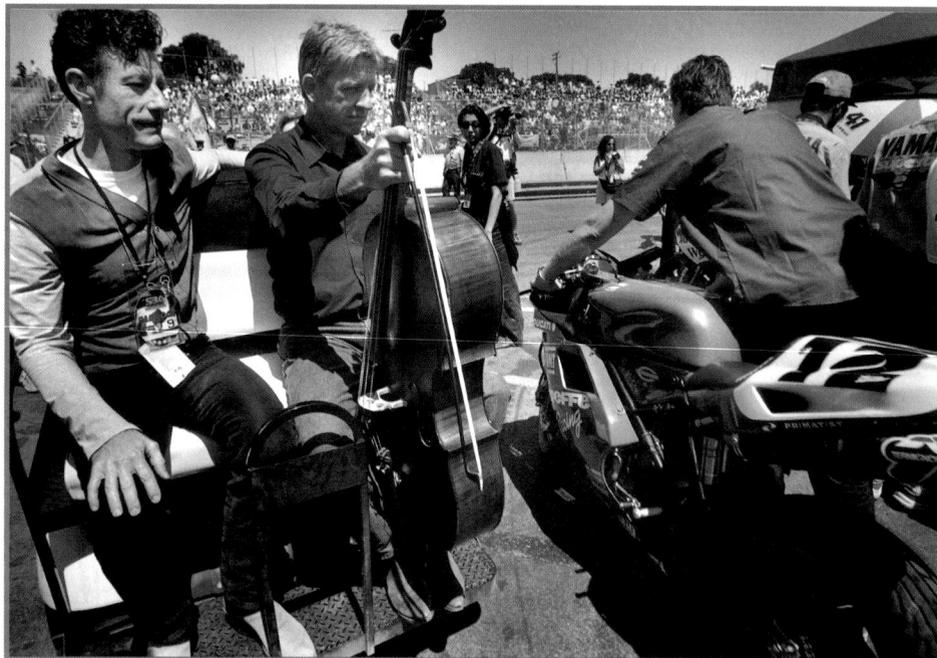

"You can't imagine the huge sacrifices my wife has made so I could chase my dream." commented Danny Hull, a lead mechanic on the Erion Honda team. "I traveled the world, over fifty countries, for eight years in World Superbike. The things that evoke my strongest memories come in triumphs and tragedies: over twenty-five Gran Prix World Superbike victories with Fred Merkel, Fabrizio Pirovano, Scott Russell and Anthony Gobert. . . winning back to back U.S. Superbike Championships with Doug Chandler in 1996 and 1997. . . winning the Daytona Arai 200 in 1994 and 1995 with Scott Russell and in 2000 with Kurtis Roberts in the 600 cc. You can't lead a normal life and do all that."

being hired by them next season. It is the most rewarding thing you can imagine, to beat the factory at their own game." he relished with a smile. "My Dad and I have both done it."

Life on the circuit can be grueling, with weekly races hundreds of miles apart. The big teams, who make all of the venues, have setup and breaking camp routines down to a science.

Off seasons are spent fine tuning and testing men and machines. Engines on test frames in the dyno room. Suspensions, tires and riders on the track, in a never-ending search for that perfect combination of maneuverability, reliability and speed.

"AMA races a variety of classes (750, 600, etc.) here in the United States. The World Superbike is considered a bigger career deal for the riders and teams because it races a circuit that takes them to Europe, Asia and South America. The only World Superbike race in the U.S. is the Laguna Seca event." added Elizabeth Piper with the Motorcycle Industry Council's Motorcycle Safety Foundation. "Riders who do well in AMA hope to move to World Superbike and then move up to GP racing."

But, that's only the professional side of the coin. The other is composed of literally thousands of amateur racing teams in local and regional competitions that form the bedrock for the national circuit.

"Racing is comprised of ninety percent privateers, spending every spare dollar they have racing." declared John Long of Longevity Racing. Long, holder of three American motorcycle road racing championships and a handful of Bonneville Land Speed records, is a twenty-five year veteran privateer, himself. "Without them, there would be no race. Their main goal is to beat the factory teams with the hope of

At the professional level, it is much like life in a small town, where everyone knows everyone else. Depending on timing, need and circumstance, both riders and mechanics move from factory team to factory team, circuit to circuit, like hired guns. It was summed up as I watched one of the mechanics on the World Superbike circuit greet a former co-worker at Laguna Seca, with a slogan that seems to sum it all up for the pros: "Same shit, different shirt."

For the privateers, it tends to be more personal. The core of the racing effort is the rider, who usually owns the bike and starts out as his or her own mechanic. Then, a kind of racing family develops. Perhaps Mom and Dad sign on to help out at the races. Maybe a best friend, significant other or mate. Suddenly, you've got a team and you get serious about a trailer or van with your team's name on the side. If you win a few races, maybe you can get some local business to sponsor you, maybe even a motorcycle dealer, who could help with parts and mechanical assistance and a place to park the trailer during the week. You start thinking about which tracks you can drive to if you leave right after work on Friday night and hustle

straight back after the last race on Sunday.

"You really missed it last night." declared a smiling sponsor, Tim Dow, over beers, in his thick back-bay accent. "What a picture. We had the motor spread out all over the kitchen table, back at the condo. Jesus, there was stuff everywhere."

Daytona closes down the paddock area at six, and there was still work to do on the Dow Transportation/ Harley-Davidson of Boston entry for the first race of the season, so the work had gone home to the apartment that Dow had rented.

"The tradition of racing is an inherited factor for me." said John Long. "I grew up watching my father race and my sons have traveled the world watching me race. Together, we learned the concept that each player is respectful of each others' space, in spite of the dueling aspect on the track. We learned that mistakes can be unyielding, like the wall outside any turn on any track."

In addition to the racing teams themselves, there's also a small army of track workers at each venue. Aside from the management and maintenance staff of the track, there are corner workers, race control personnel, crash truck staffers, security and medical experts, all at work in a bee hive of activity to prepare and safely run the event. Sometimes they're specialists, like the members of USARM that run the "Drag-on Wagon" crash truck at Laguna Seca. Other times, they're volunteers, usually experienced.

At RoadAtlanta, we met Safety Specialist Mike Marquez and his buddies that run the crash trucks. These adrenaline-addicts not only volunteer their time, but also furnish their personal trucks and trailers that are used to pick up the unfortunate crashed riders and their gear.

"There's a definite adrenaline rush." Marquez agreed. "Your goal is to help control an uncontrollable situation, hopefully safely. Just being on the apron, seeing a racer get the maximum from himself and his machine is great. When we have to do a pick up, just being thanked by the riders for something I love to do, and would probably always do for free, is enough for us."

Crashing on one of these two-wheeled rocket ships is just considered an eventuality and part of the business to the riders.

"Early in my career, I was scared of crashing and did not take chances." offered John Long. "It took many years to feel comfortable and race with style. Eventually, I started winning races, being competitive and enjoying what racing had to offer me. Racing is not just riding a bike around a racetrack; it's riding with a chance to win."

Mike Marquez told me about a wicked crash at Road Atlanta in 1999. Champion rider Rich Oliver crashed in Turn Four, hitting the wall, knocking himself out for several minutes. When he came to, he realized that his left arm had been broken. To Marquez' surprise, after complaining briefly about his various injuries, Oliver looked up and said, "Well, at least it's my left arm. My right arm is my bowling arm."

Racing is the ultimate challenge." John Long concluded. "Engineering a superior machine and riding it with finesse and strategy are some of the aspects of the sport that I enjoy immensely. It is rewarding to take an inferior bike and win, knowing that, on that day, you had the better combination."

". . . the better combination." That's really what the concept of The Team represents. Pit warriors, each one, from mechanic to rider, whether professional or privateer, fiercely proud and competitive, each one giving whatever it takes to be the best, to win and win consistently.

After all, as Danny Hull commented, "It's not just what you win. It's who you beat to win it."

Jon Ward

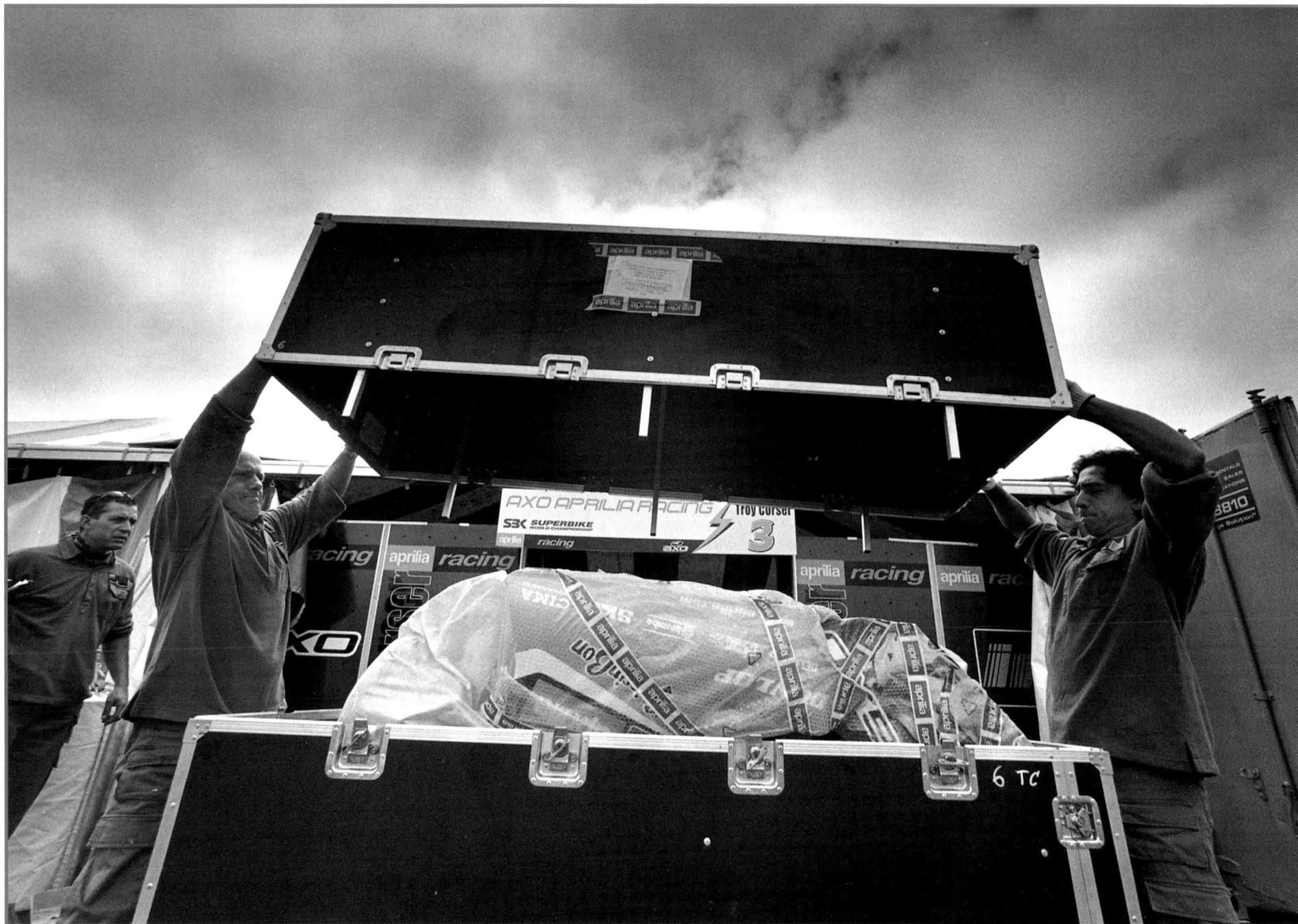

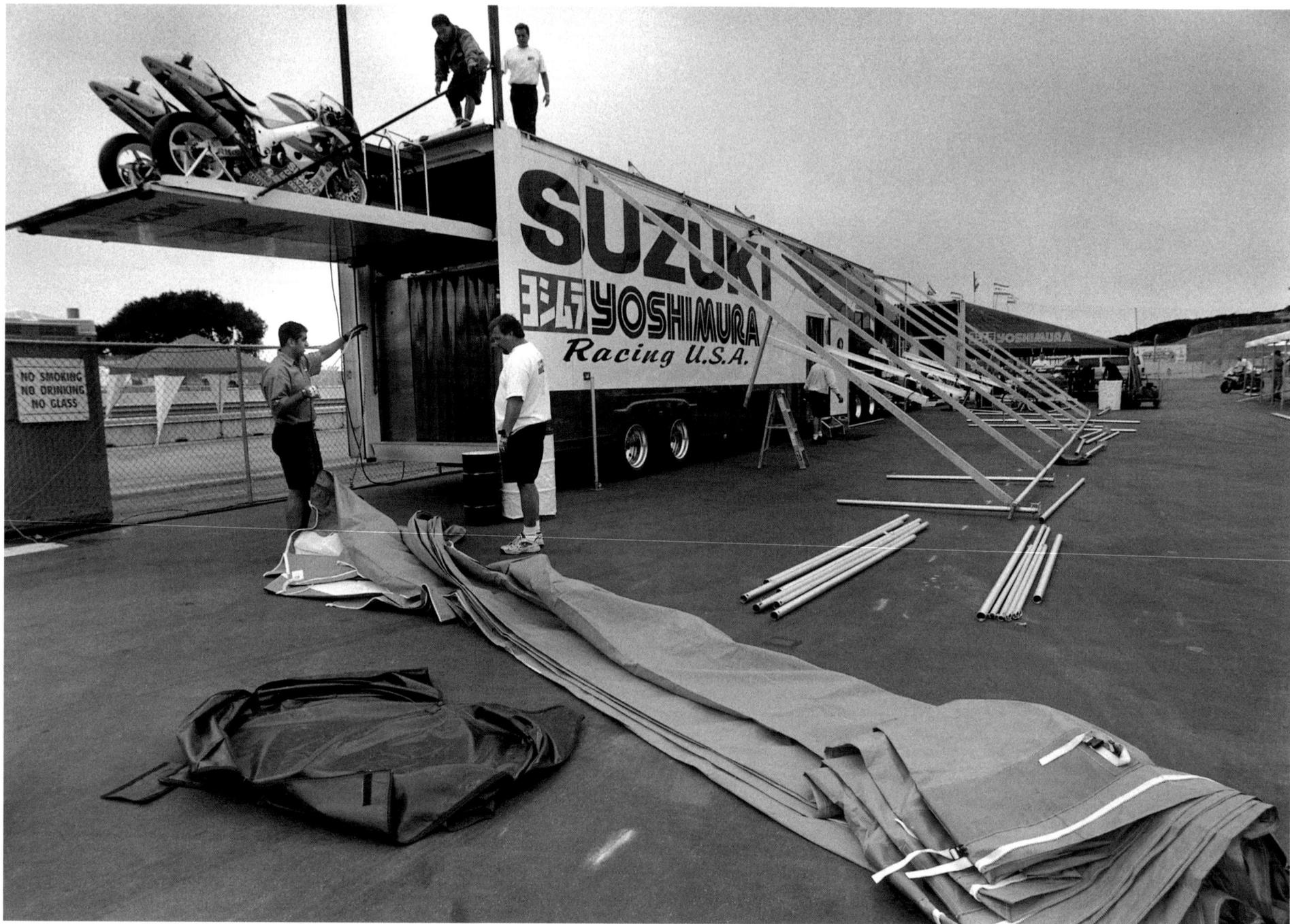

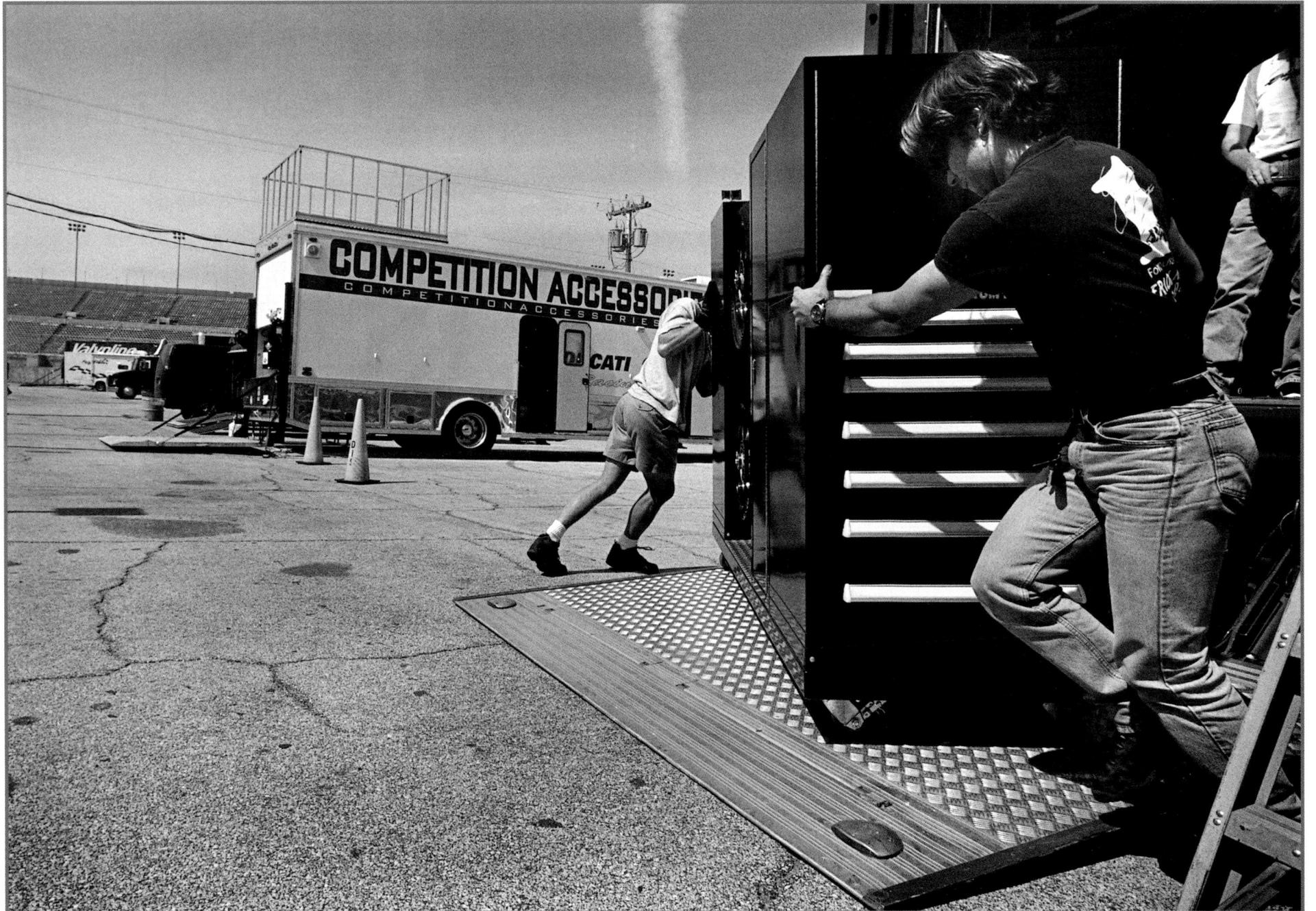

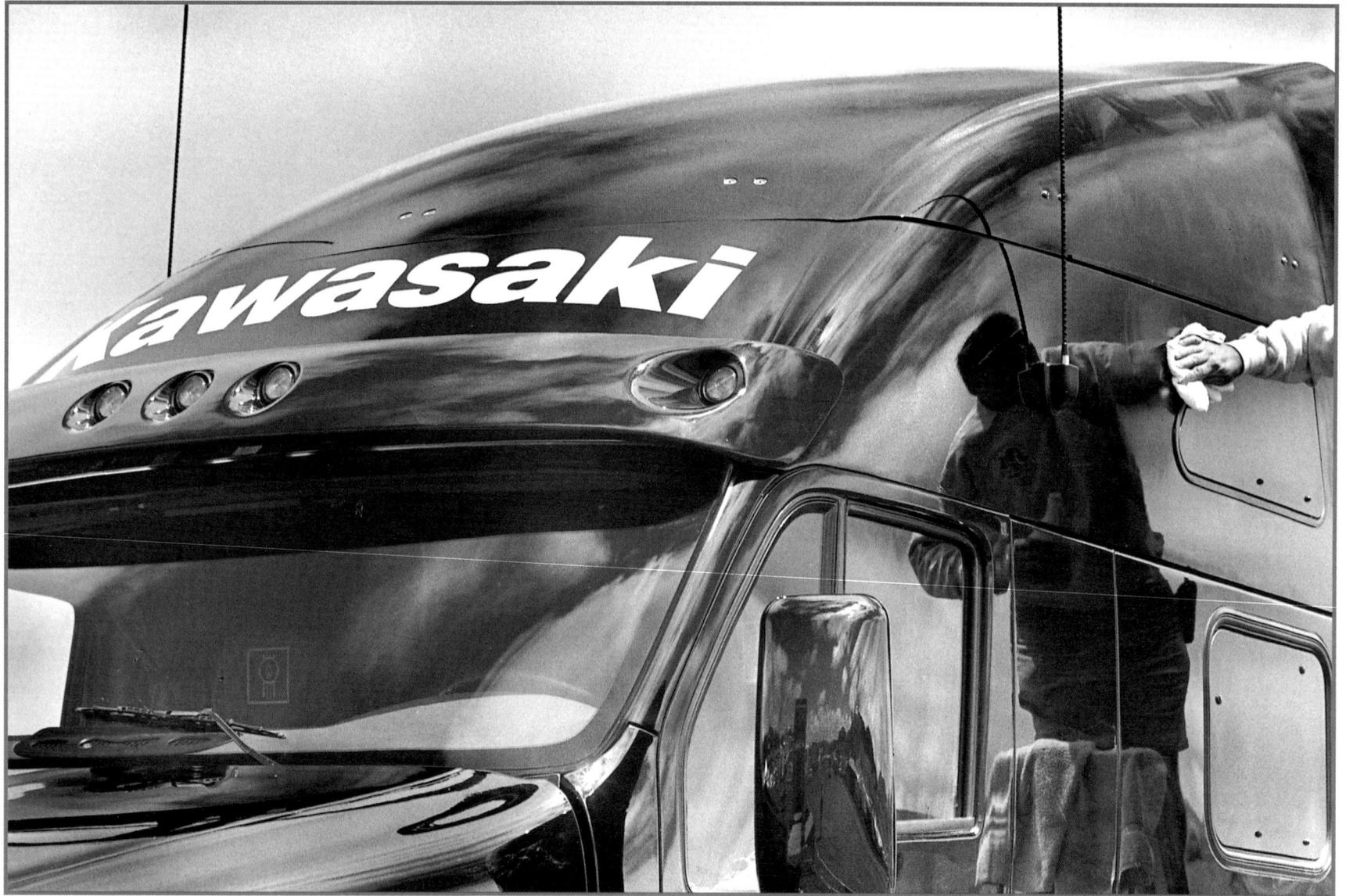

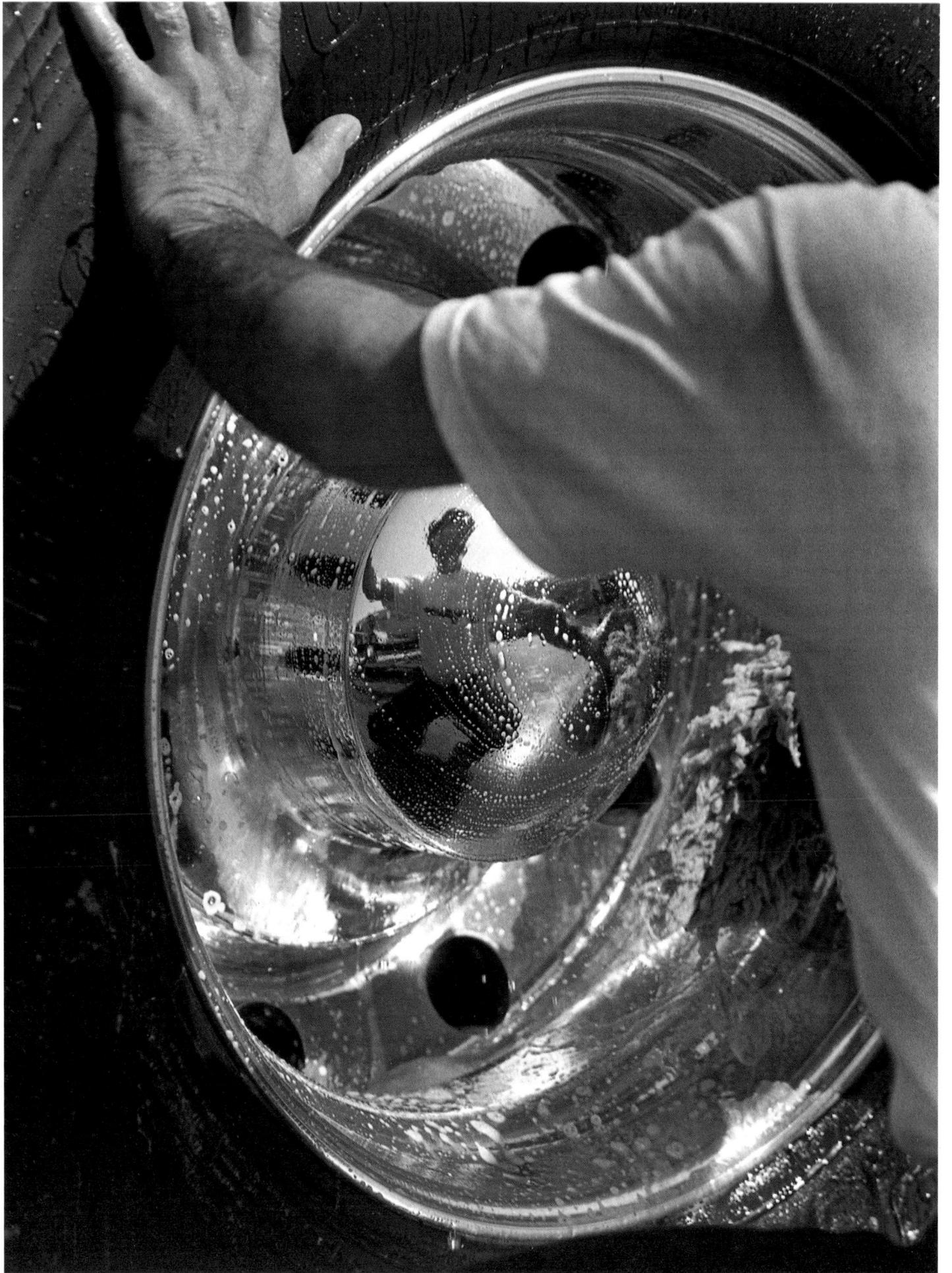

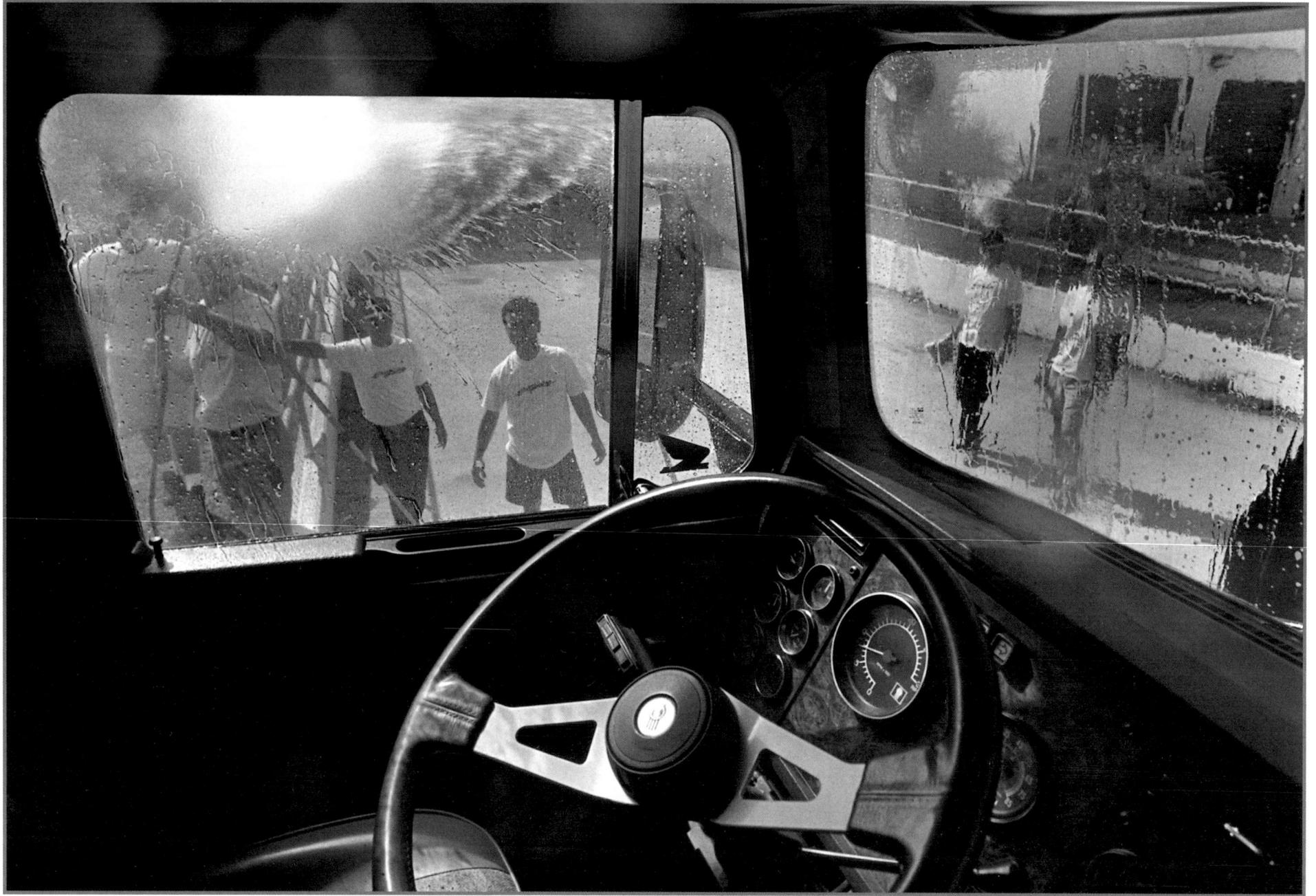

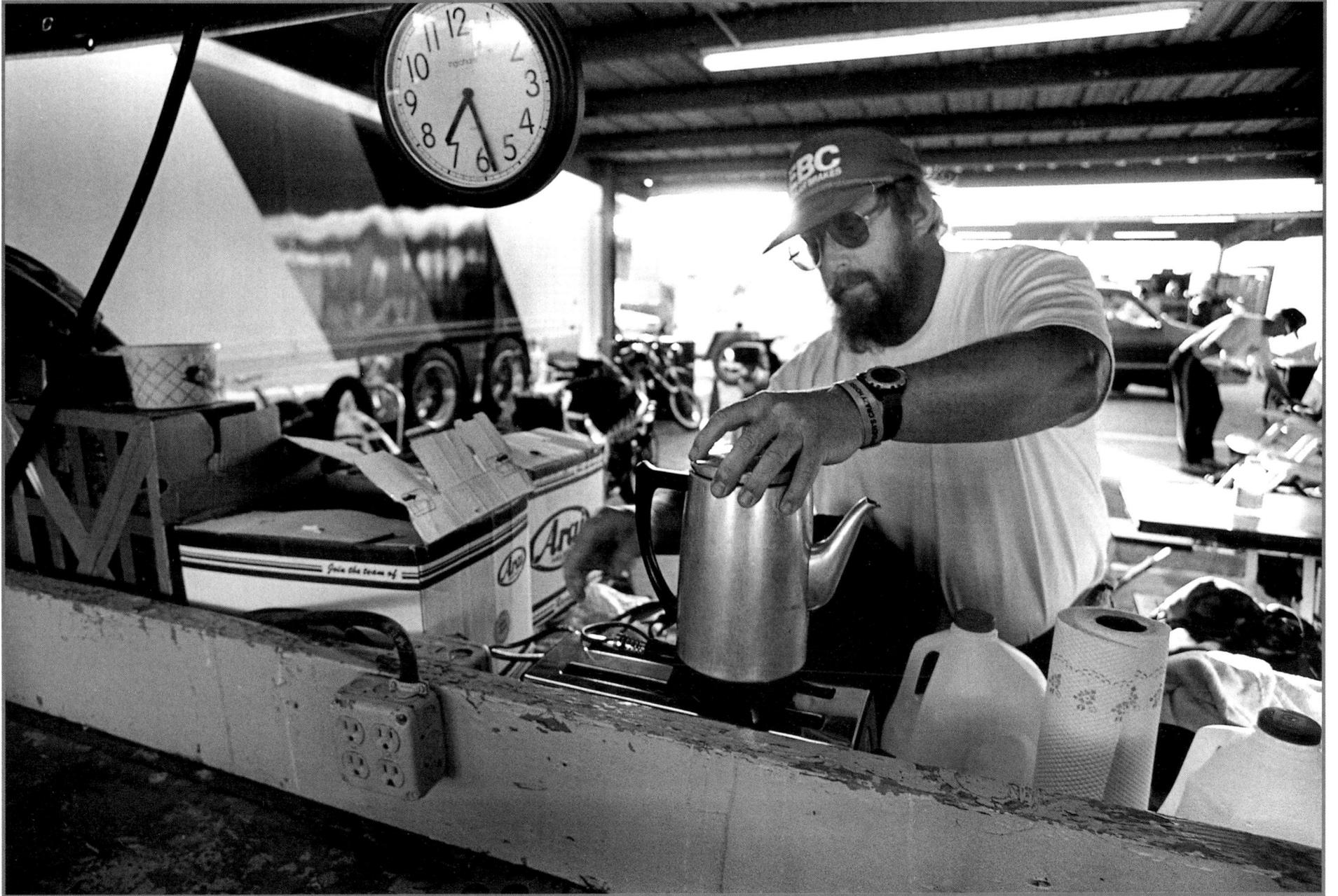

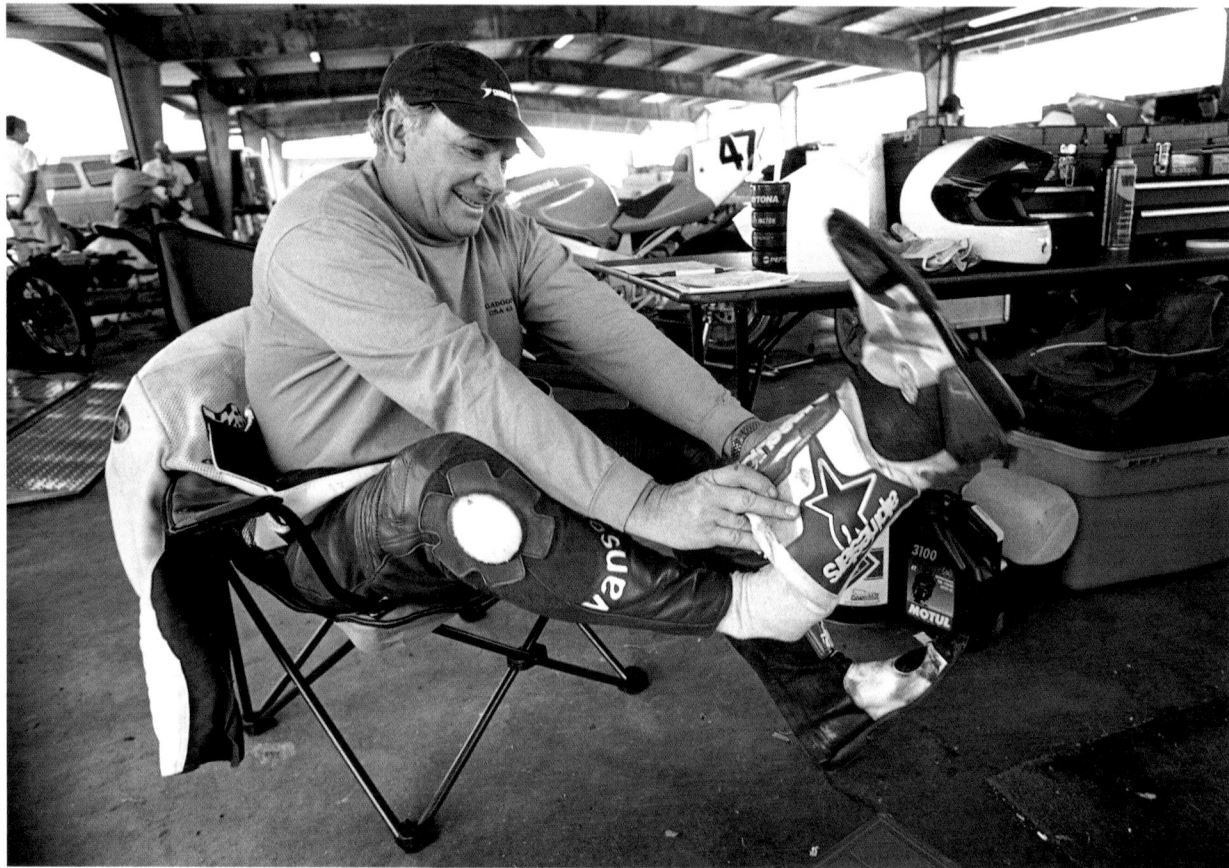

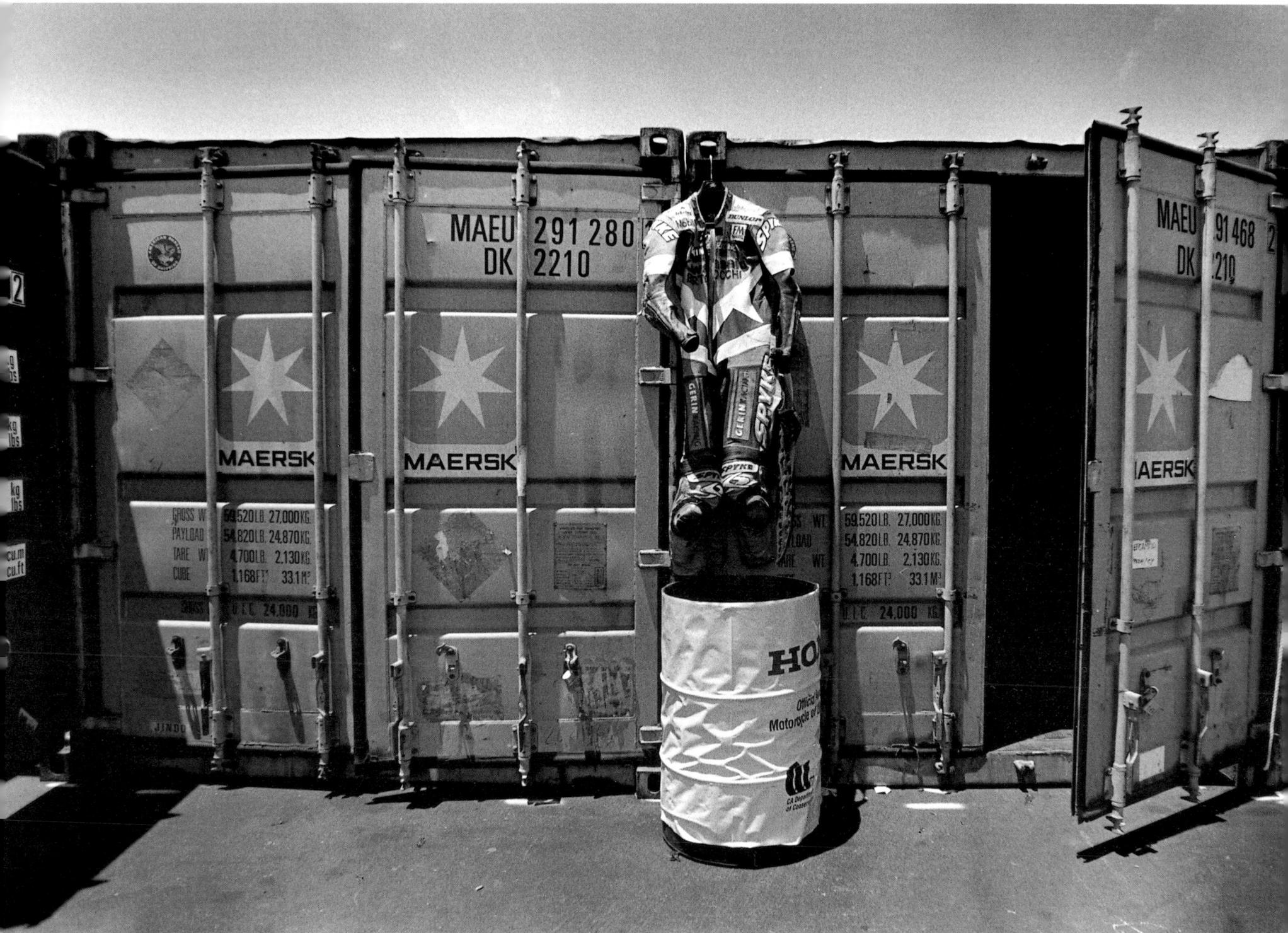

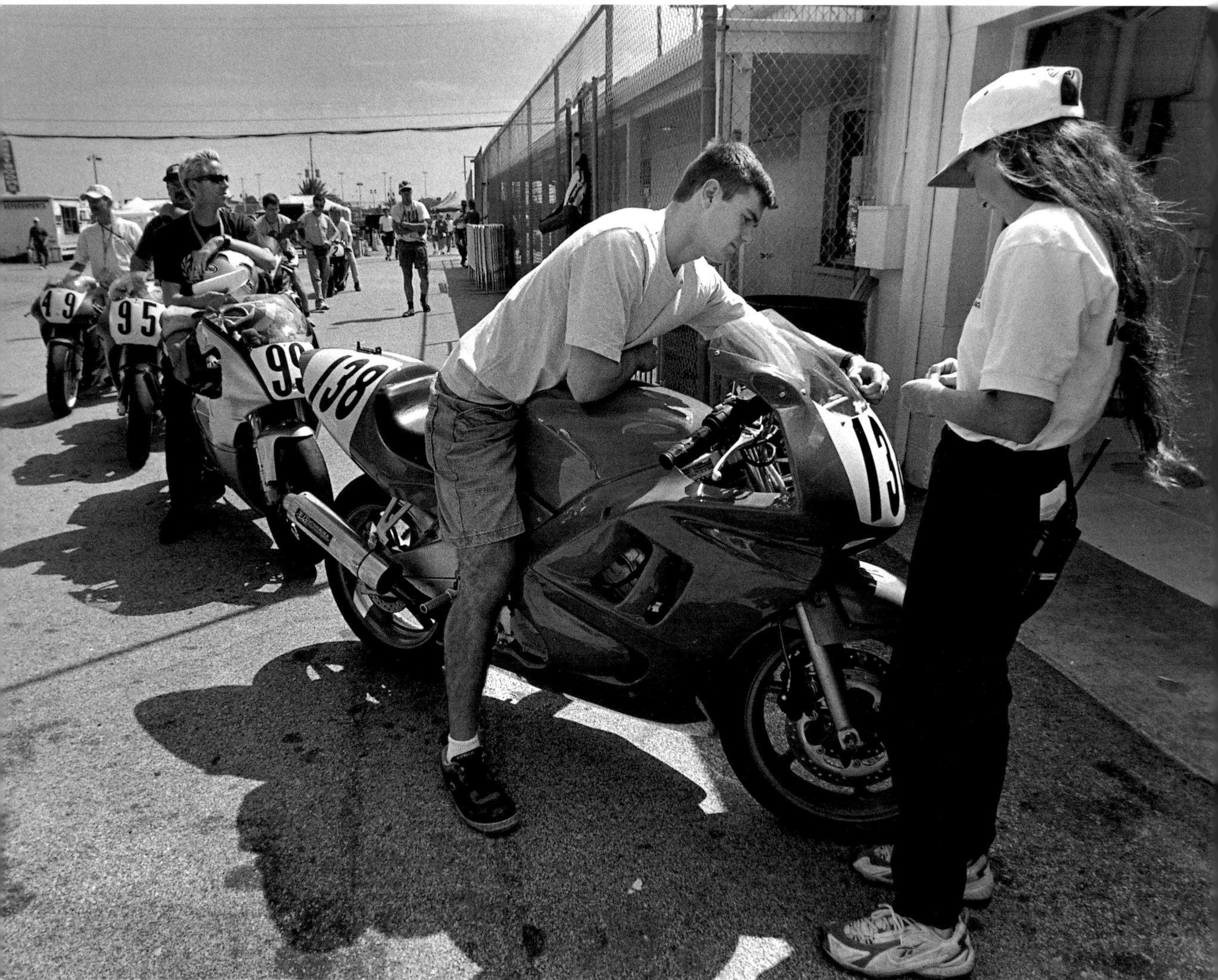

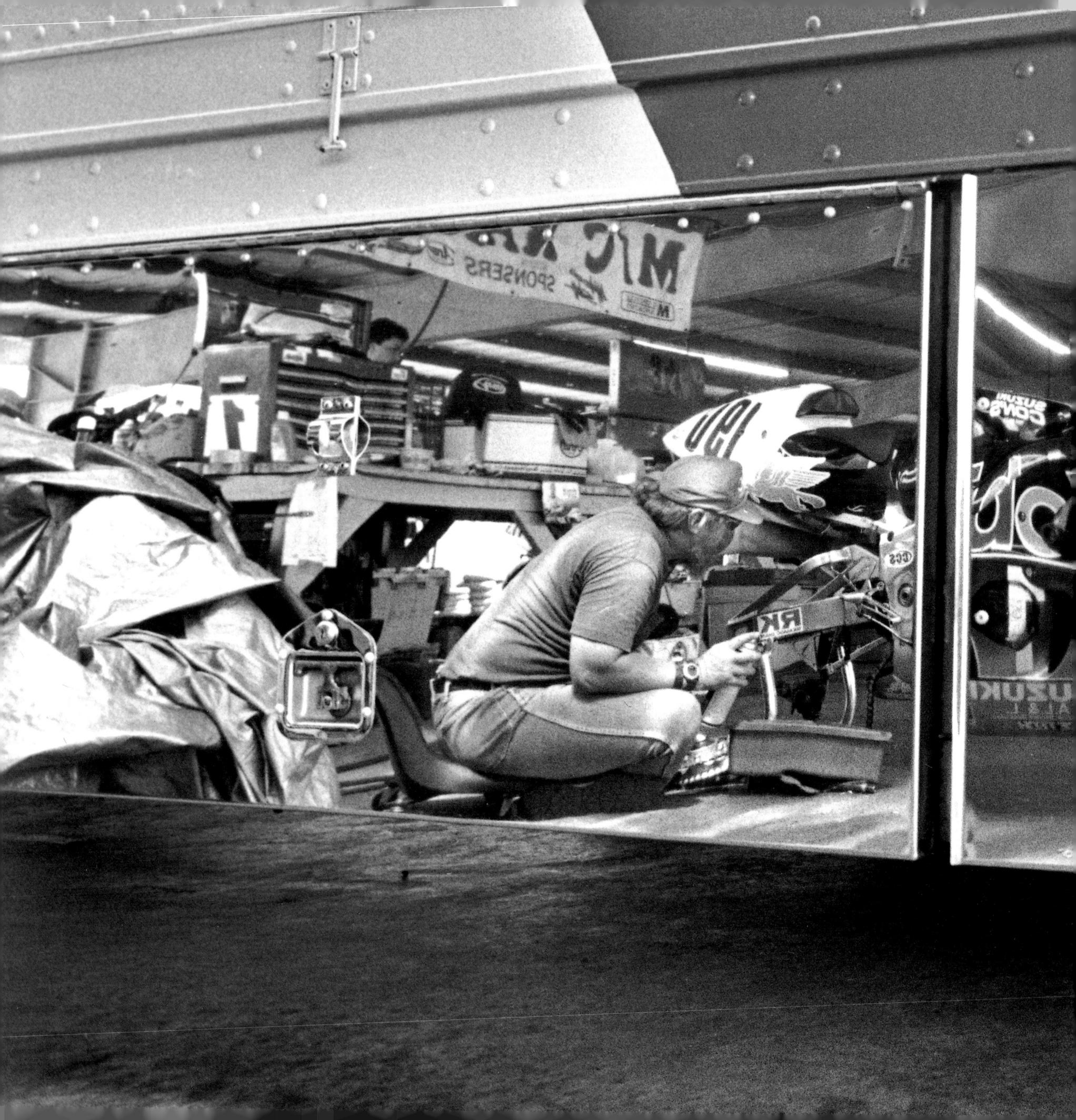

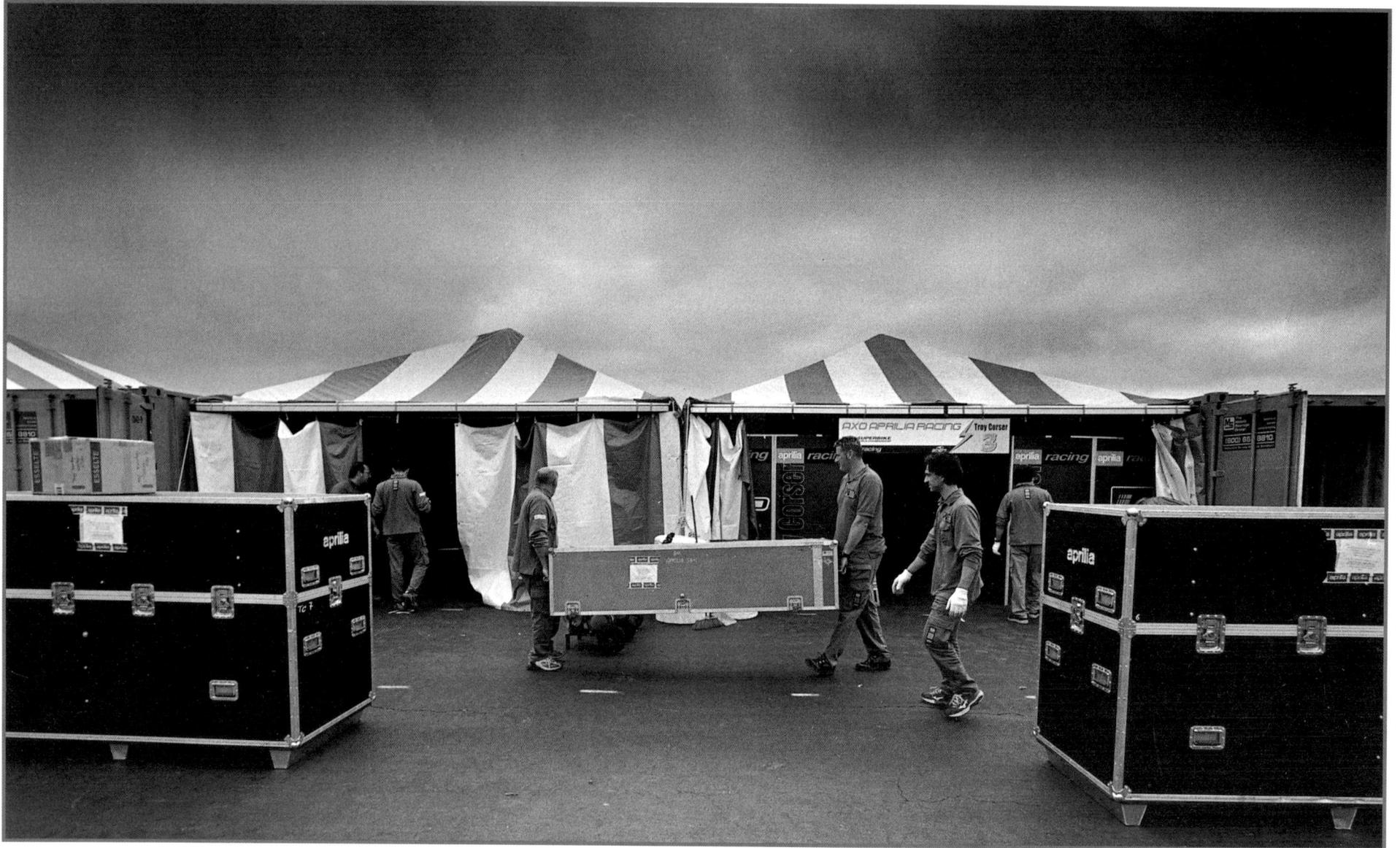

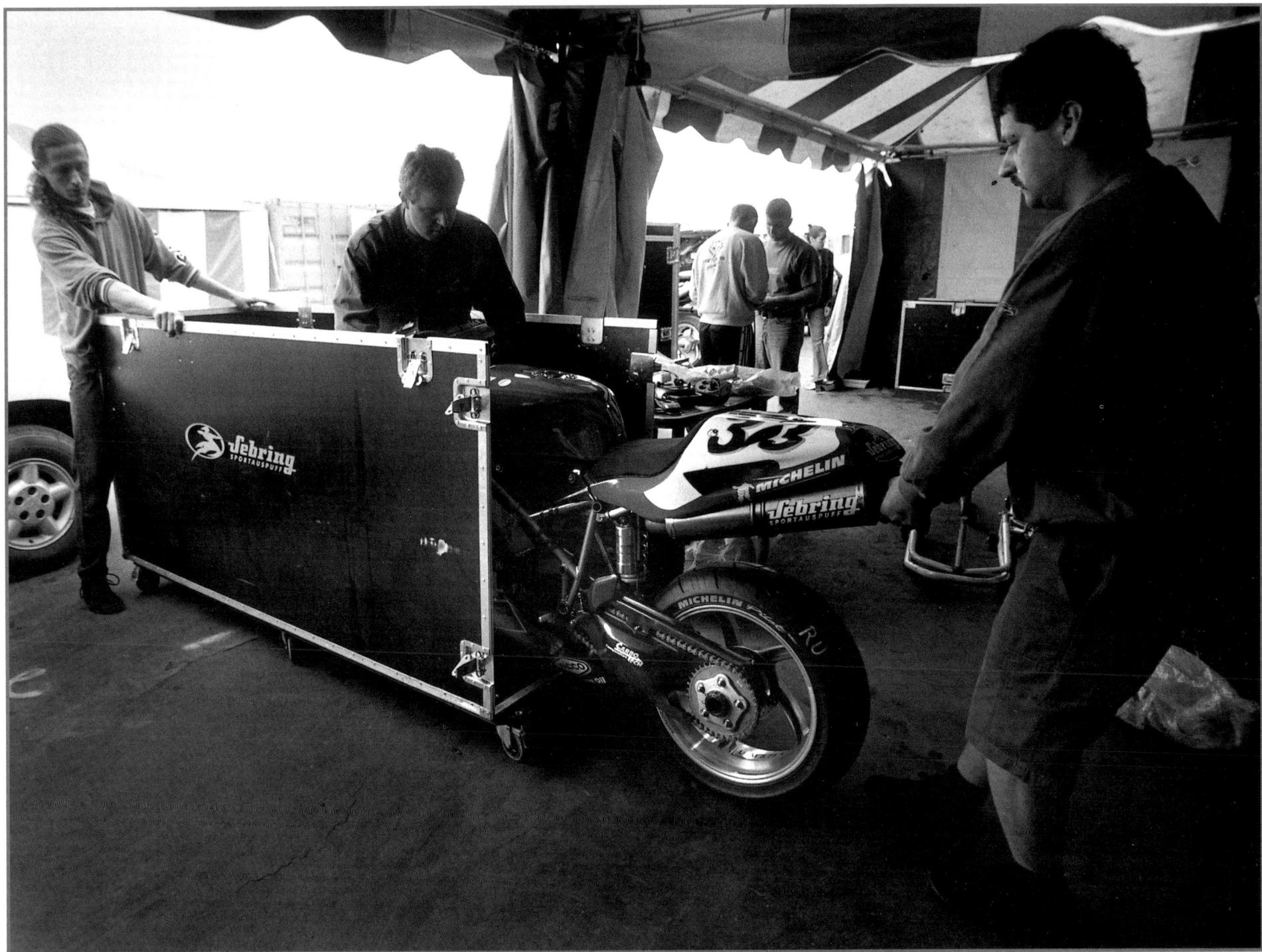

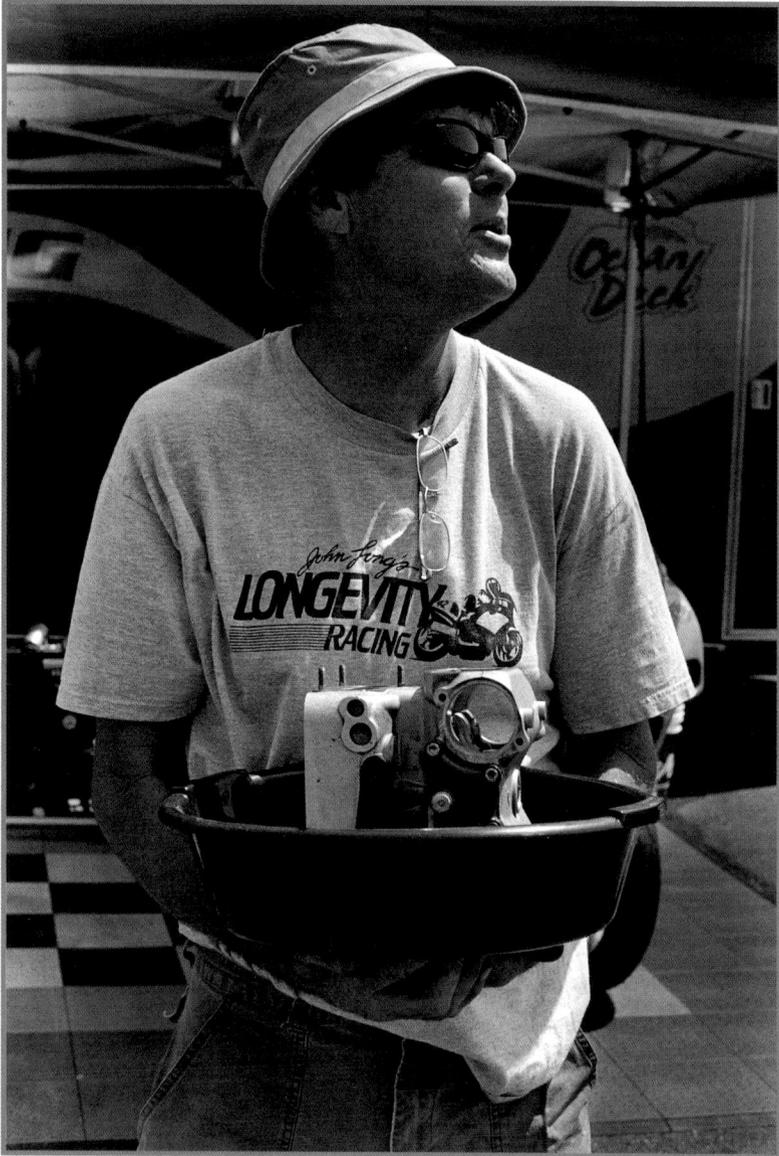

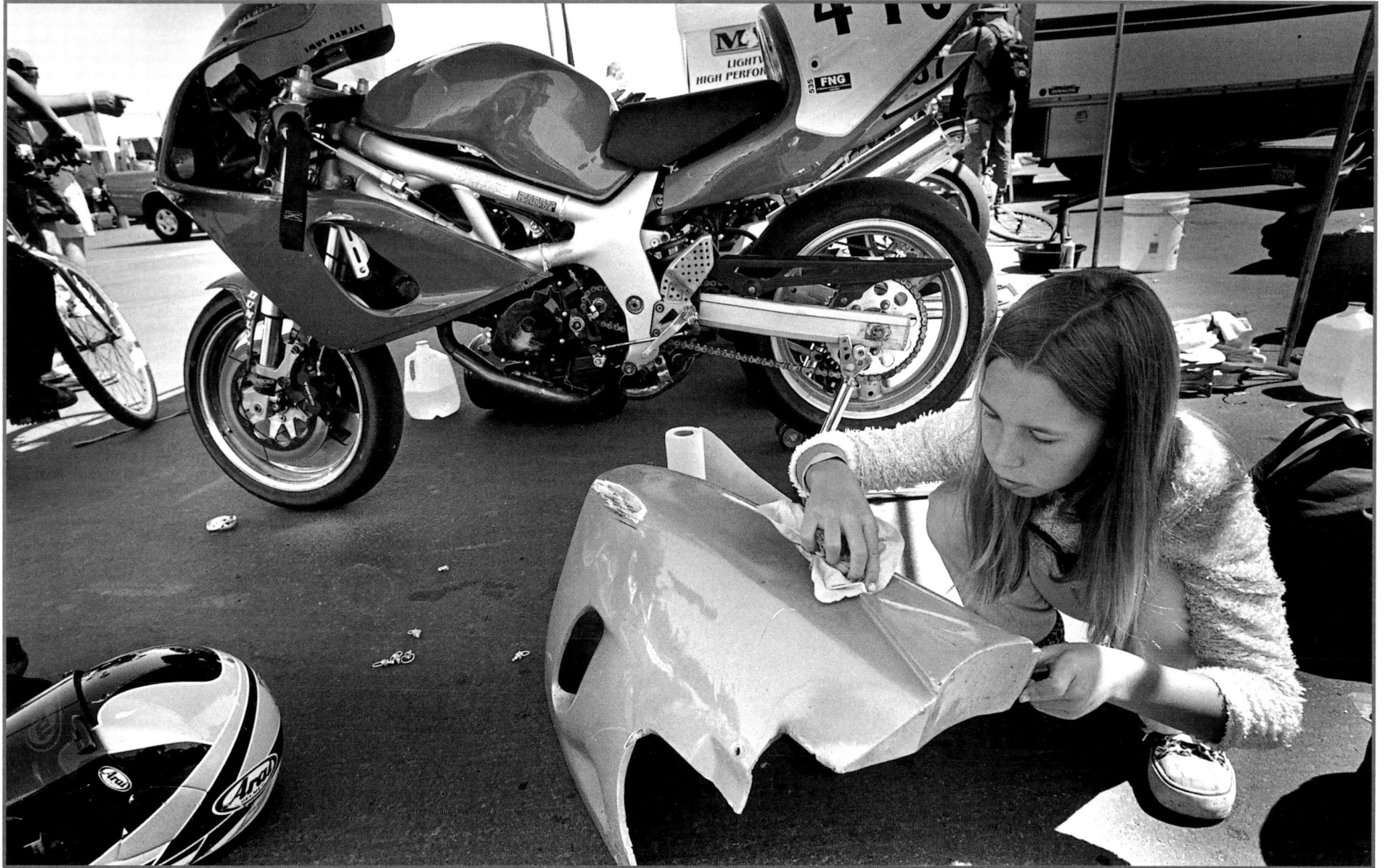

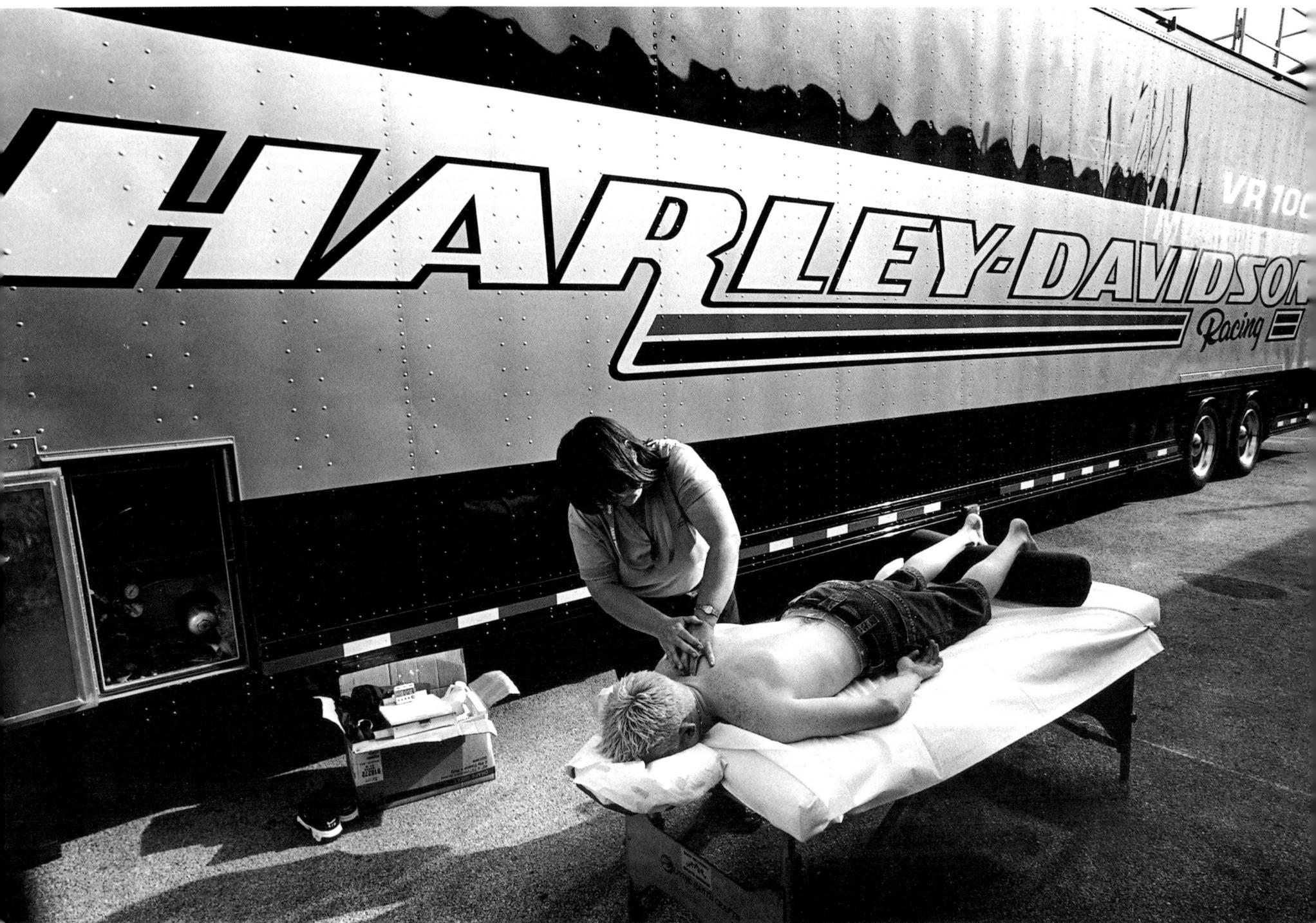

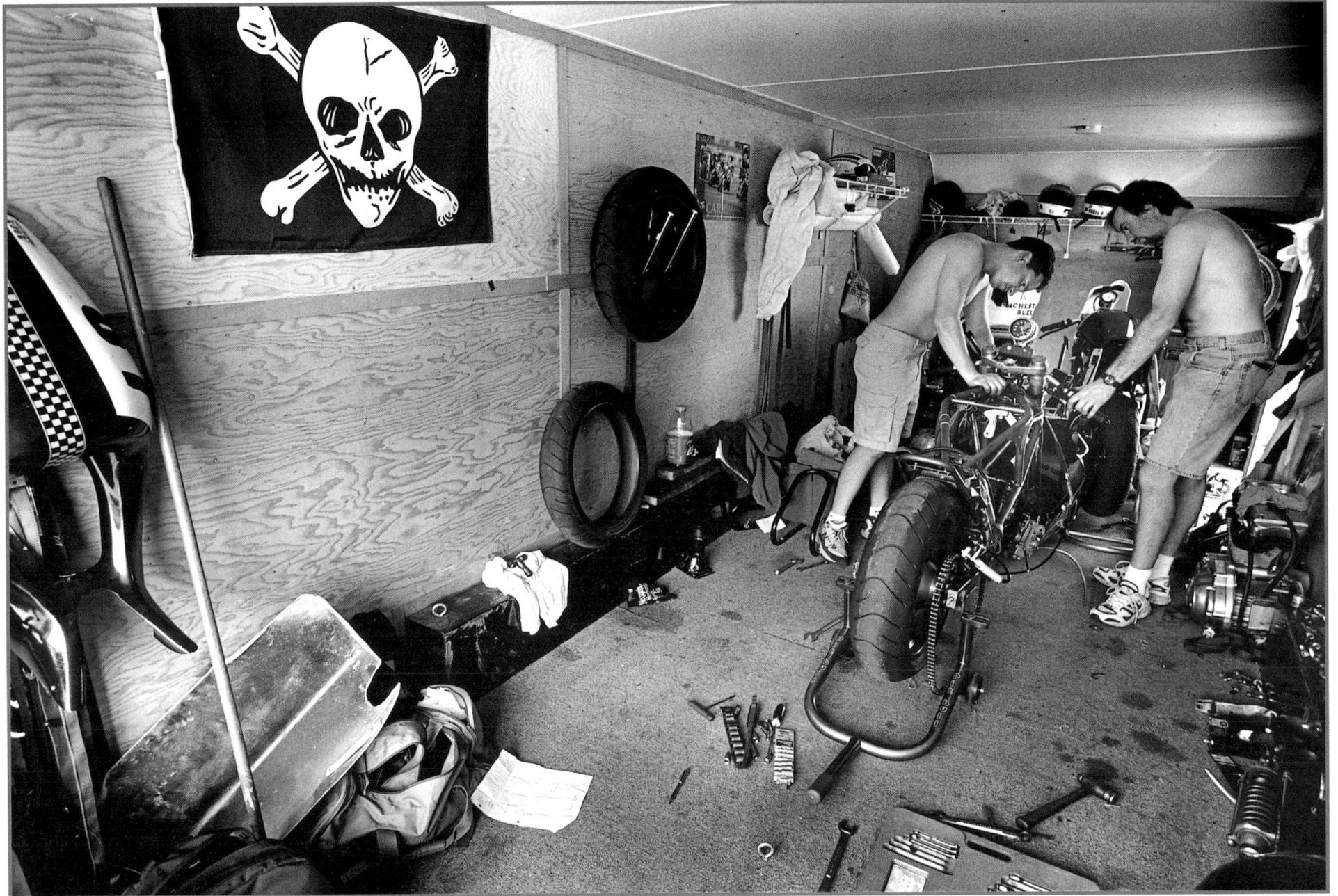

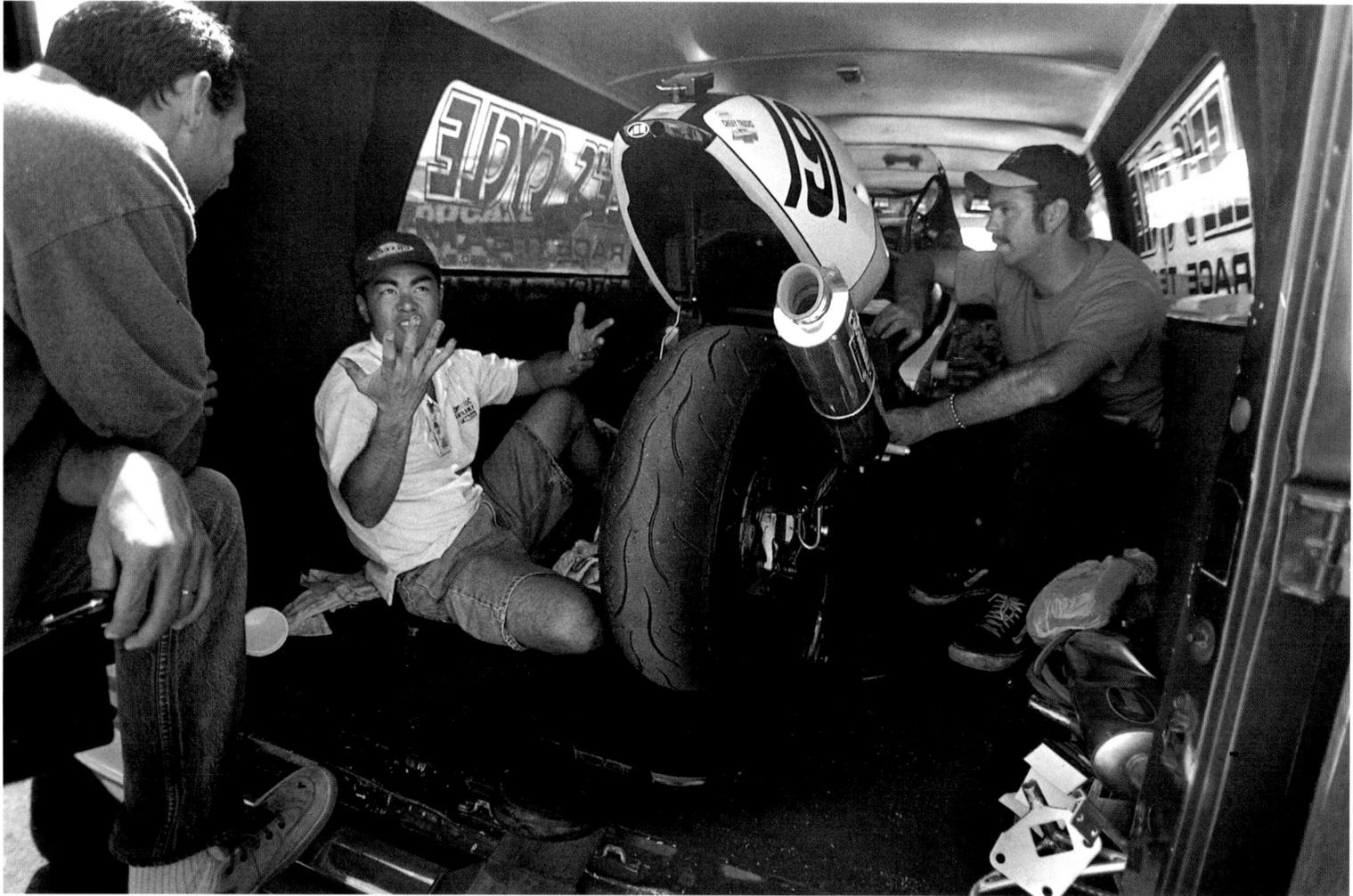

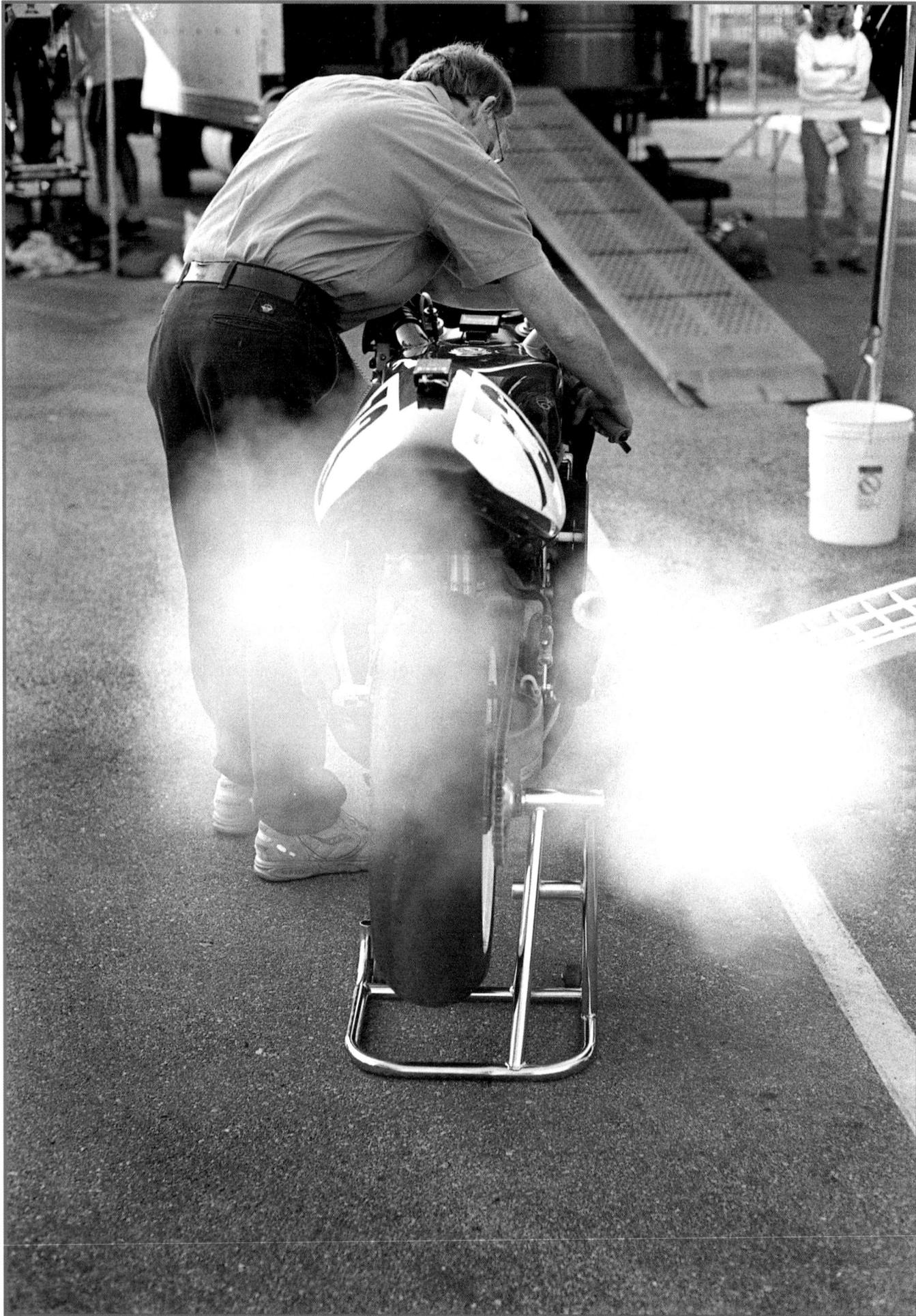

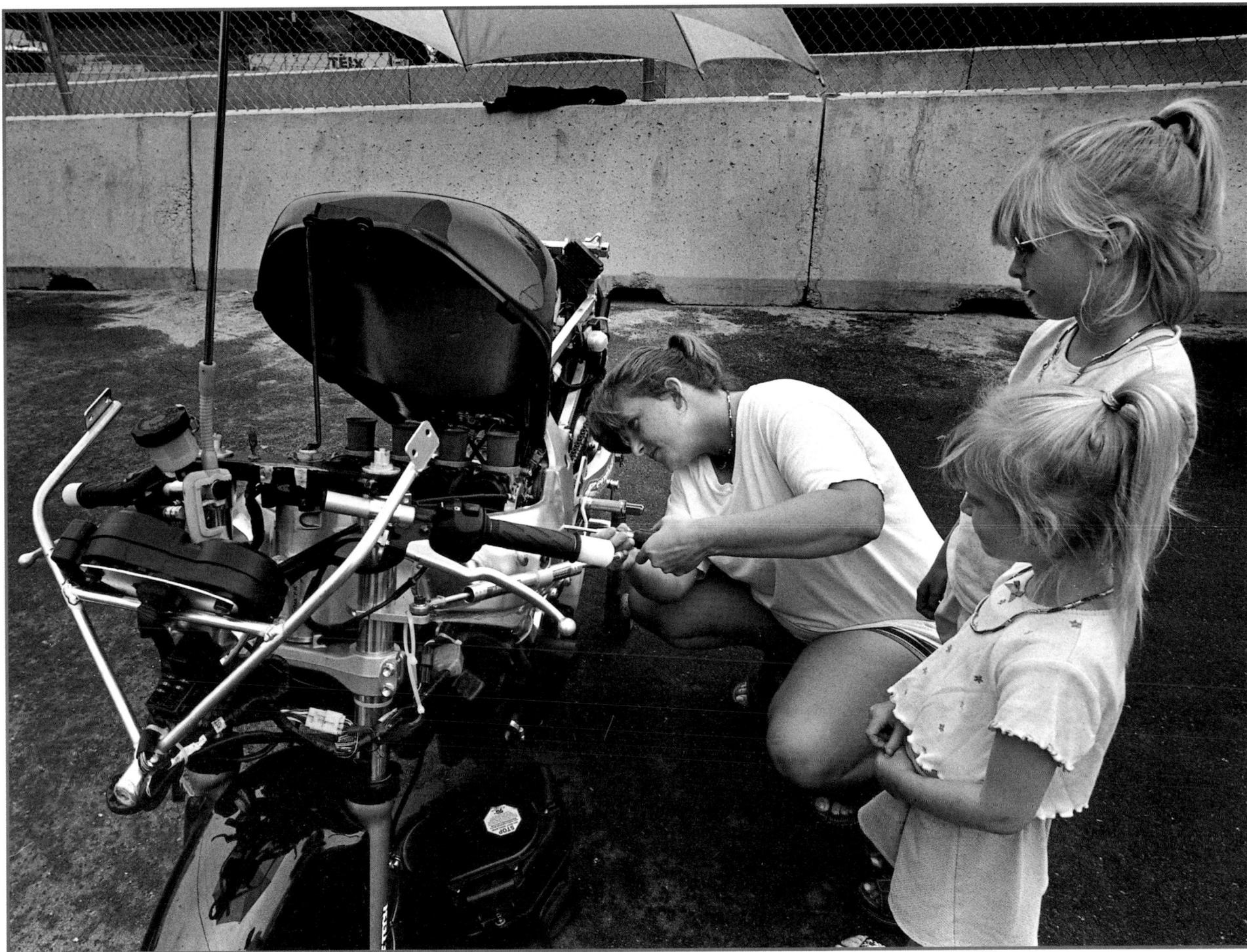

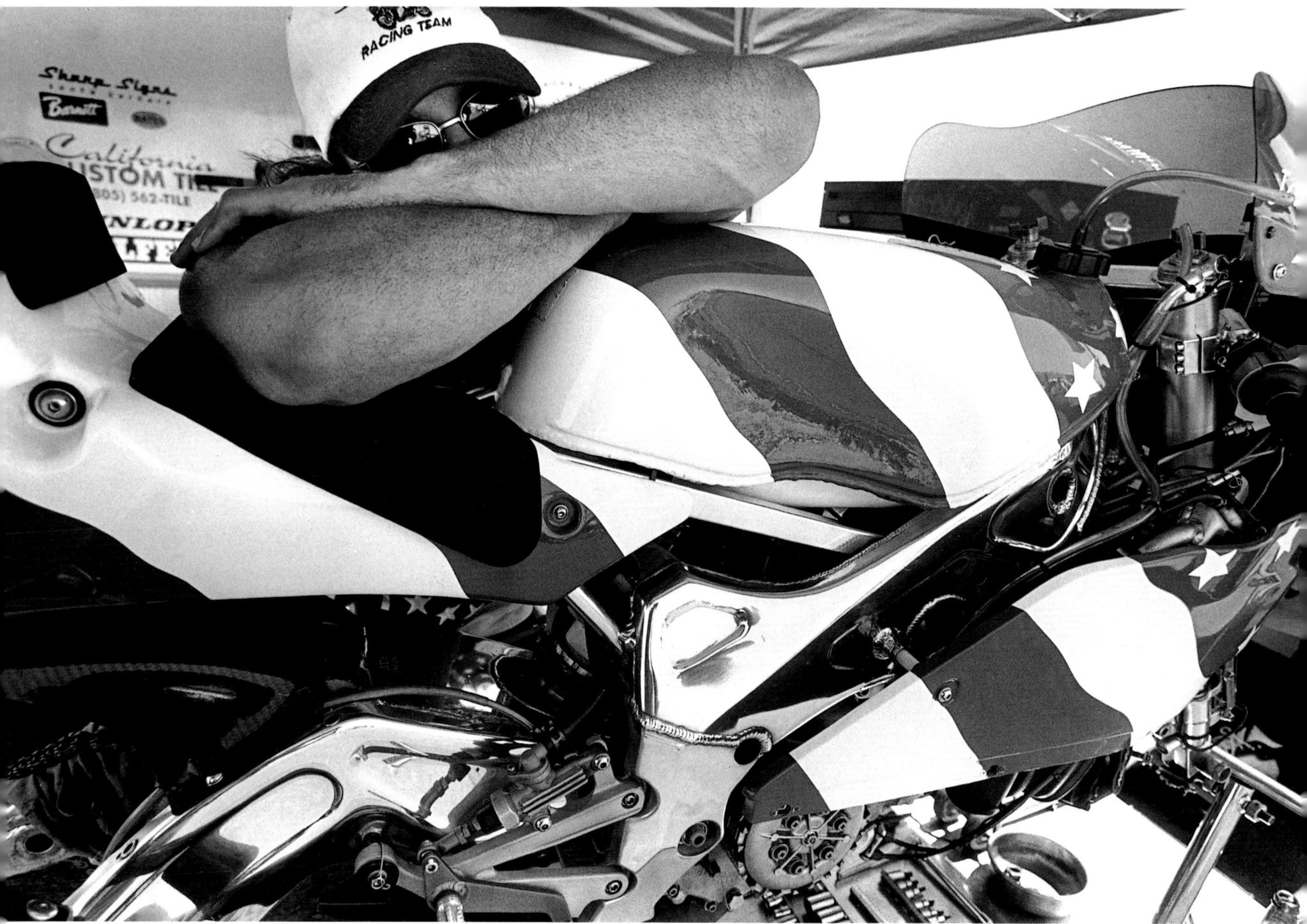

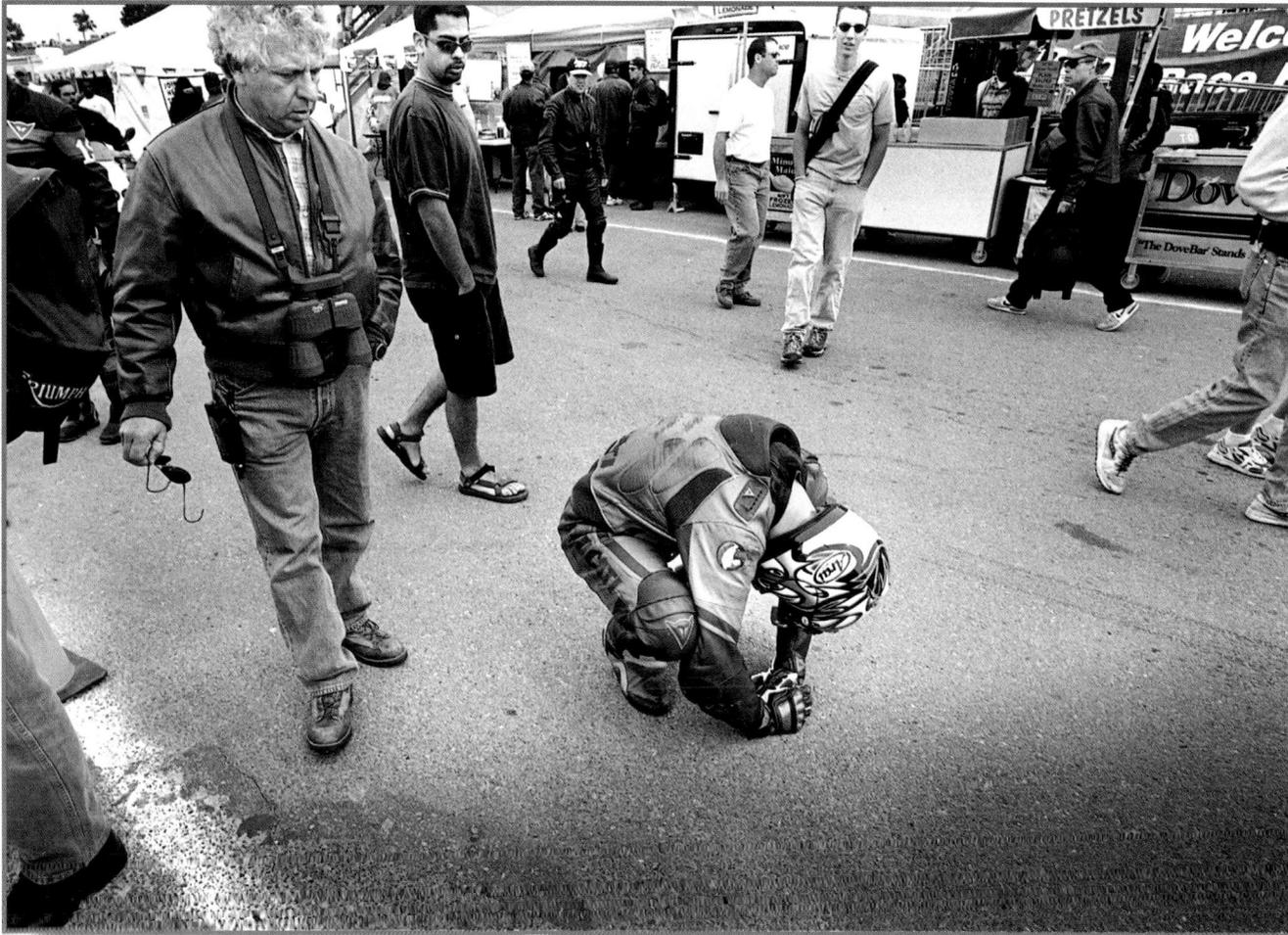

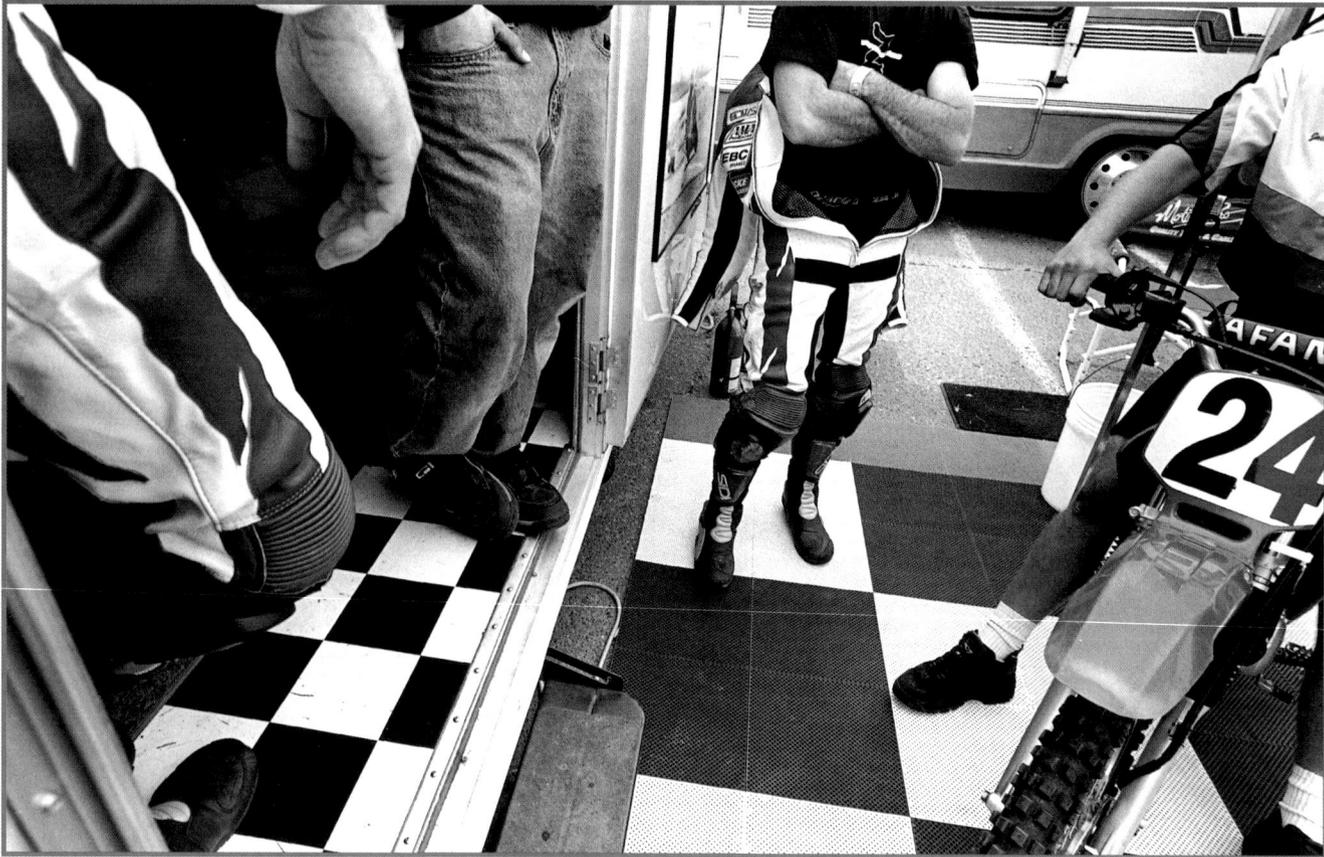

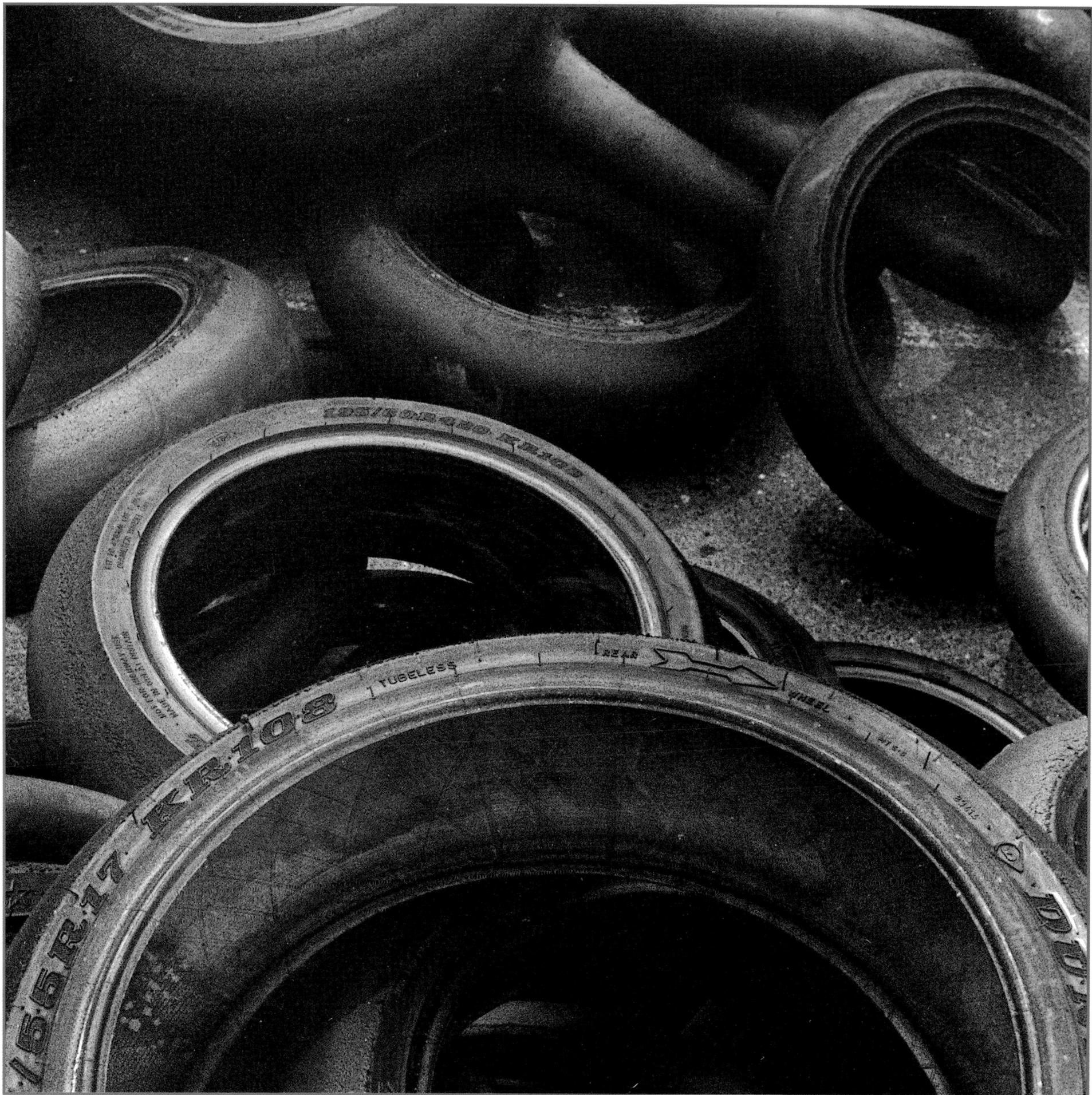

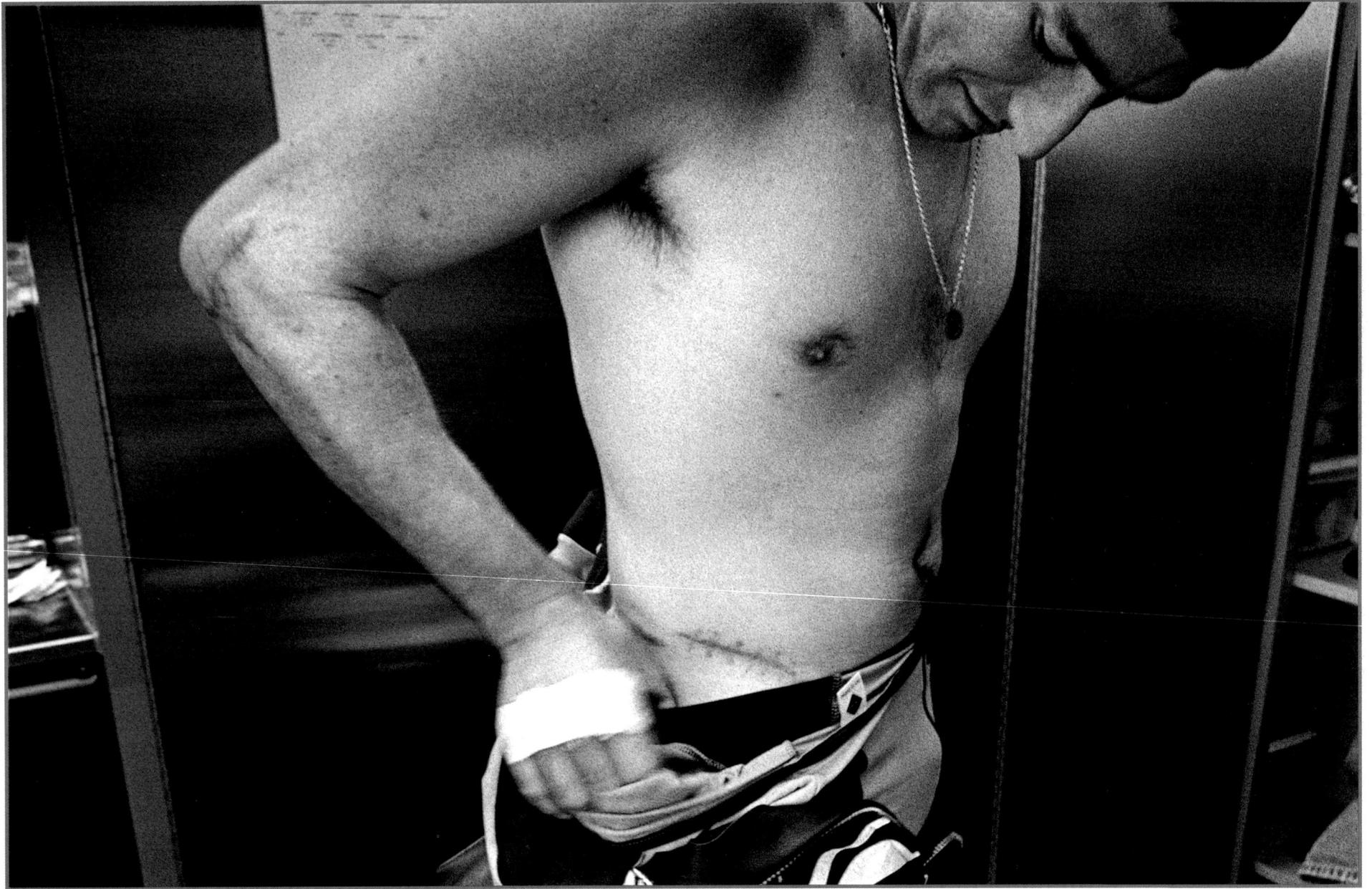

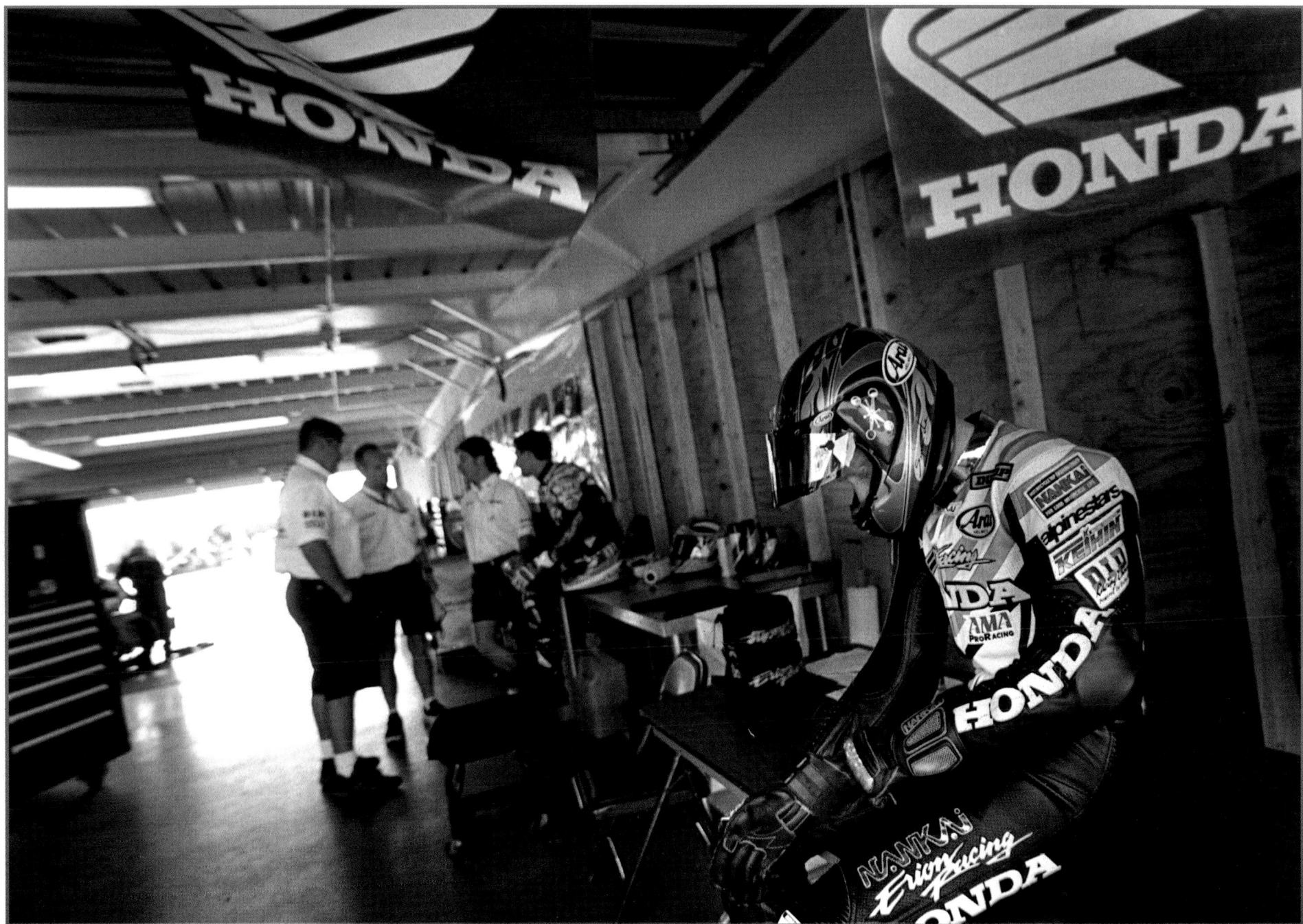

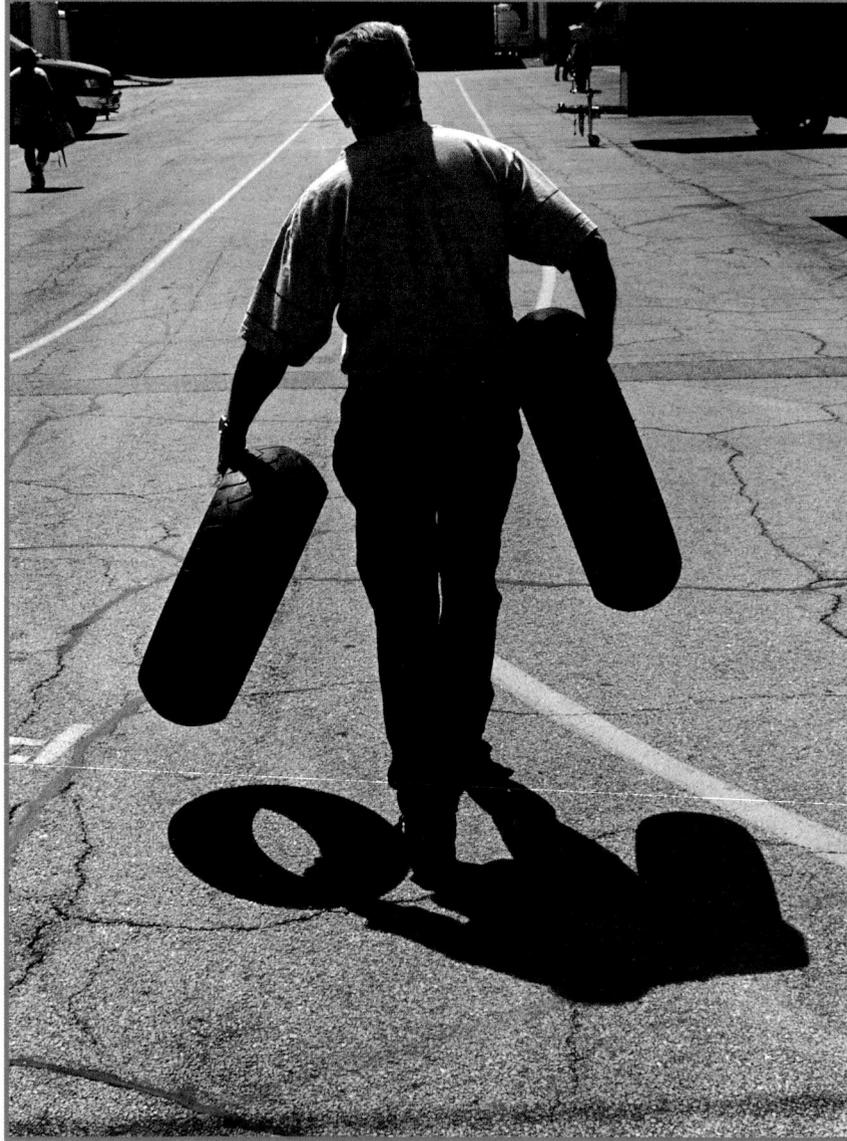

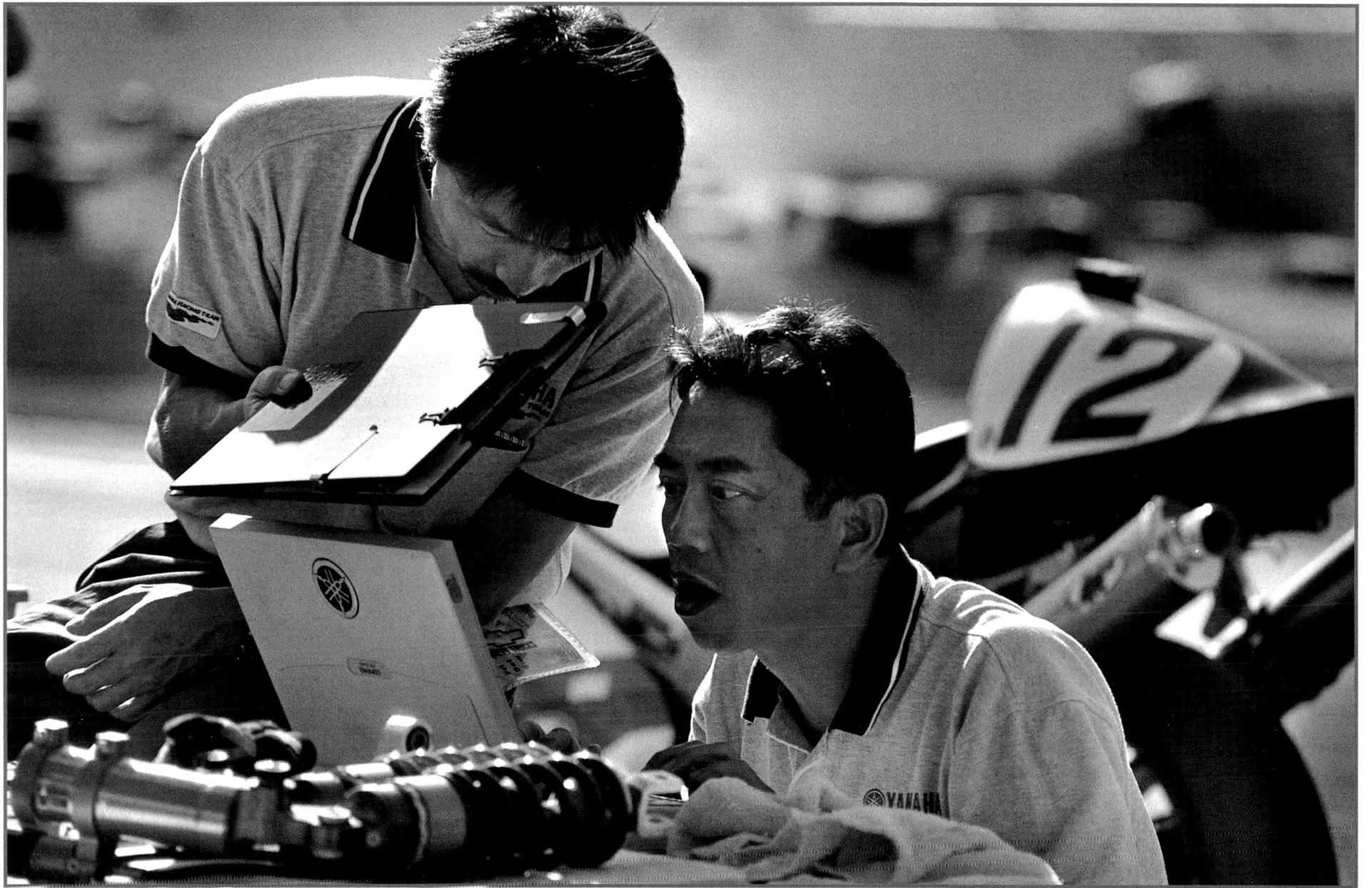

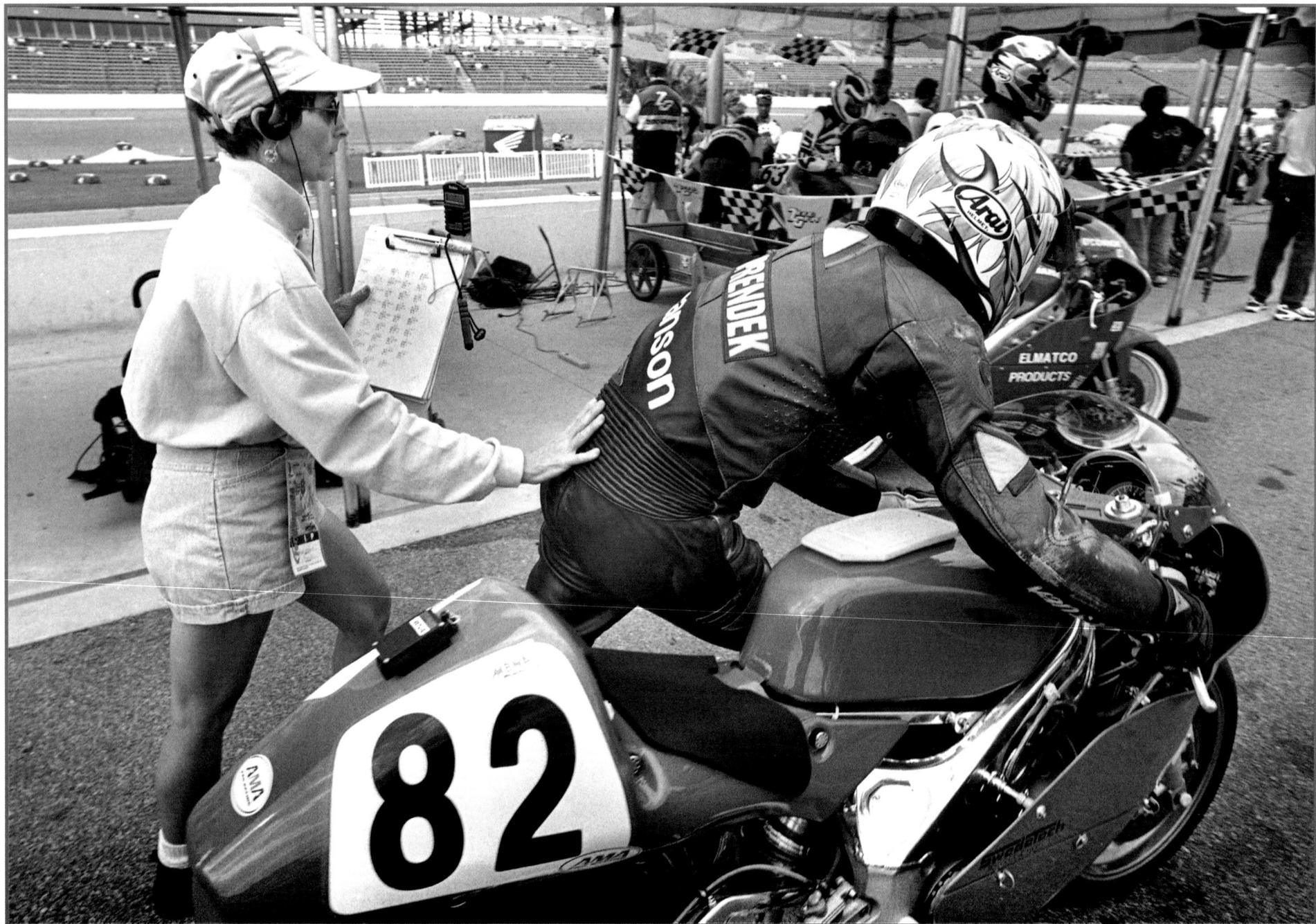

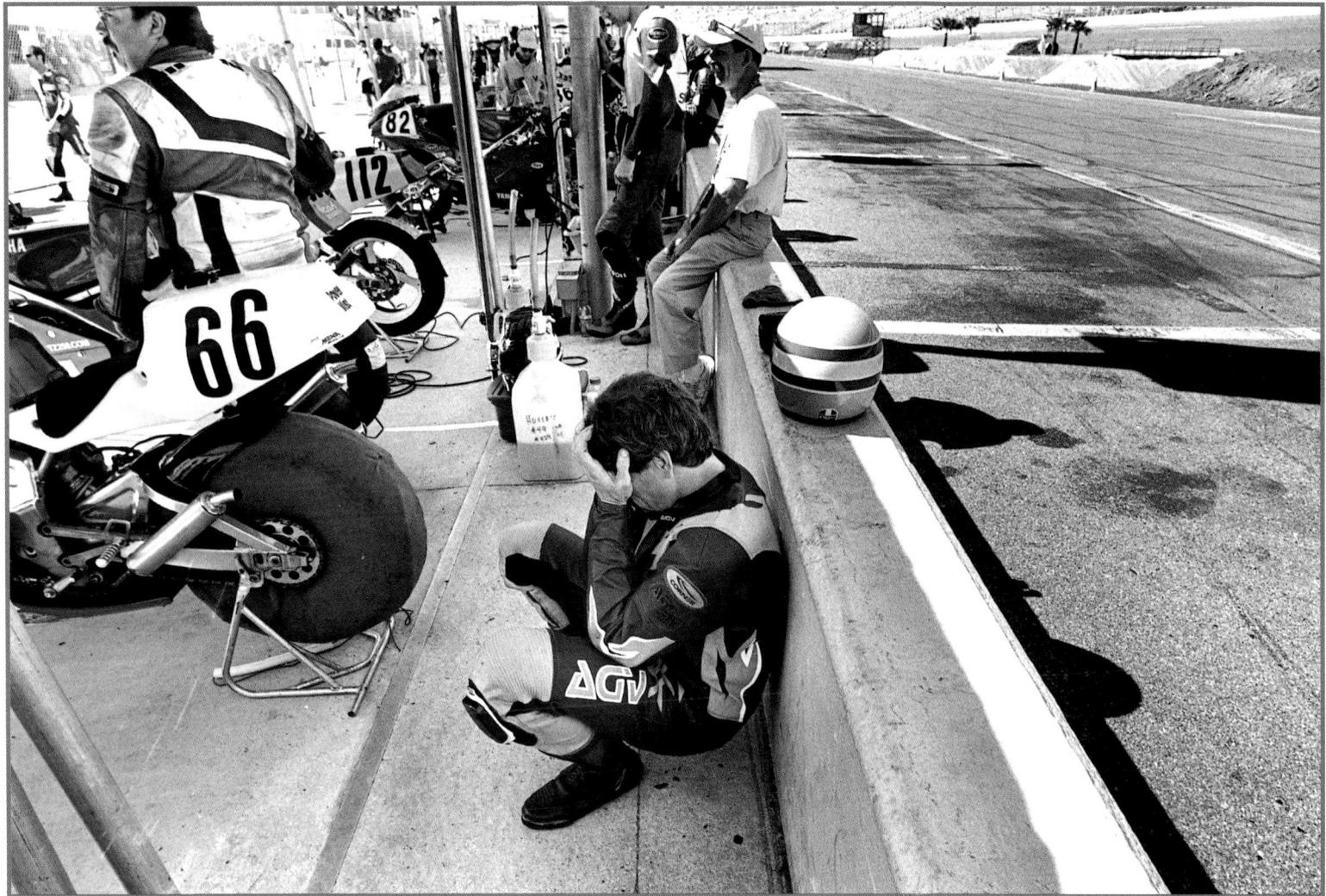

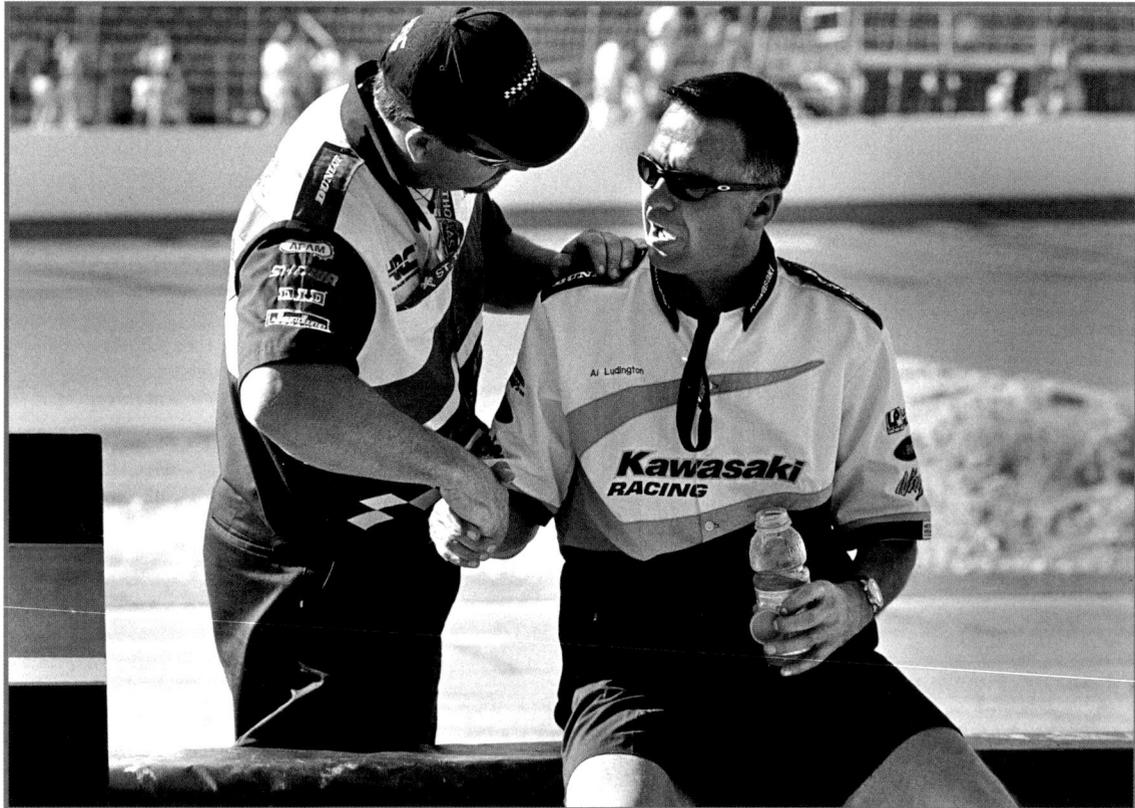

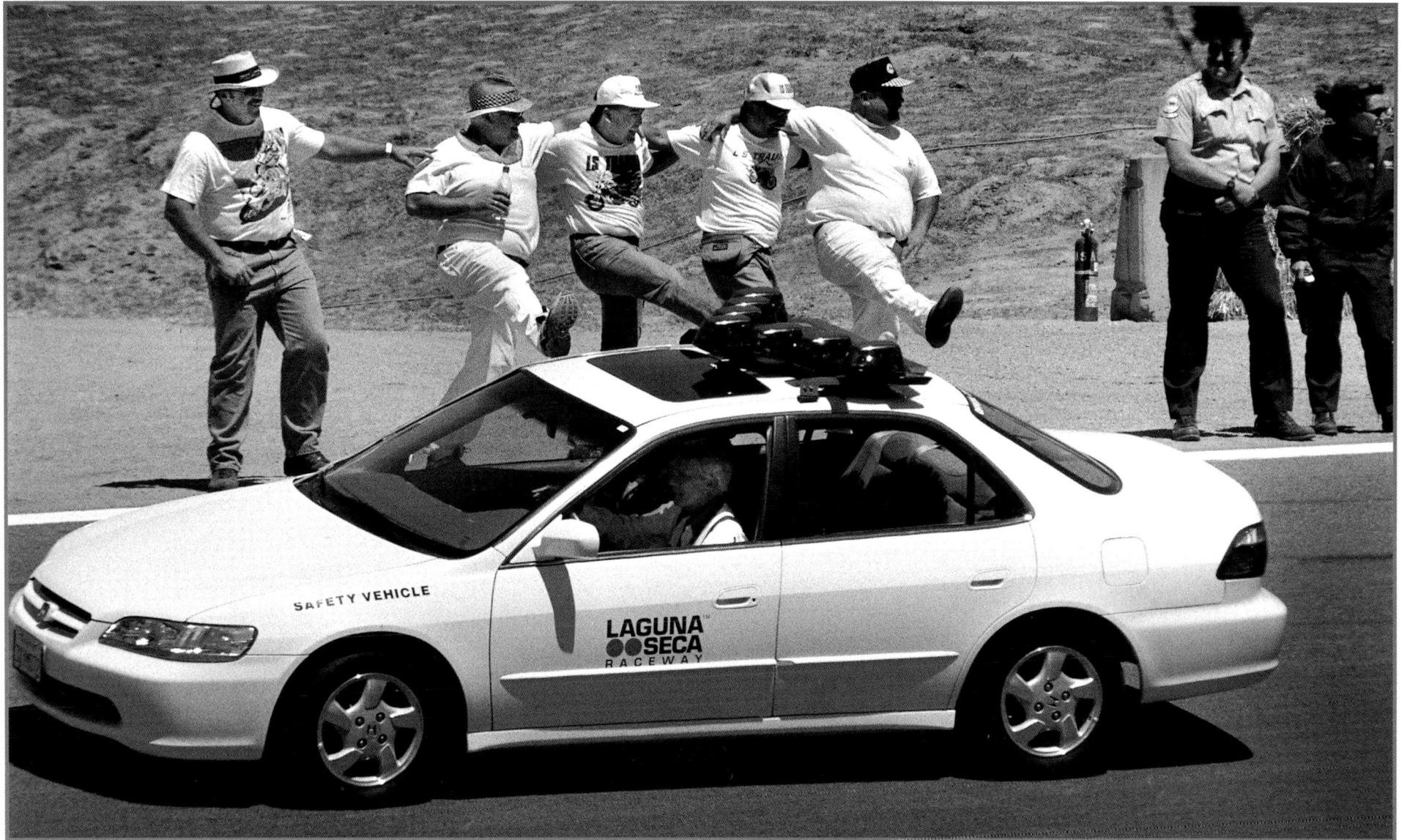

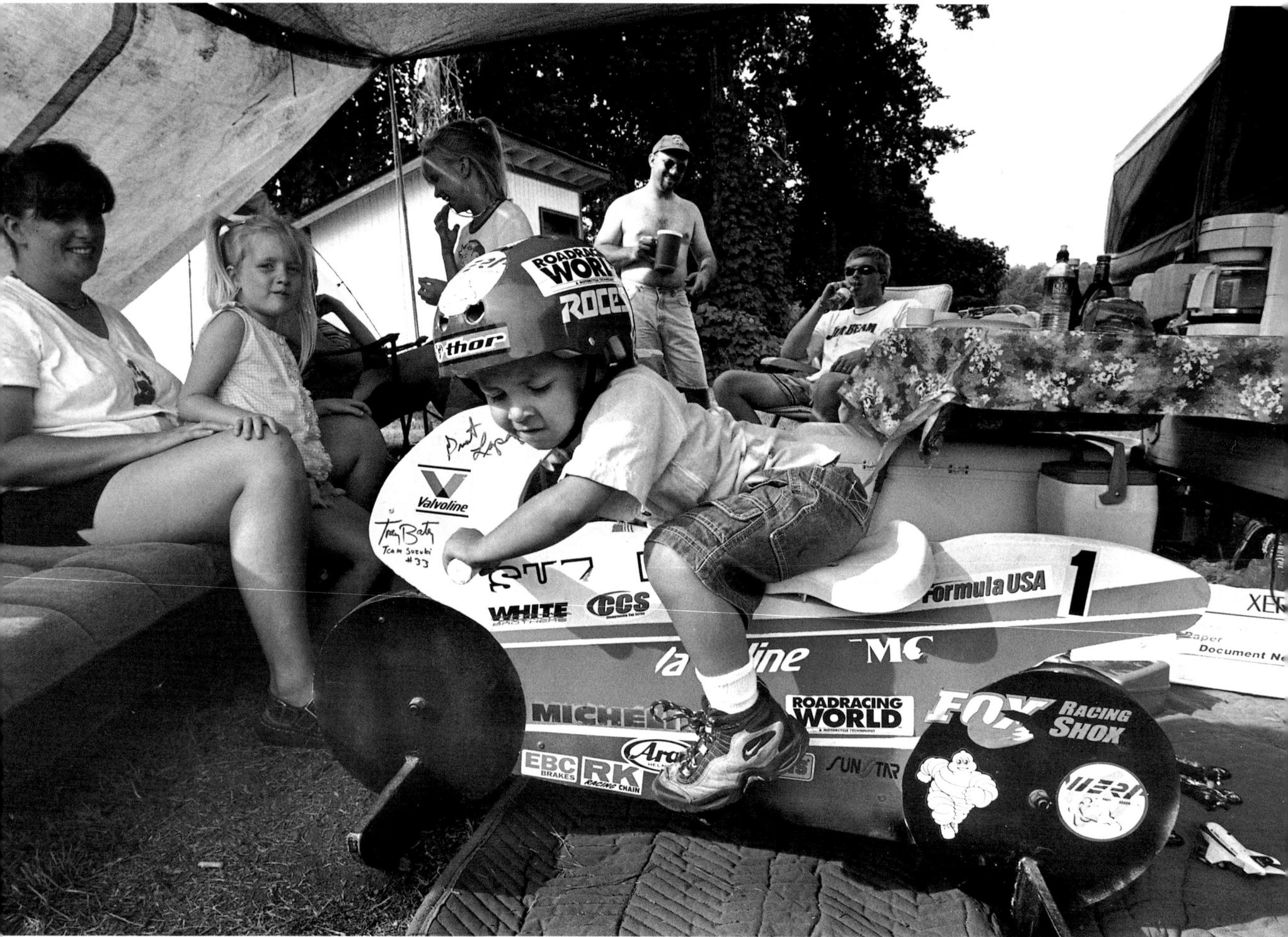

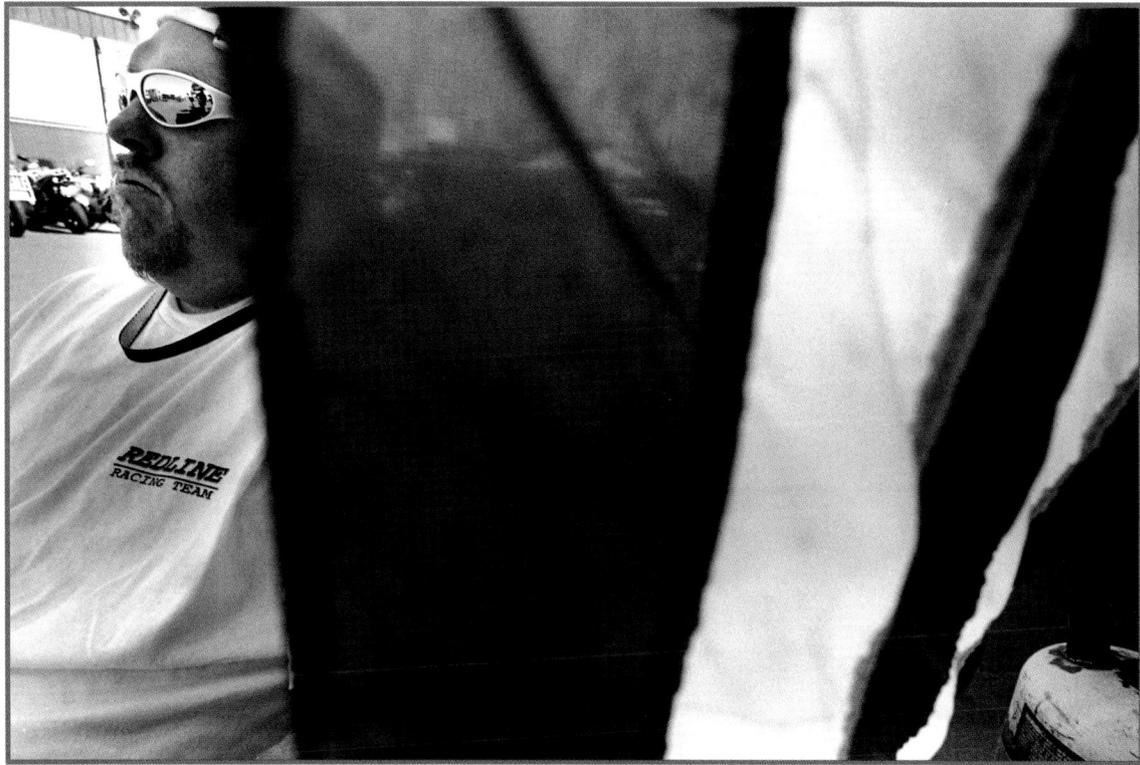

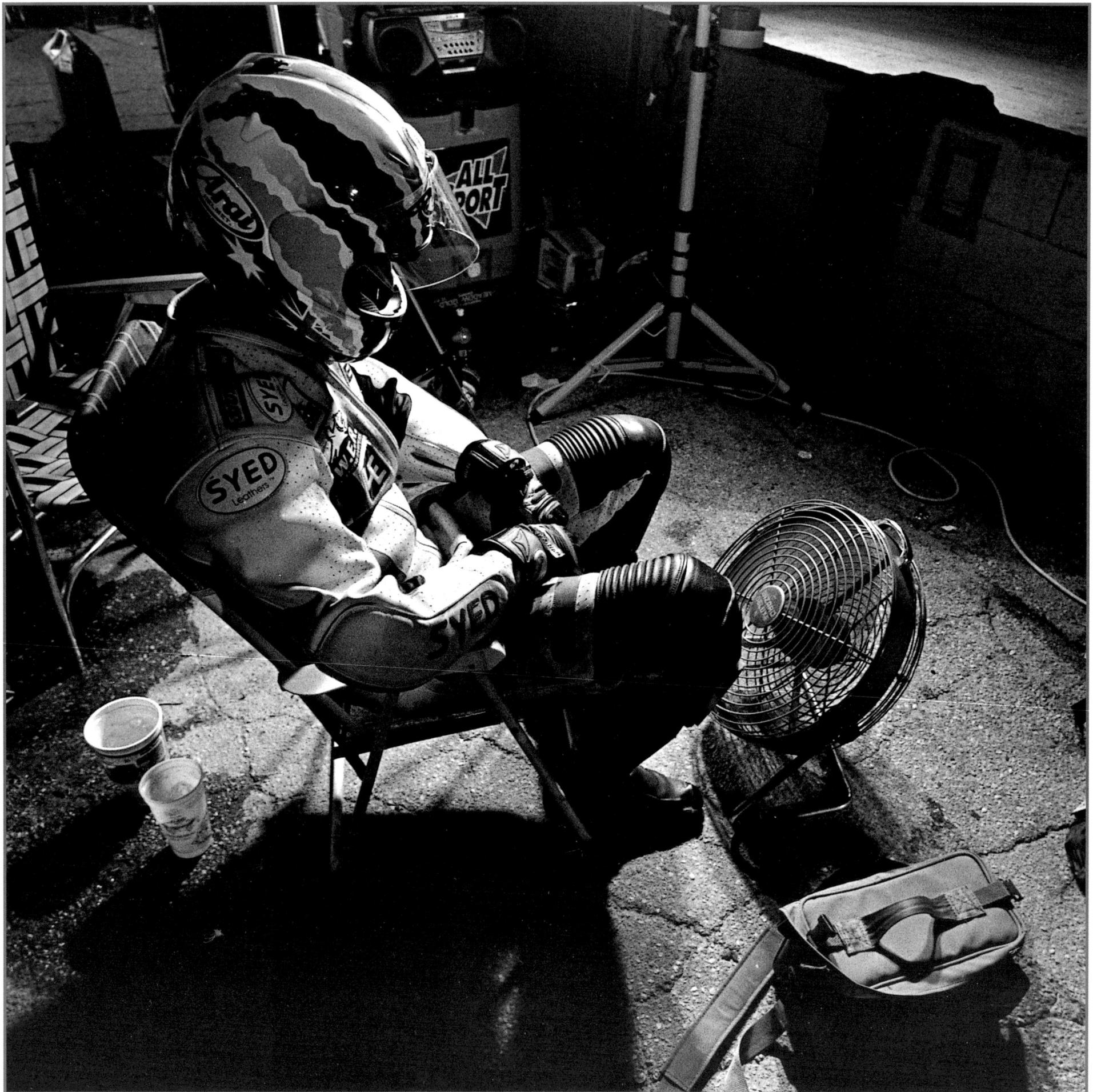

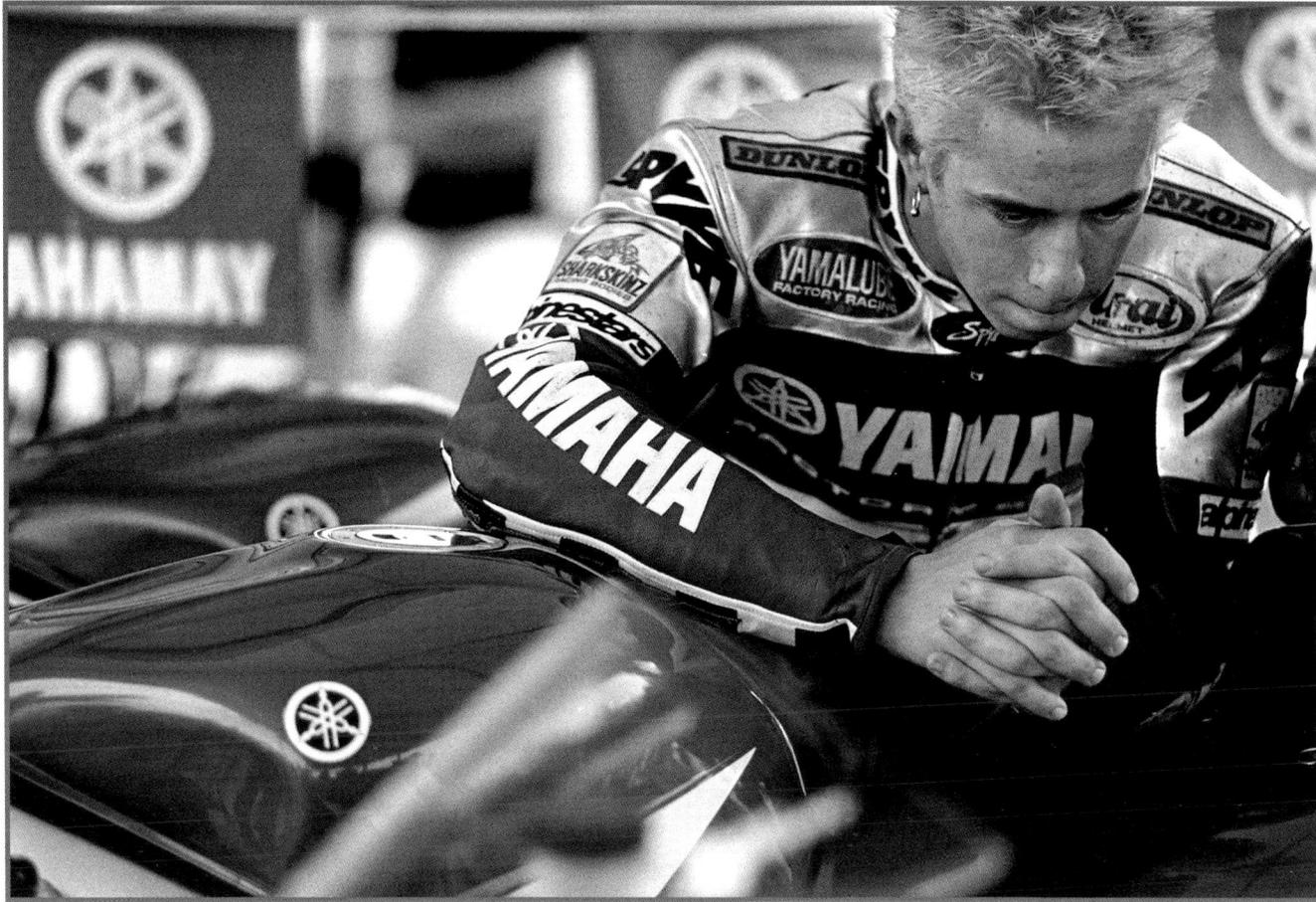

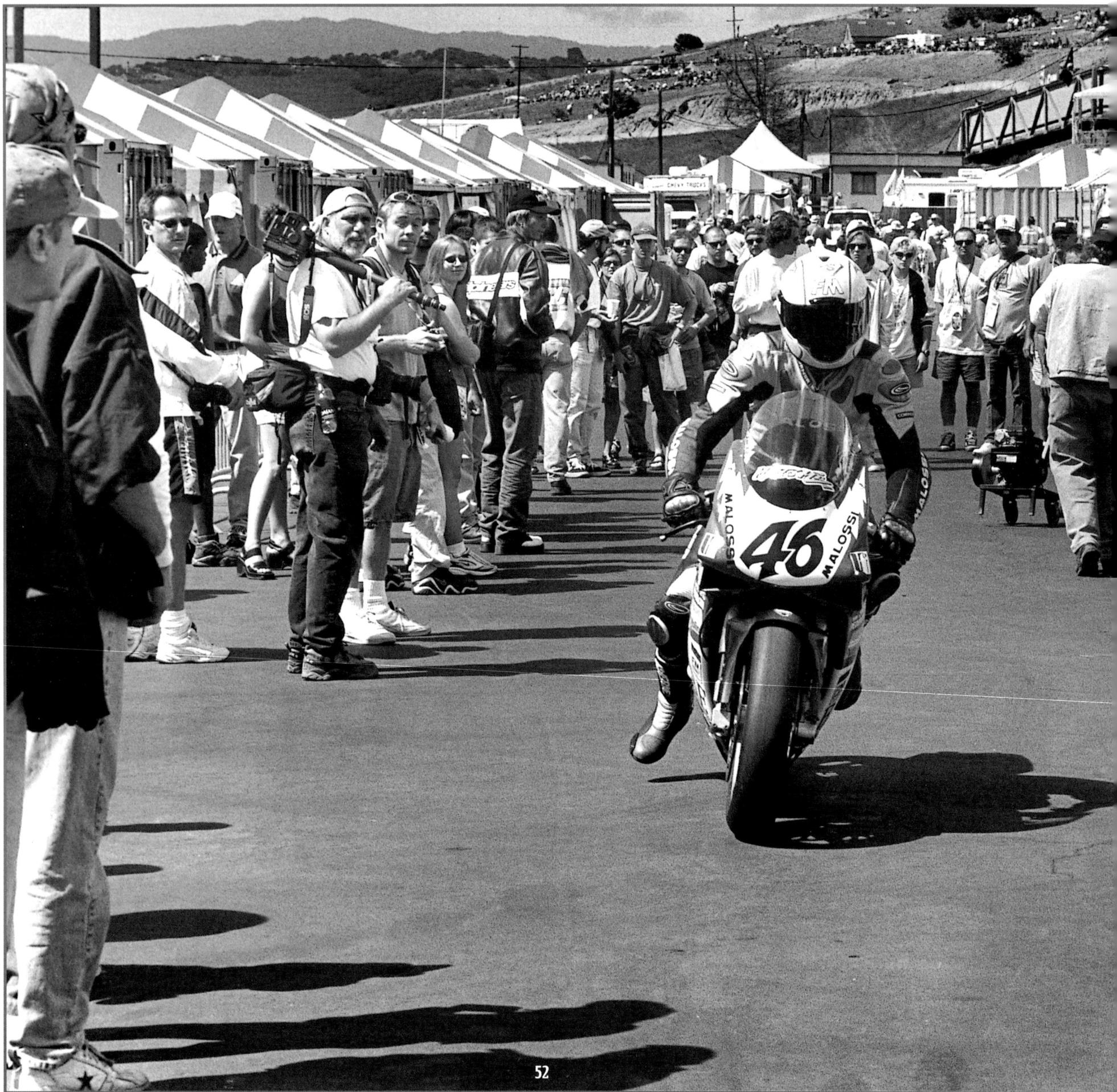

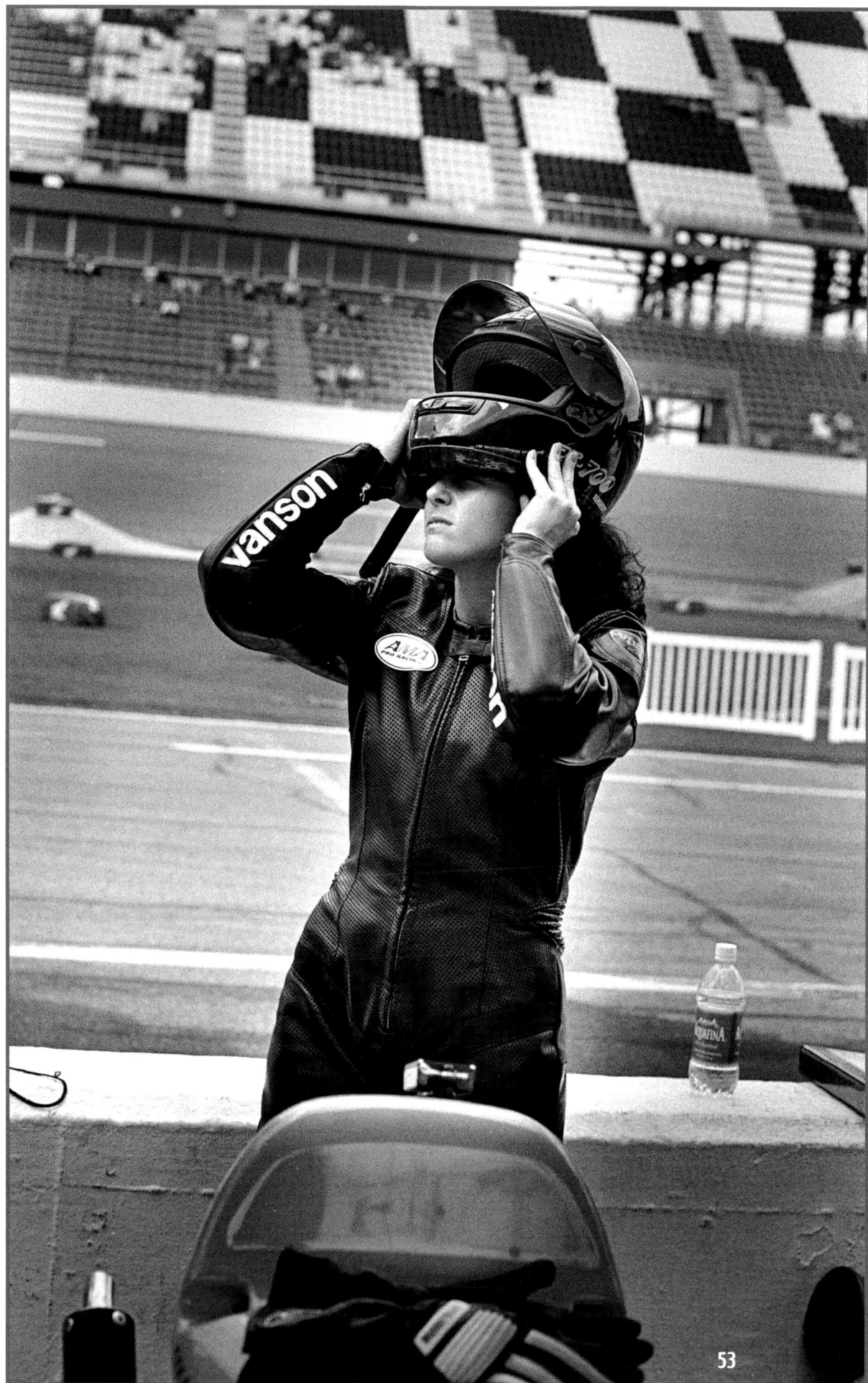

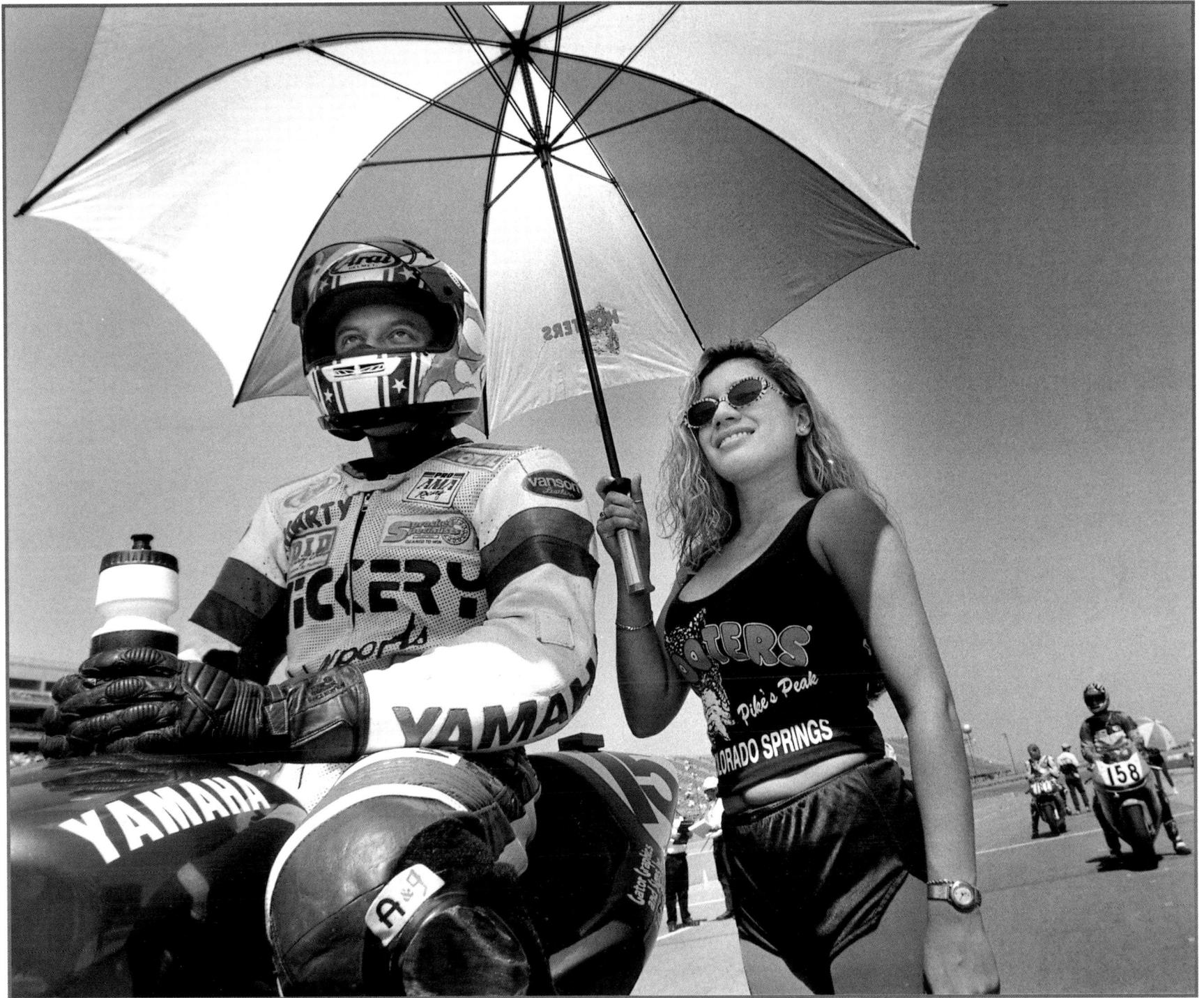

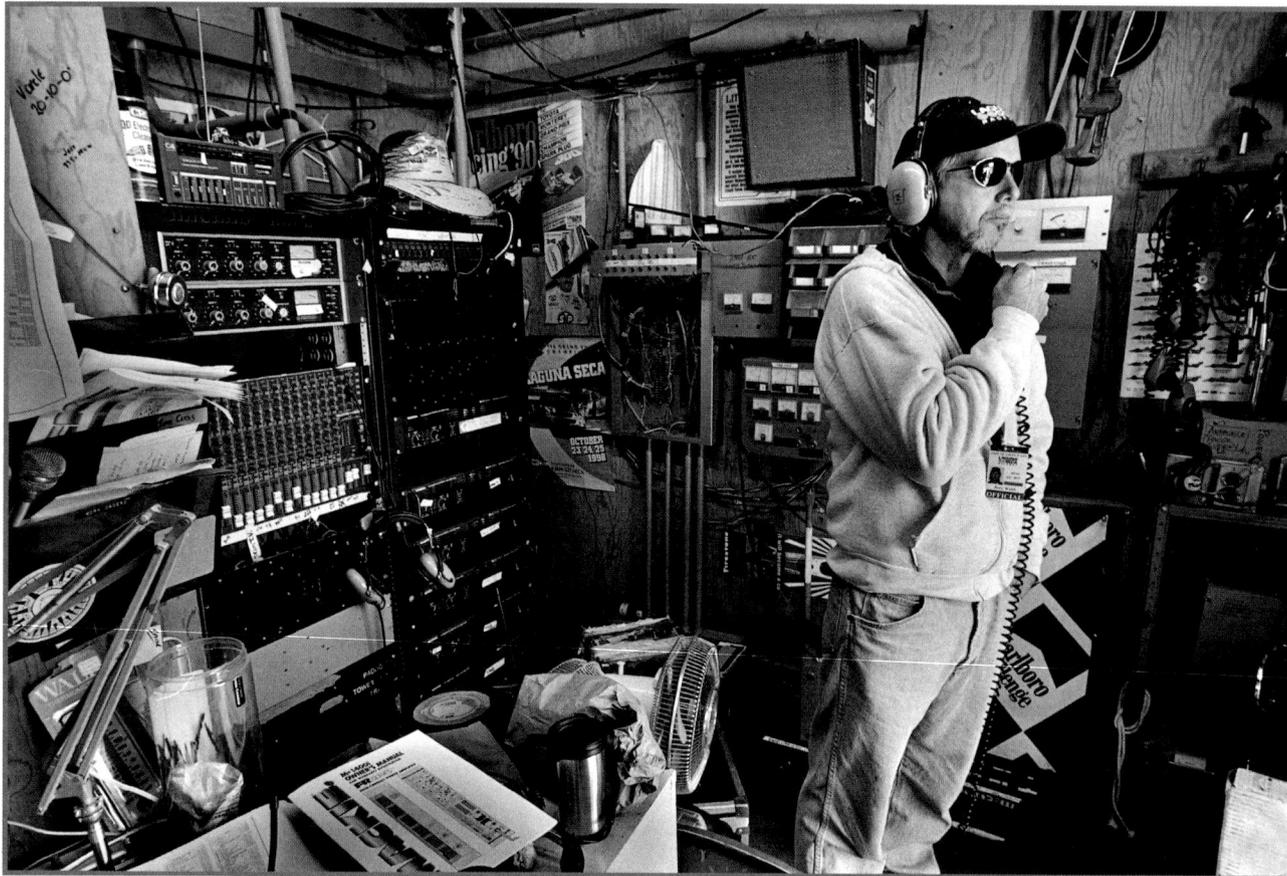

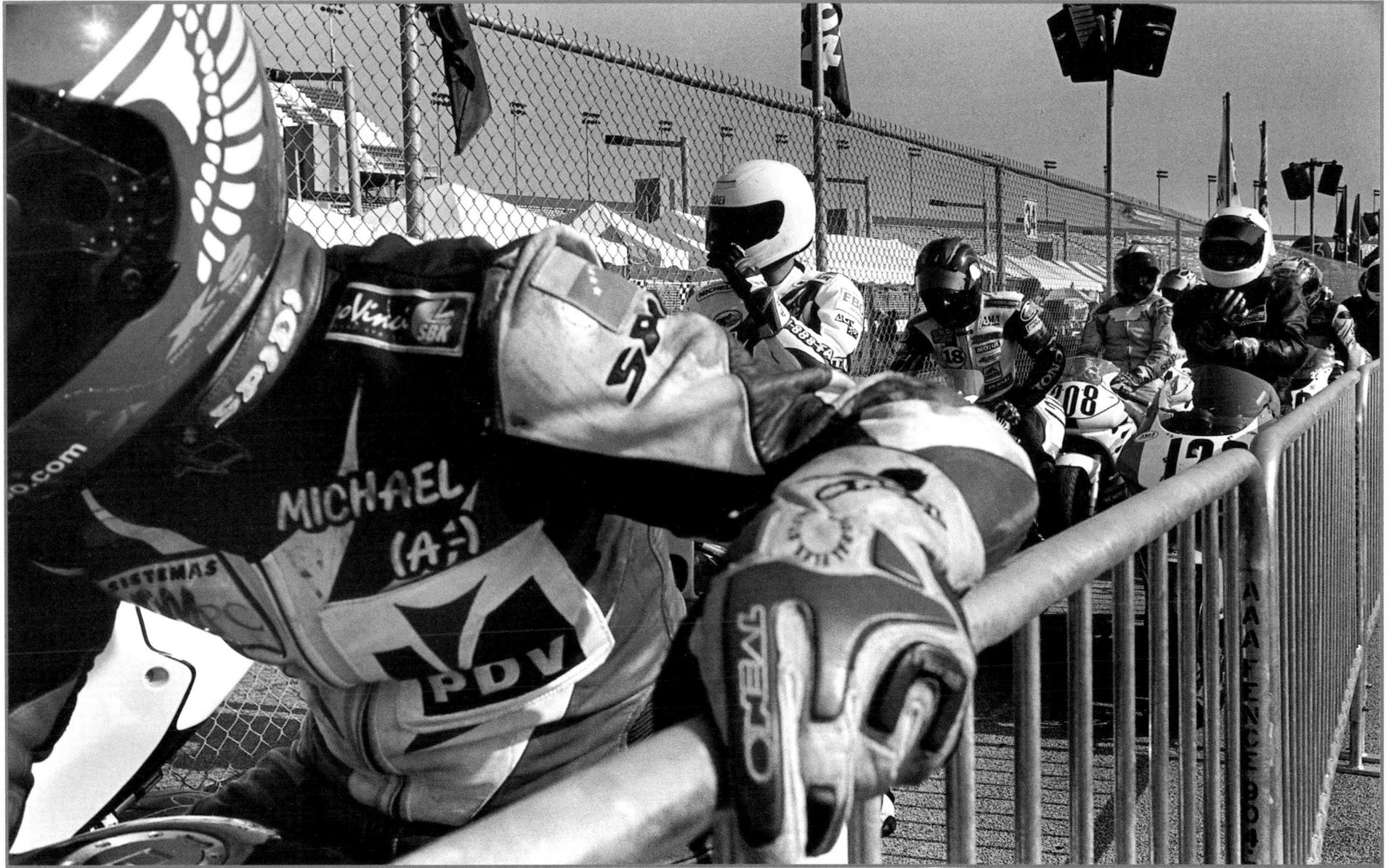

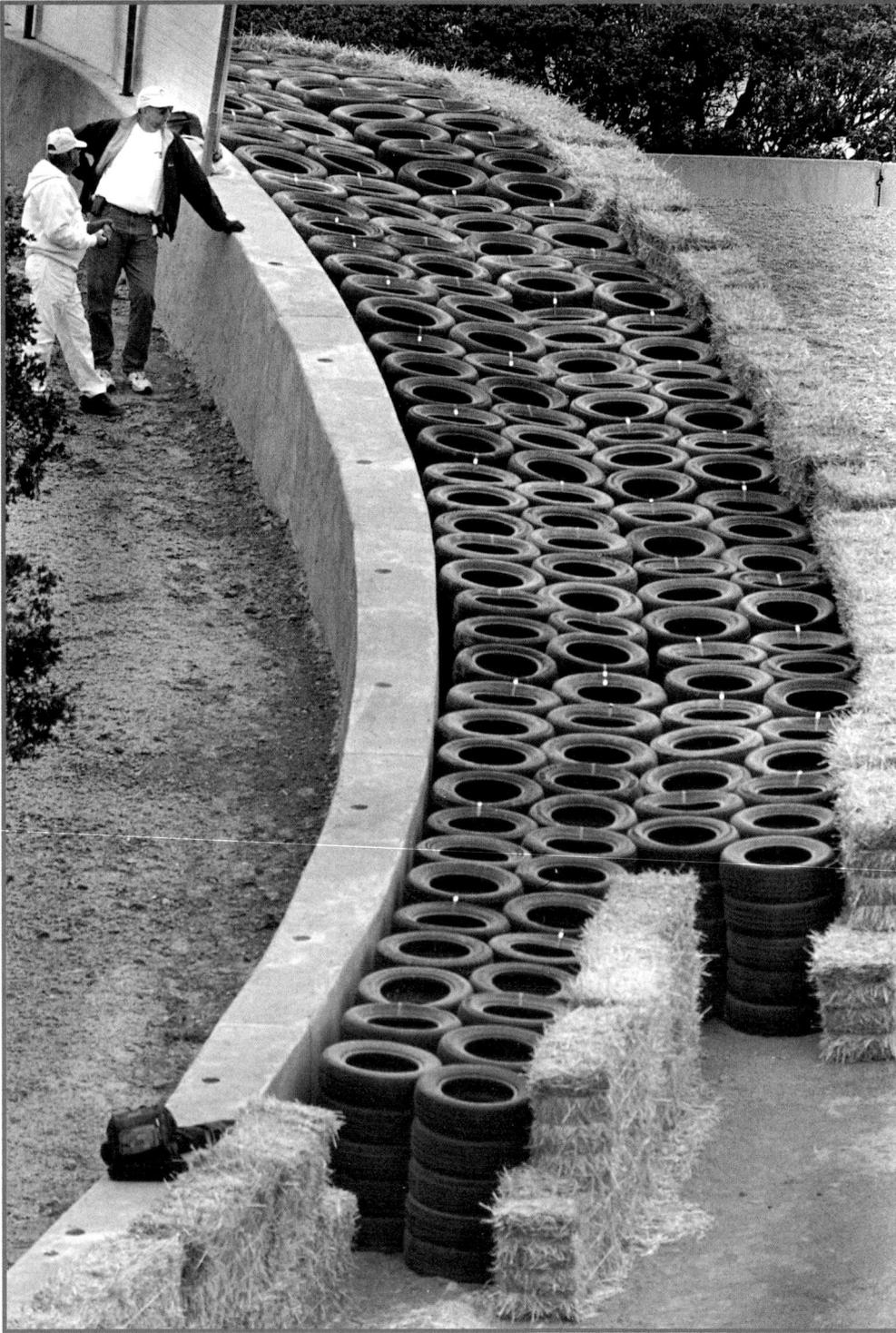

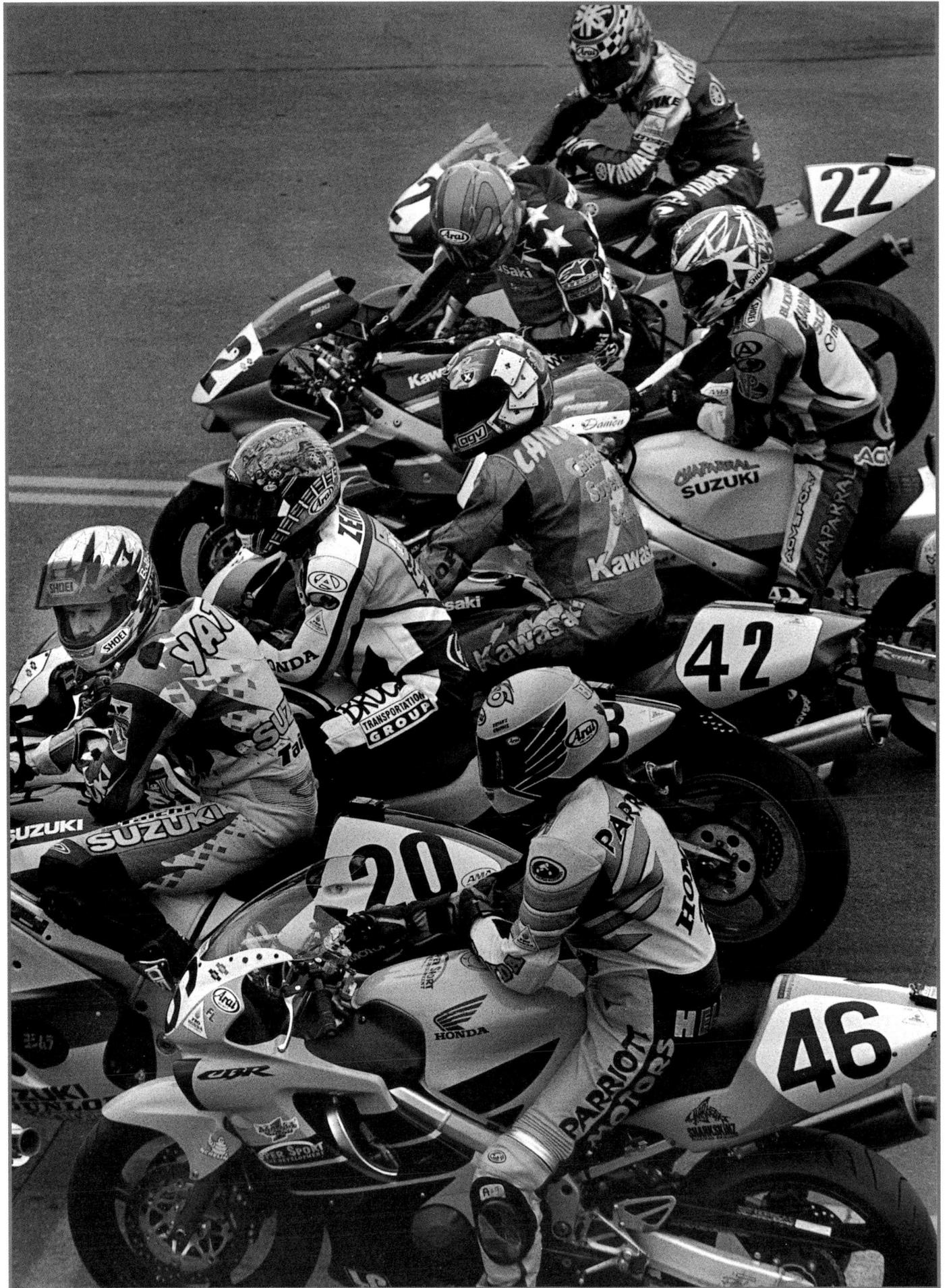

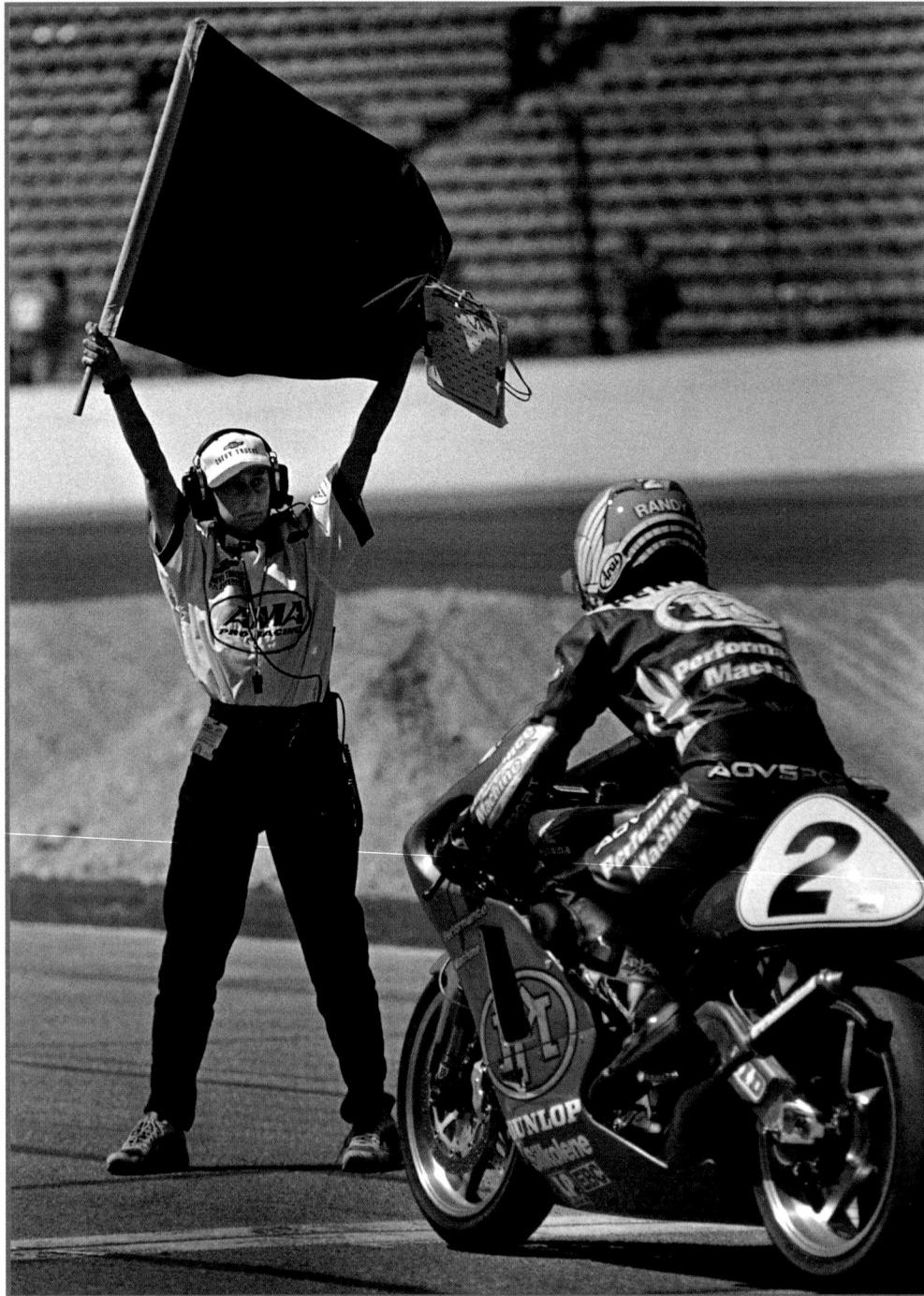

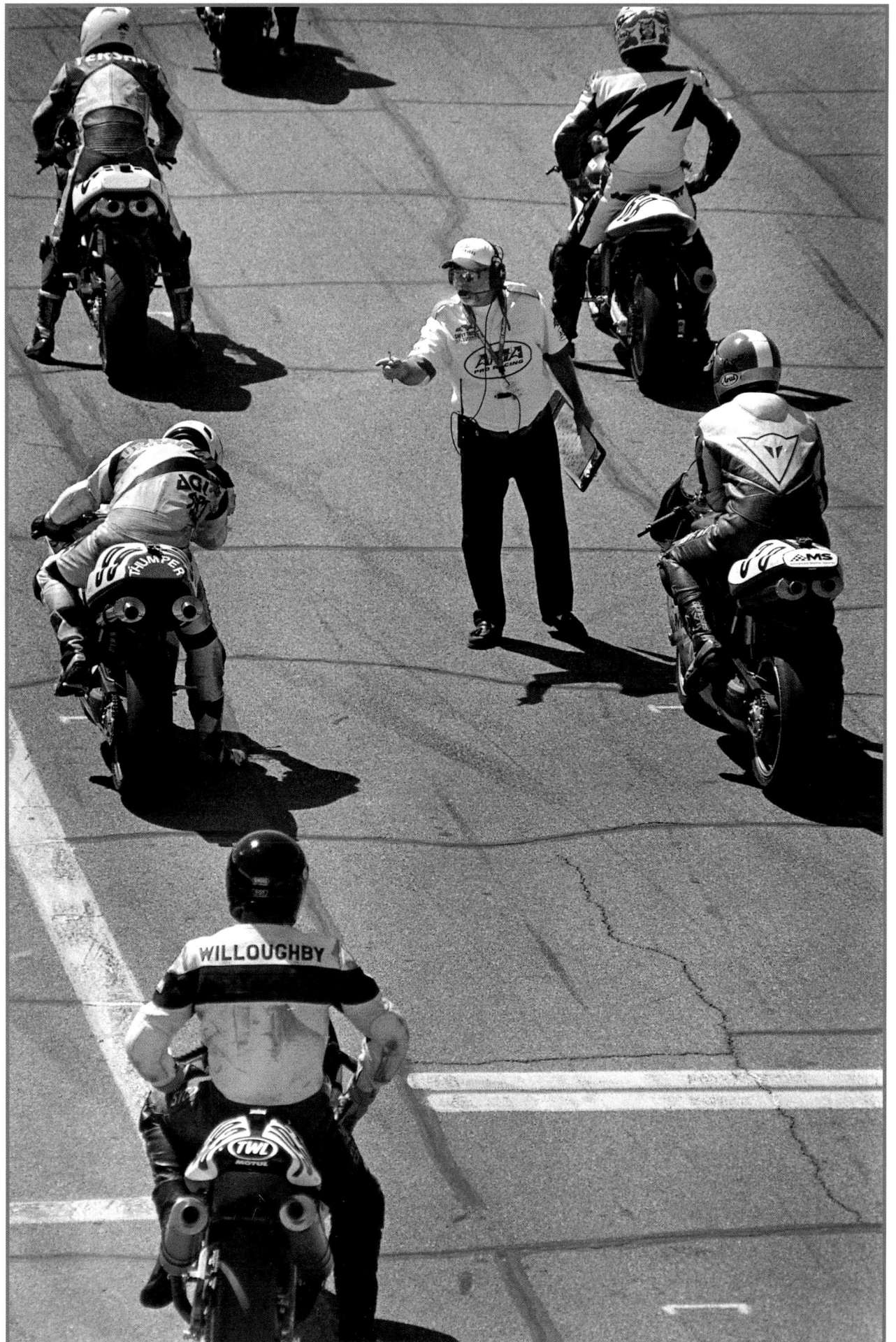

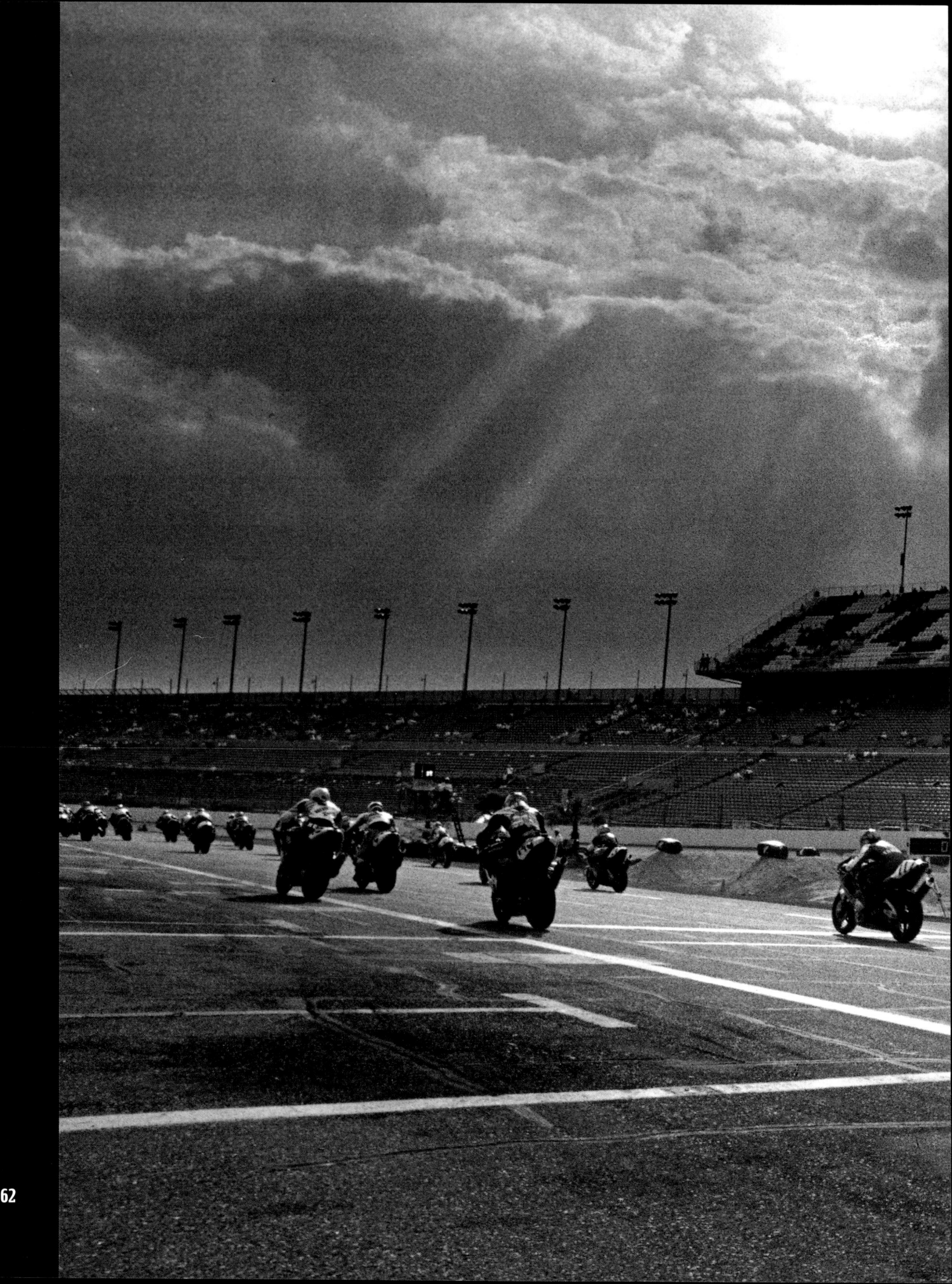

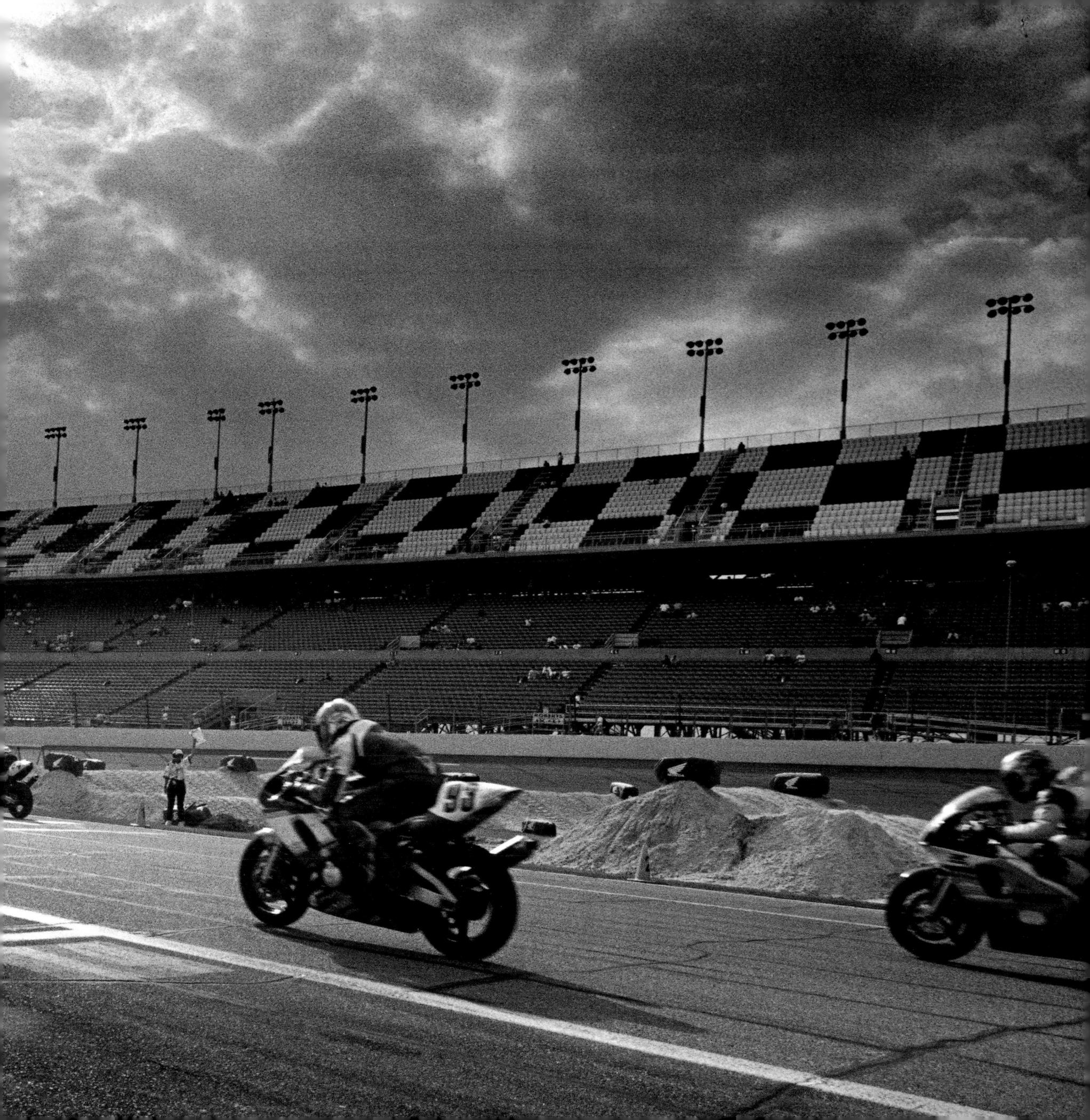

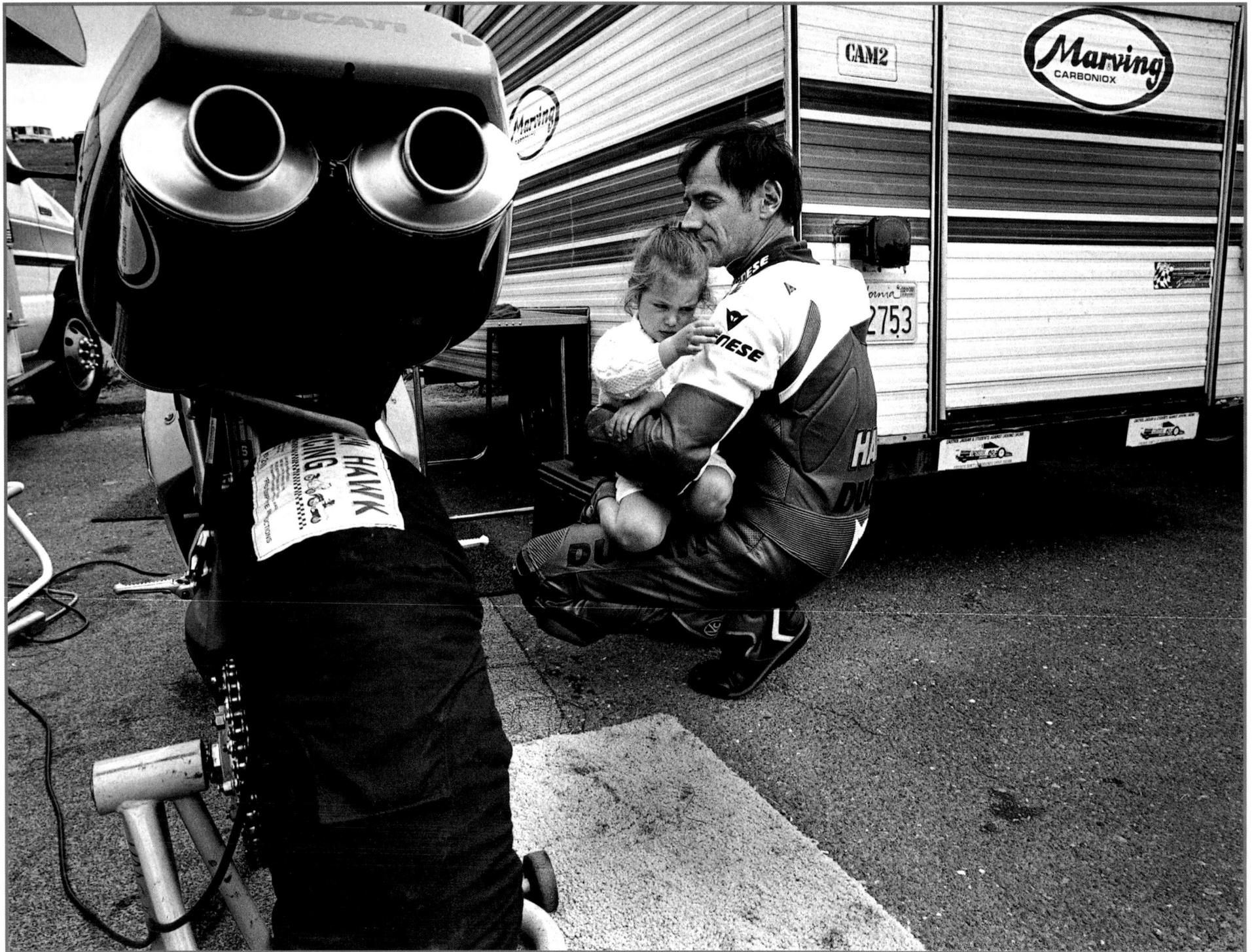

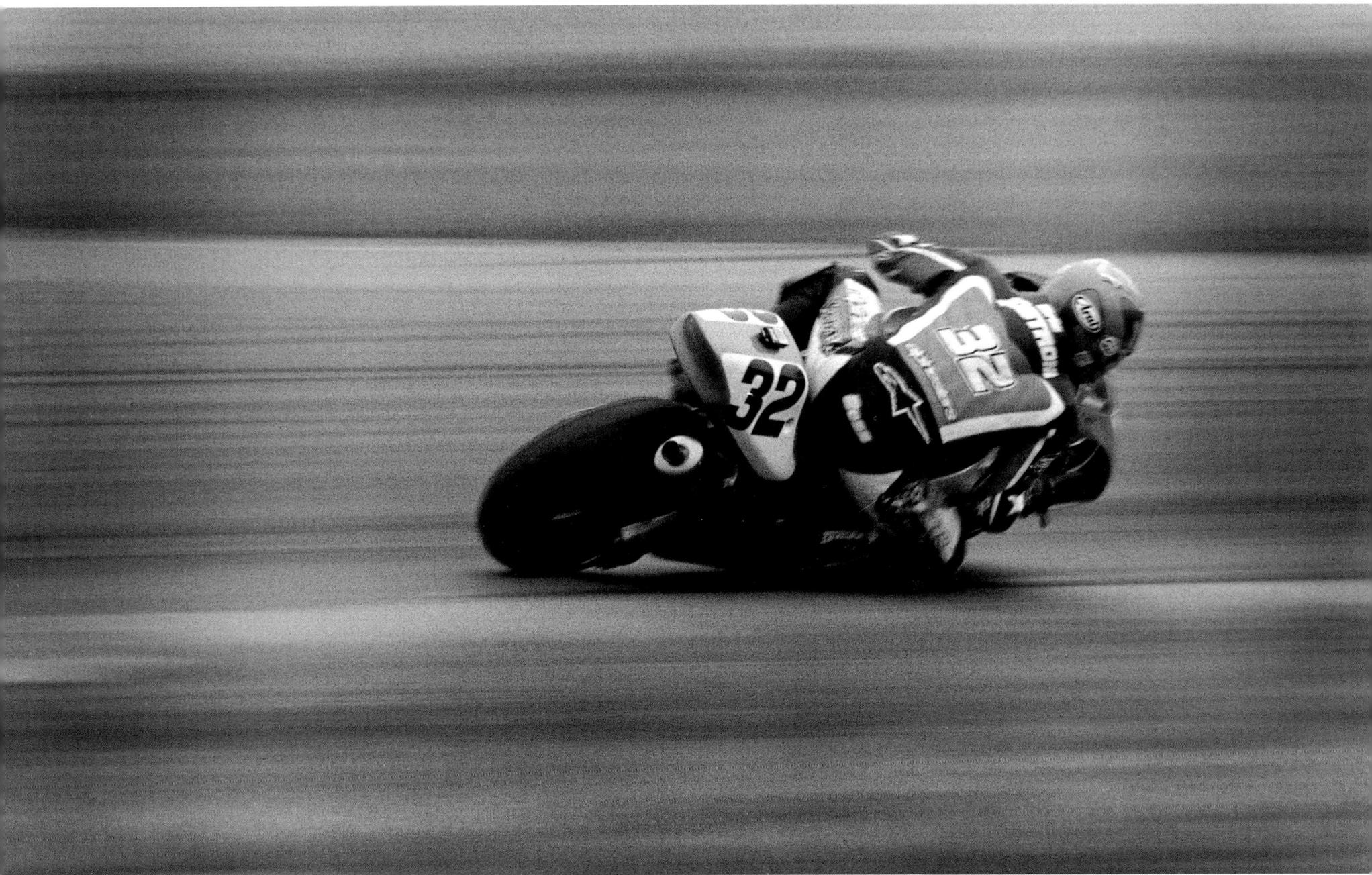

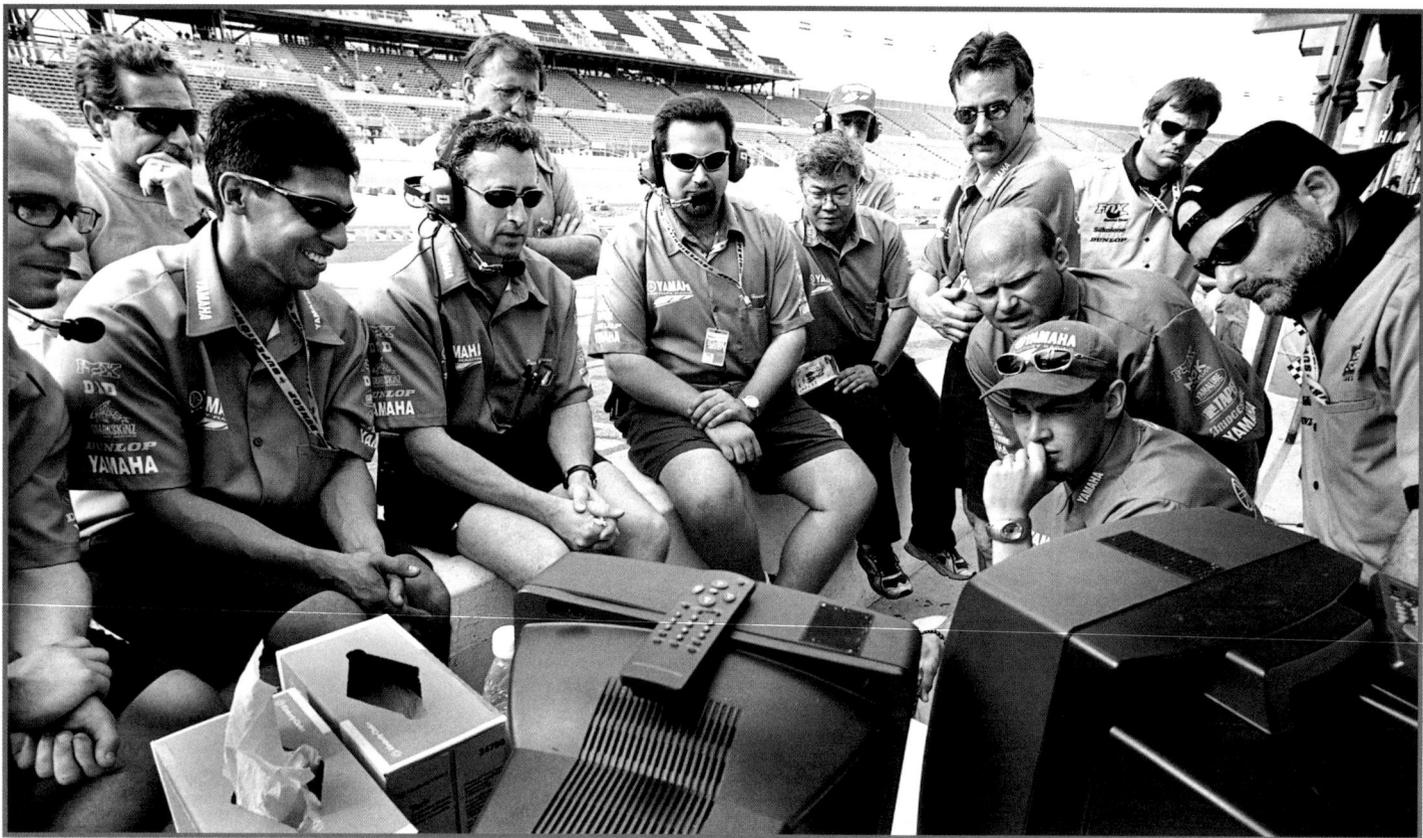

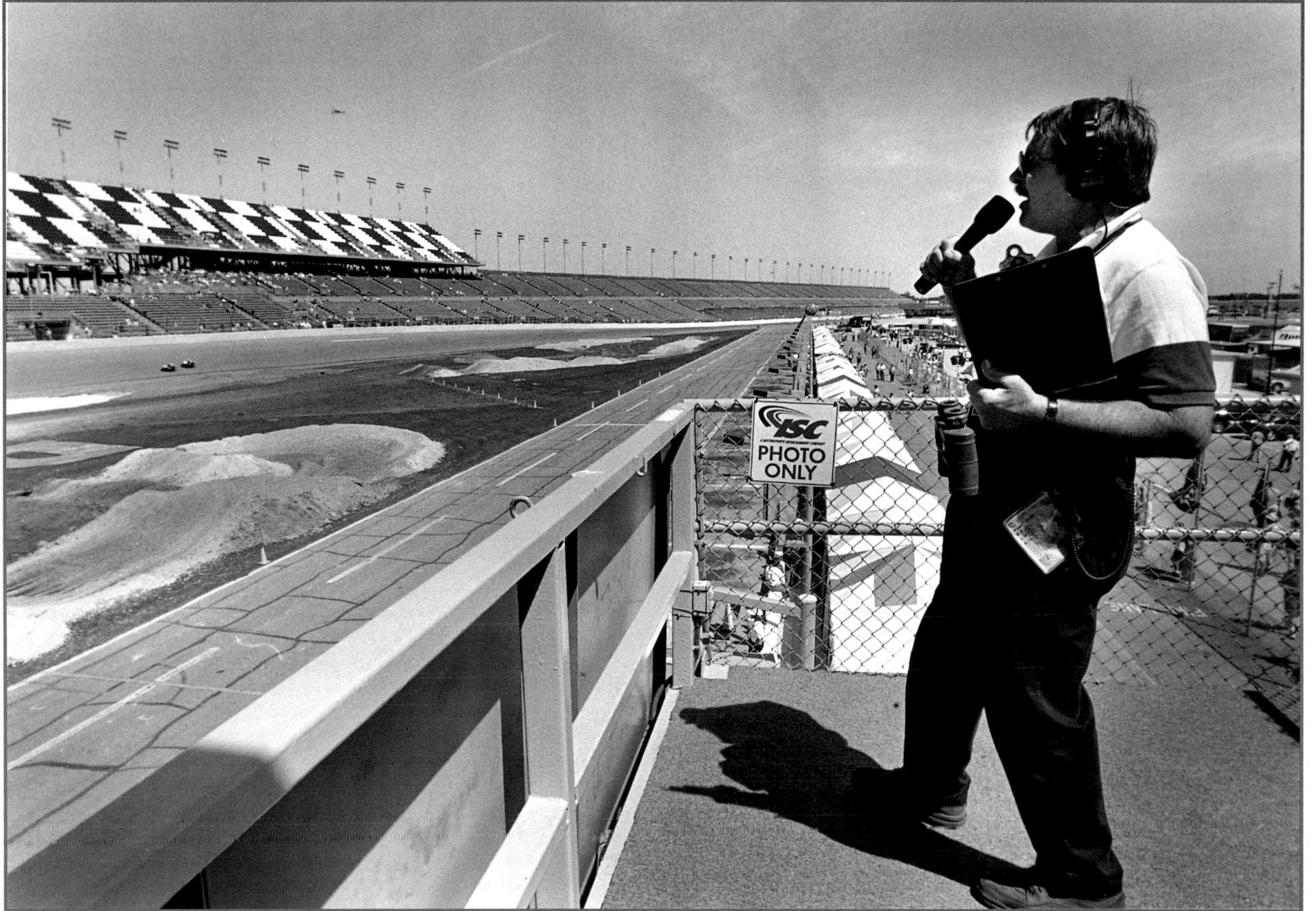

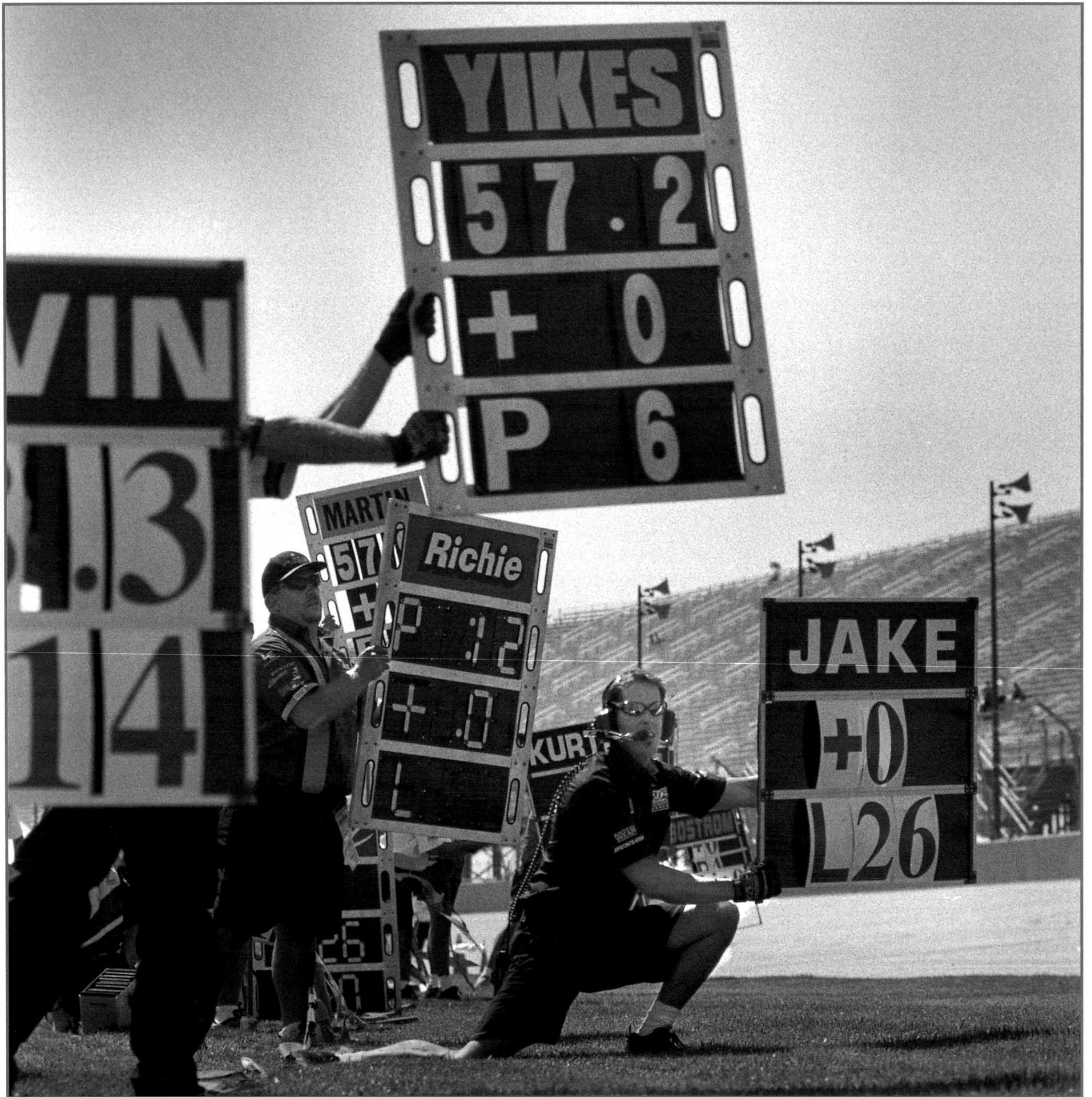

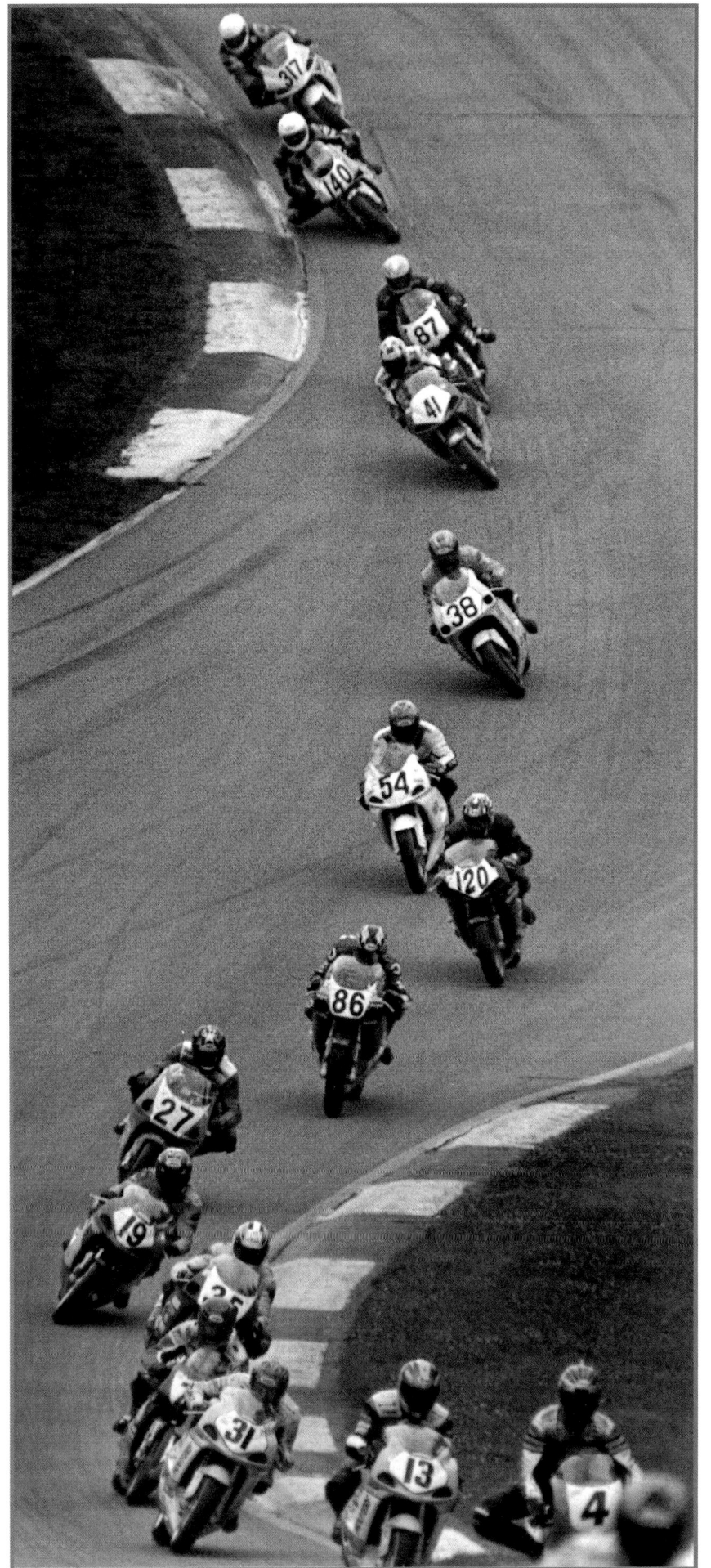

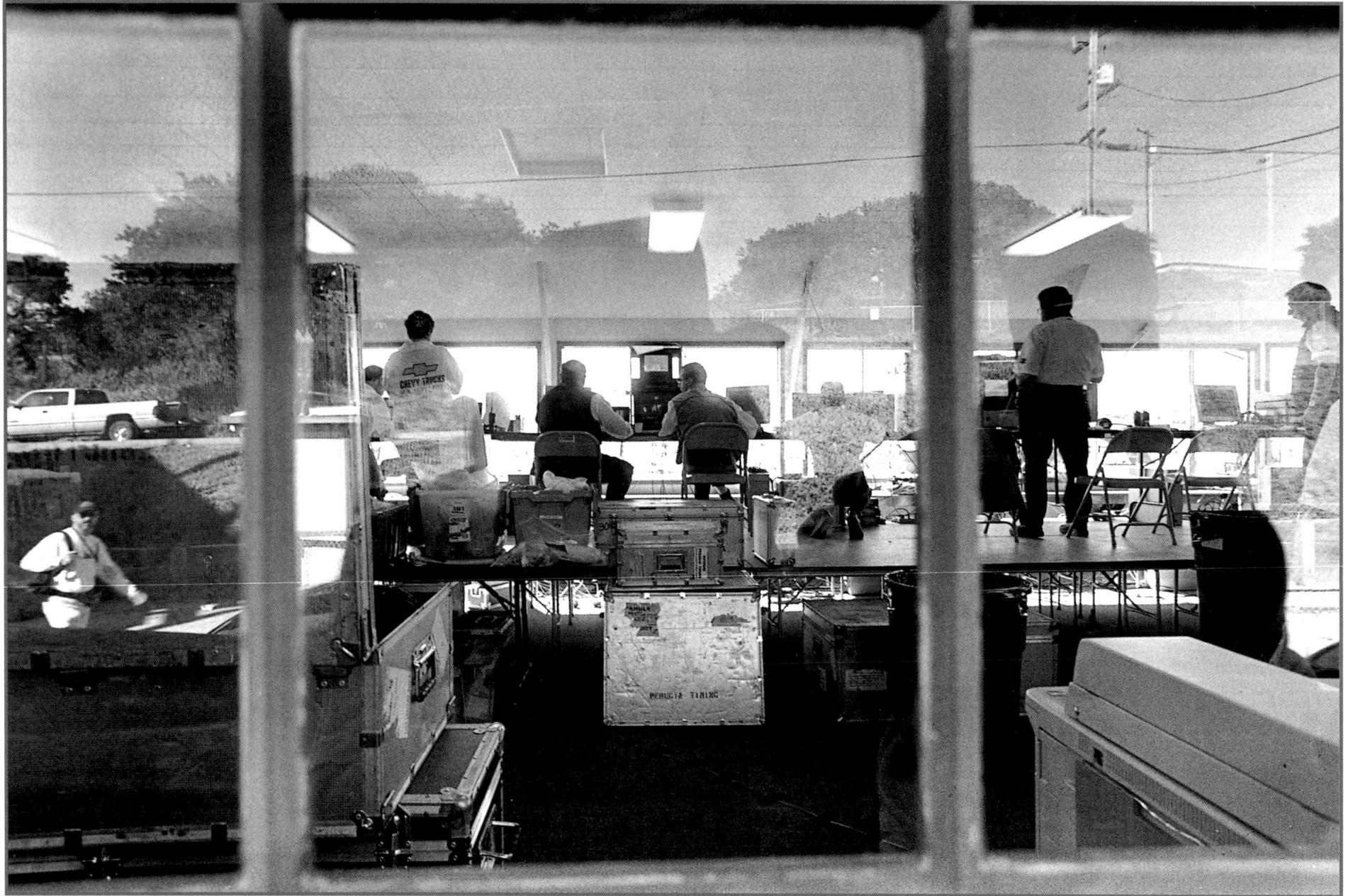

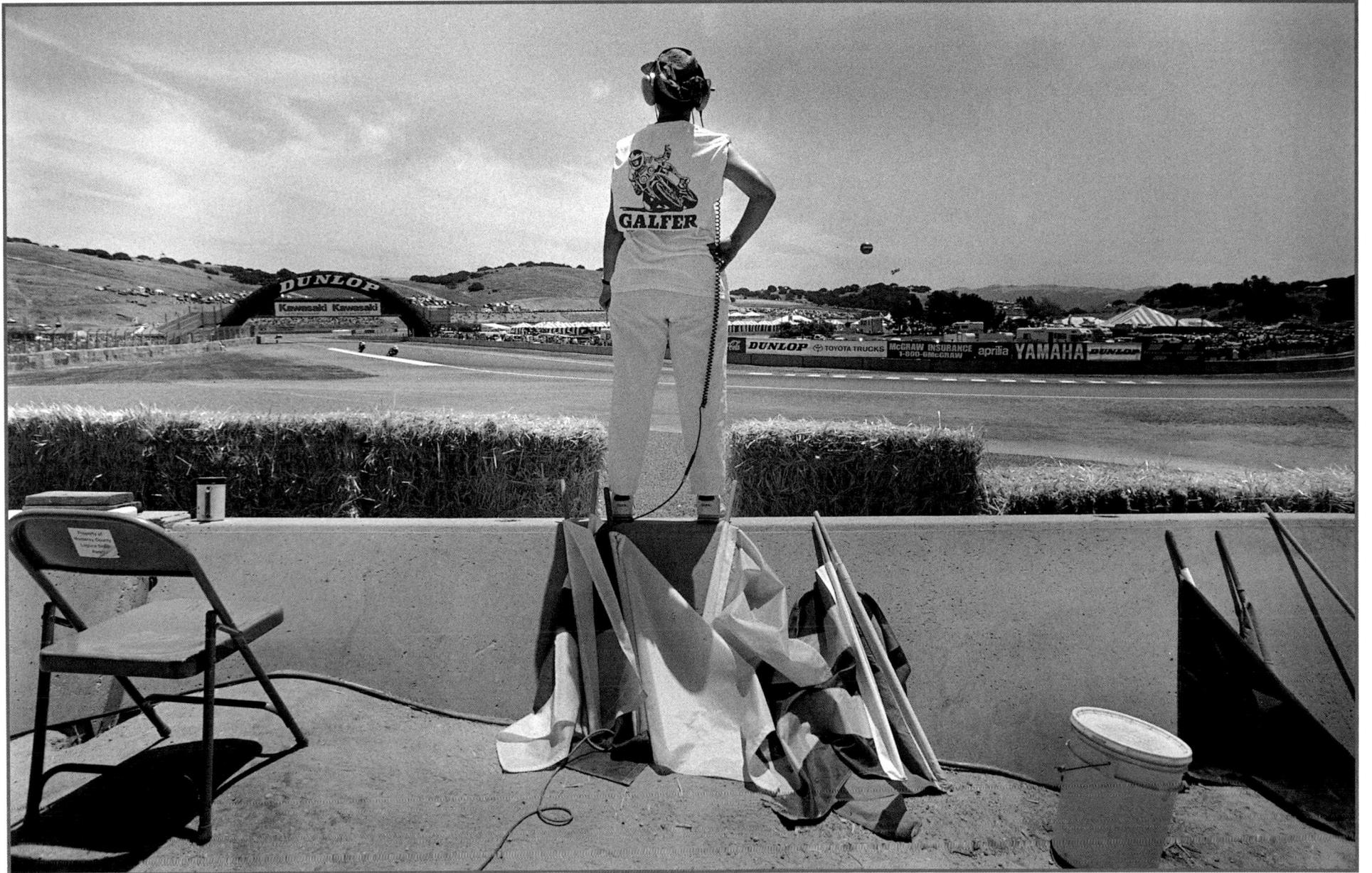

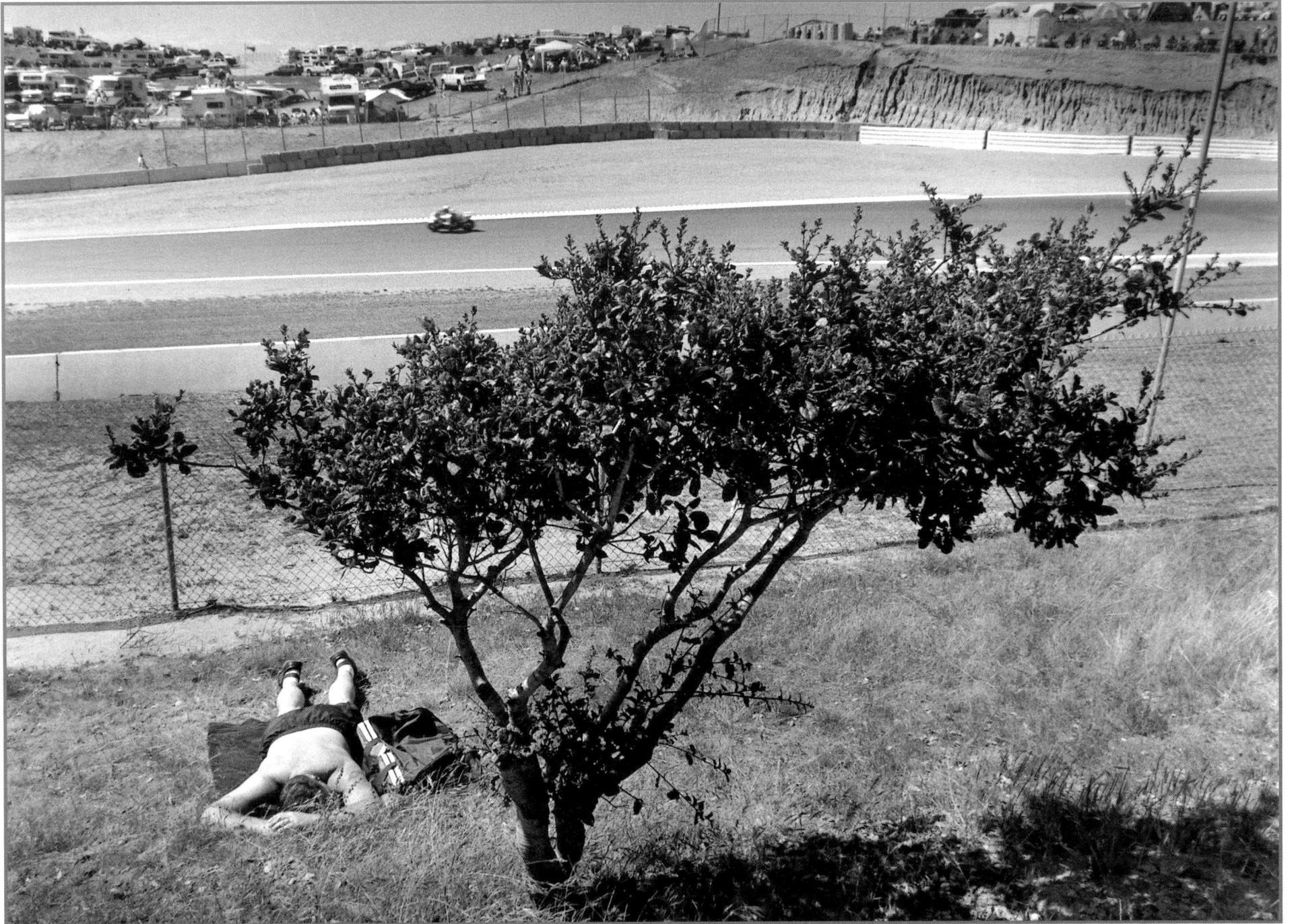

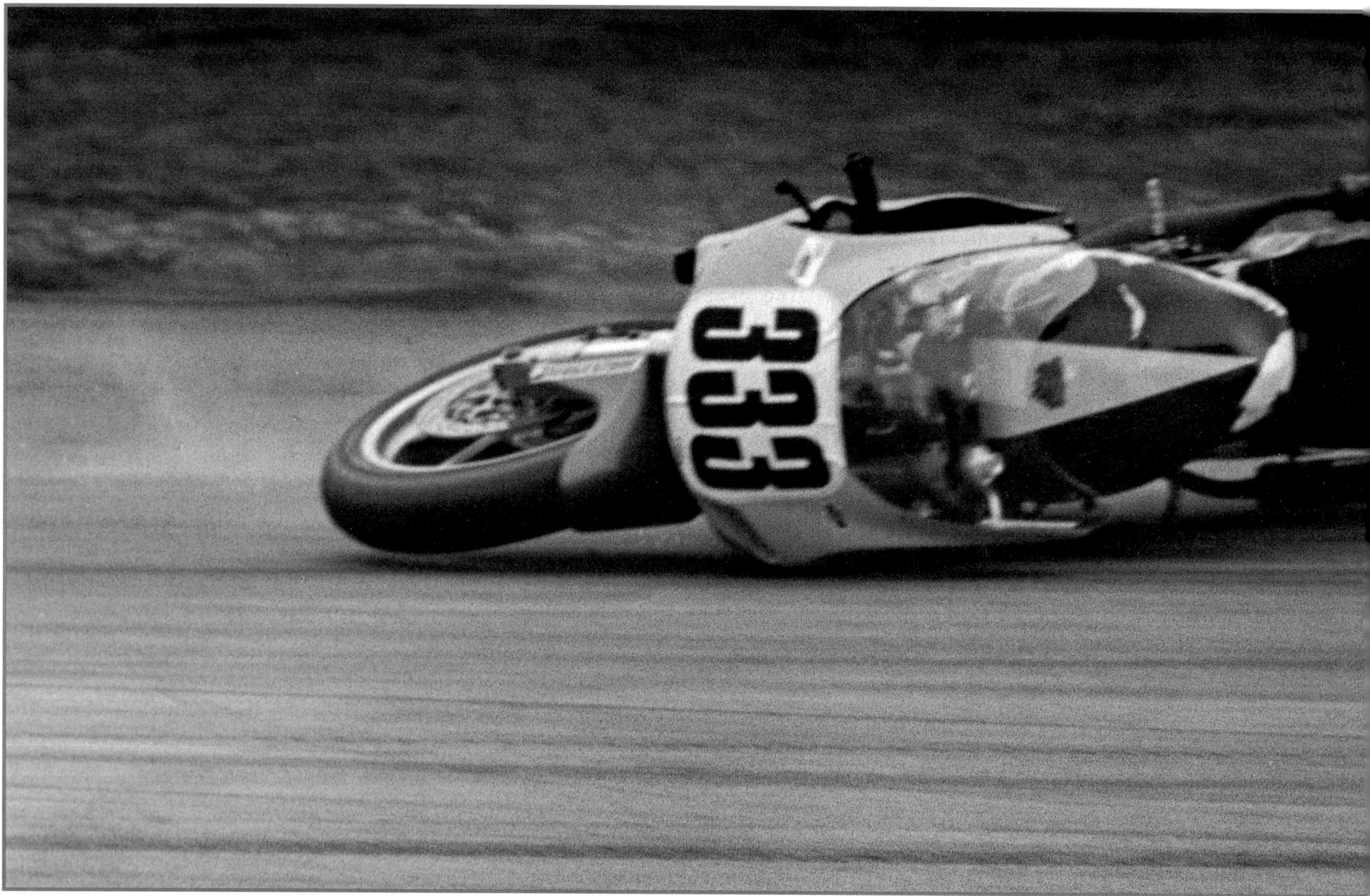
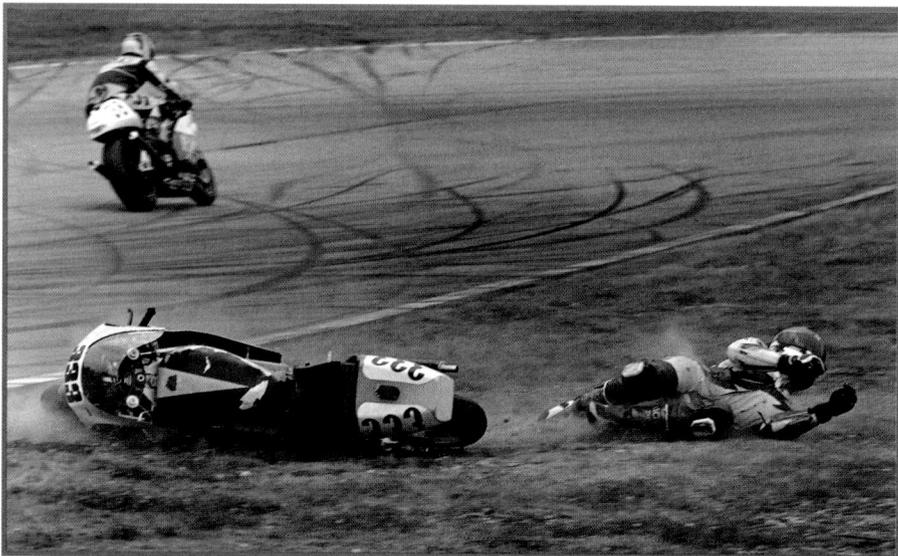
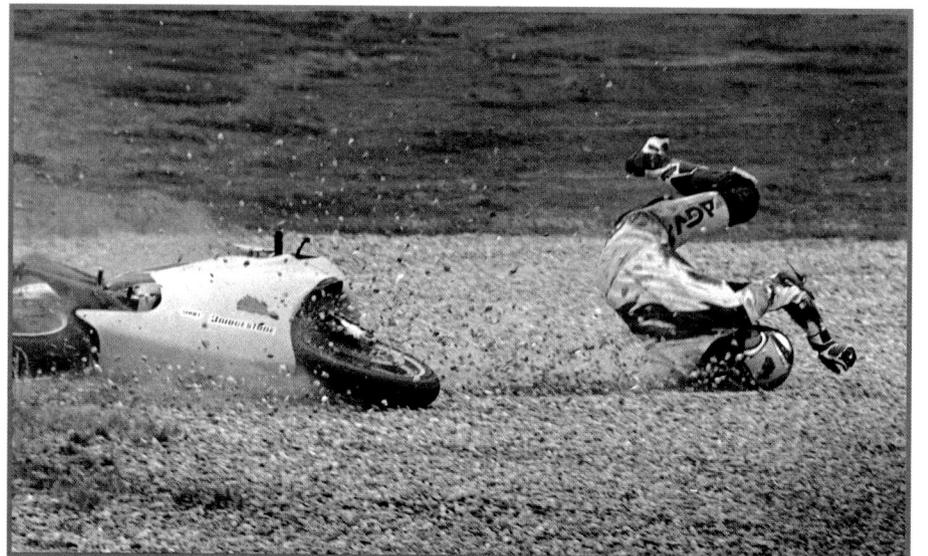

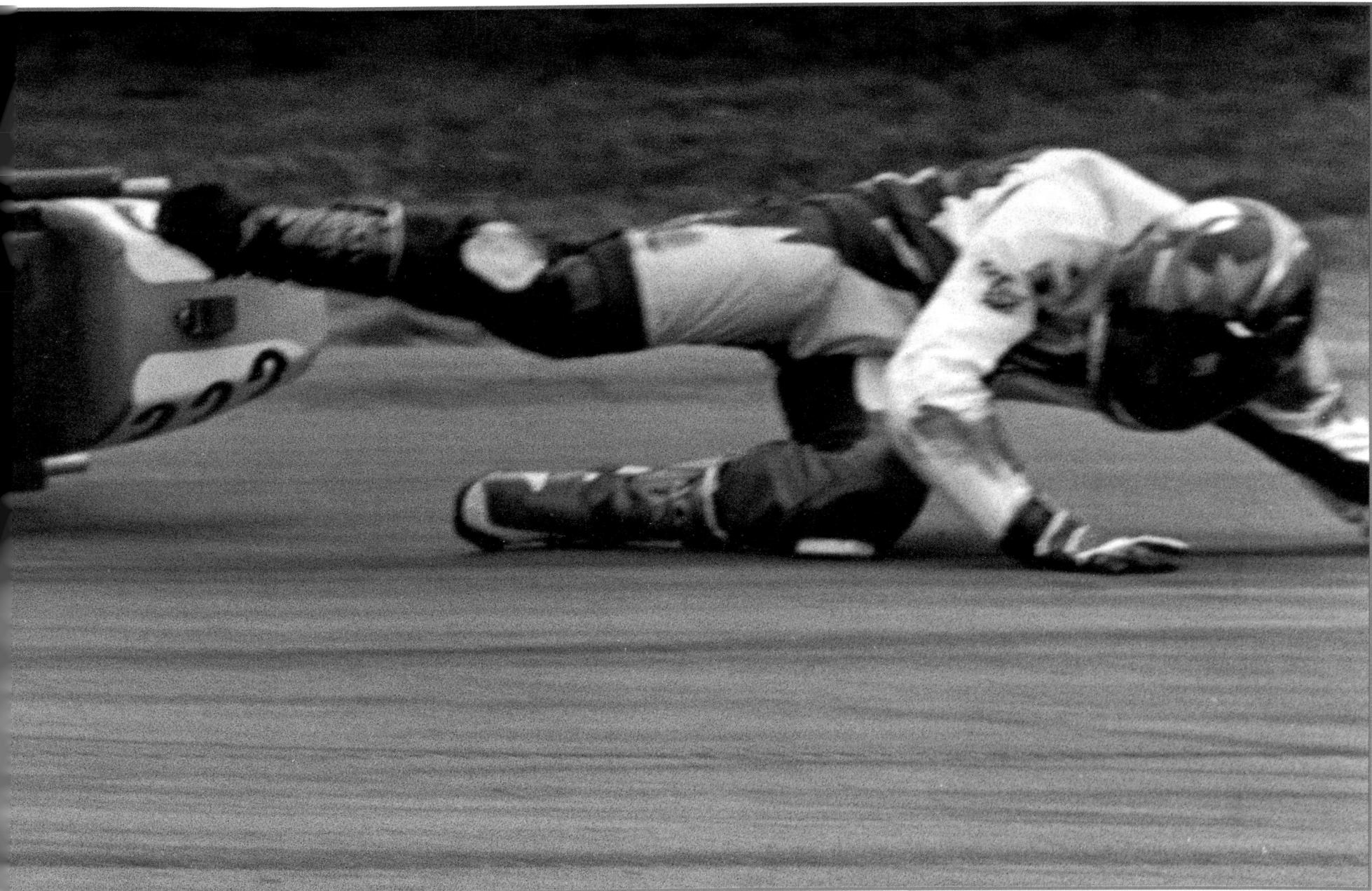
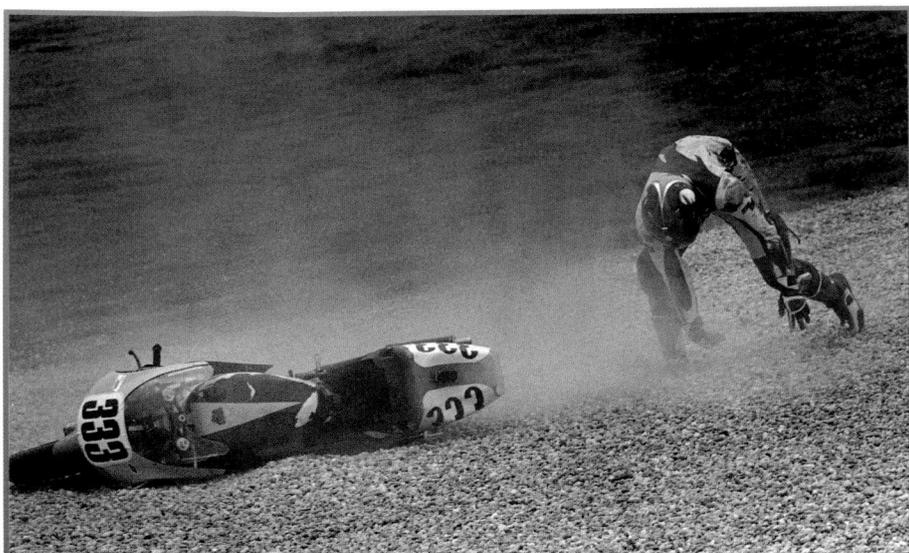
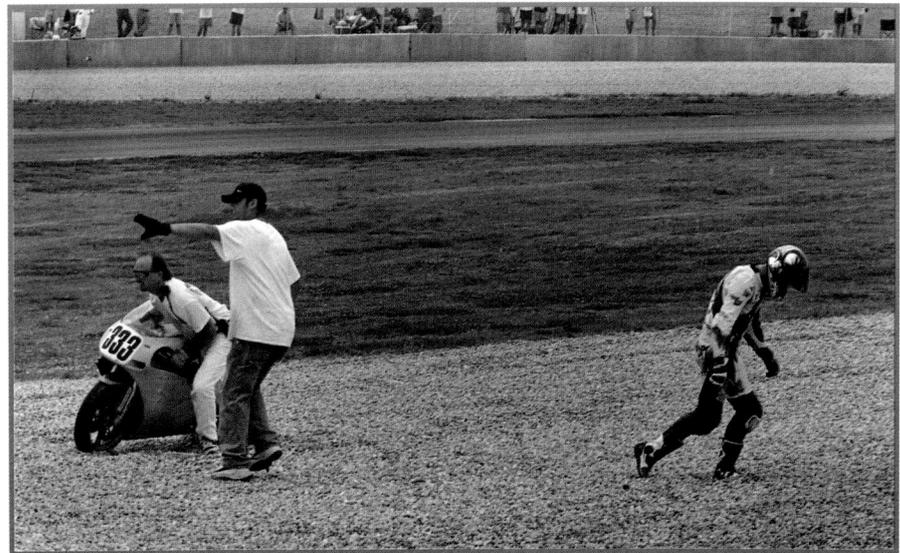

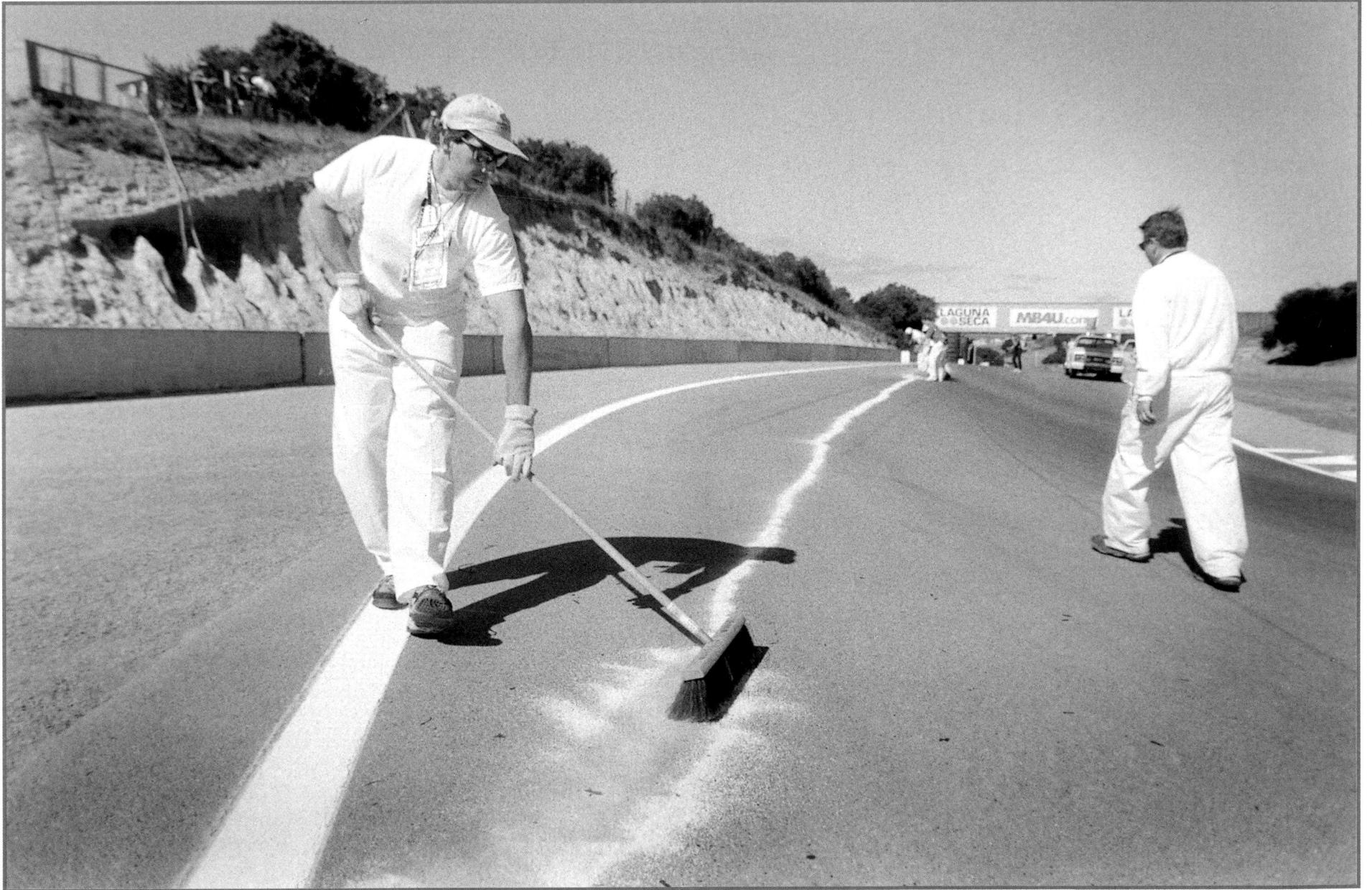

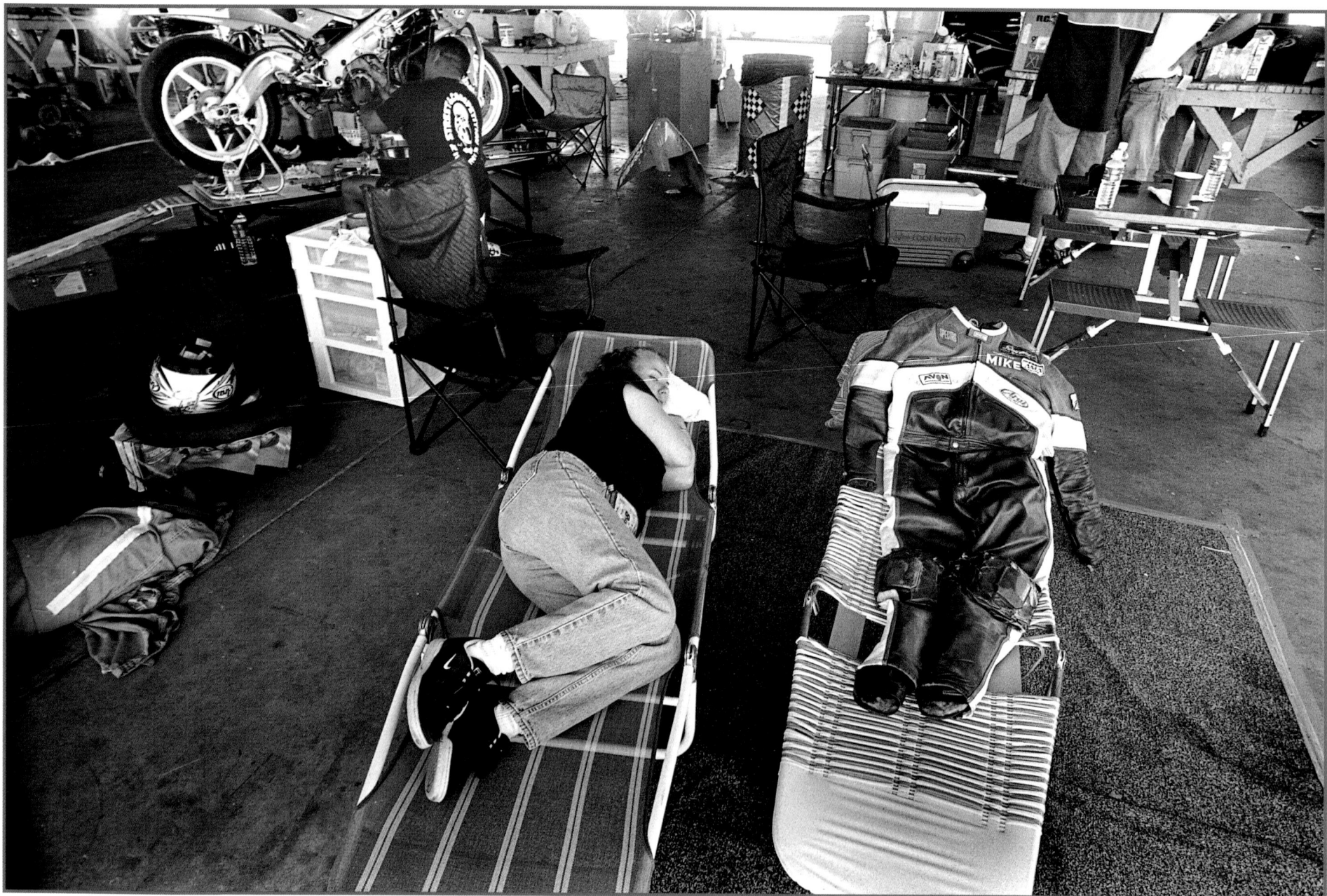

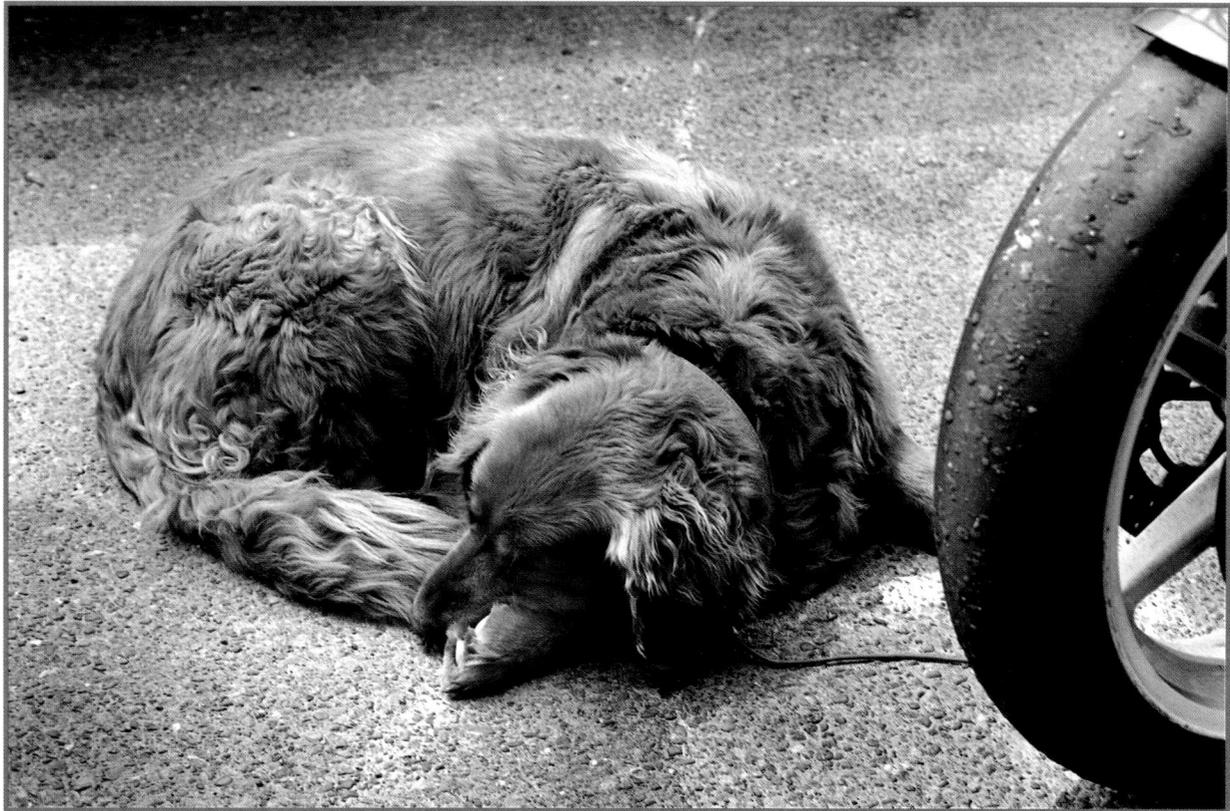

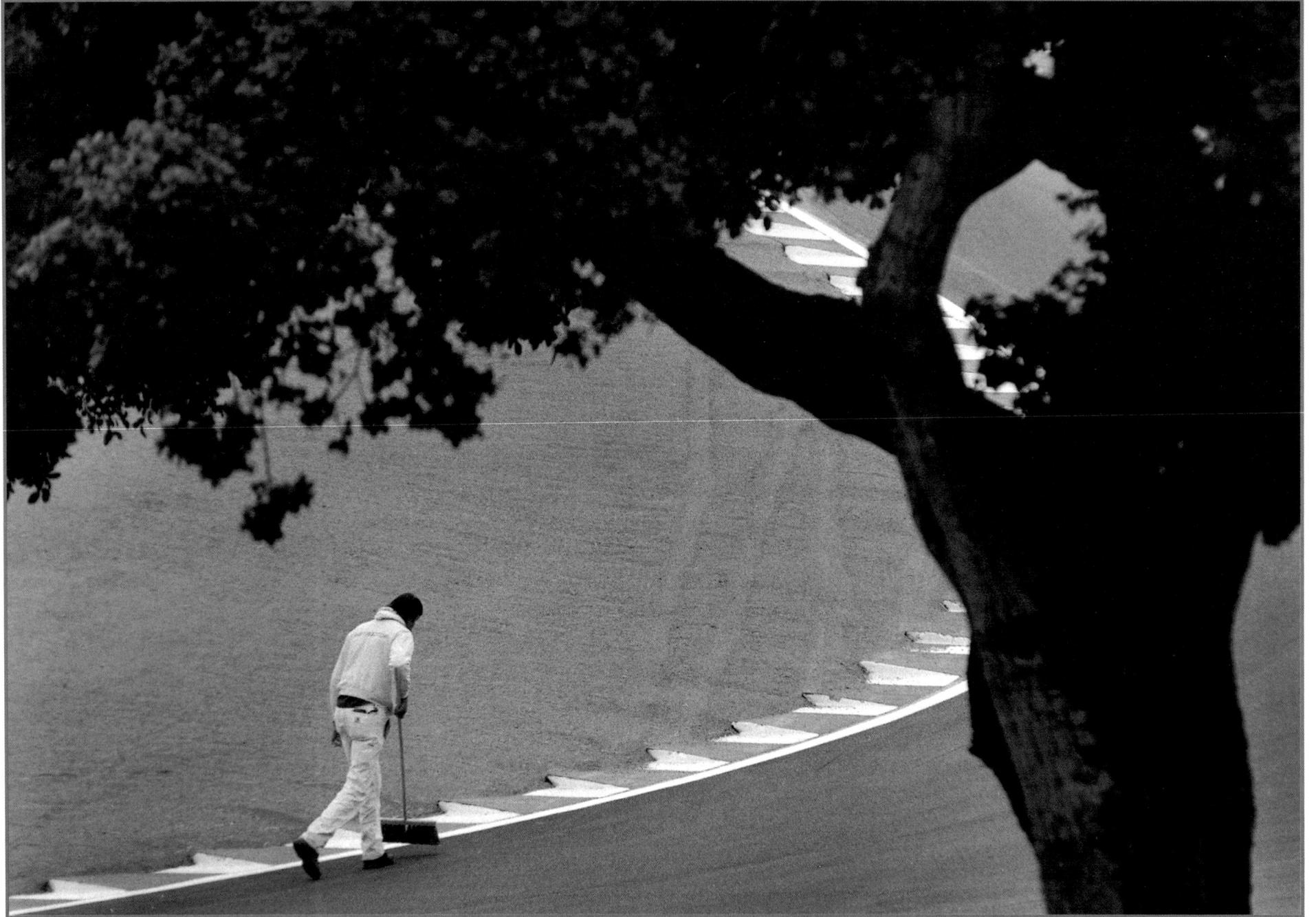

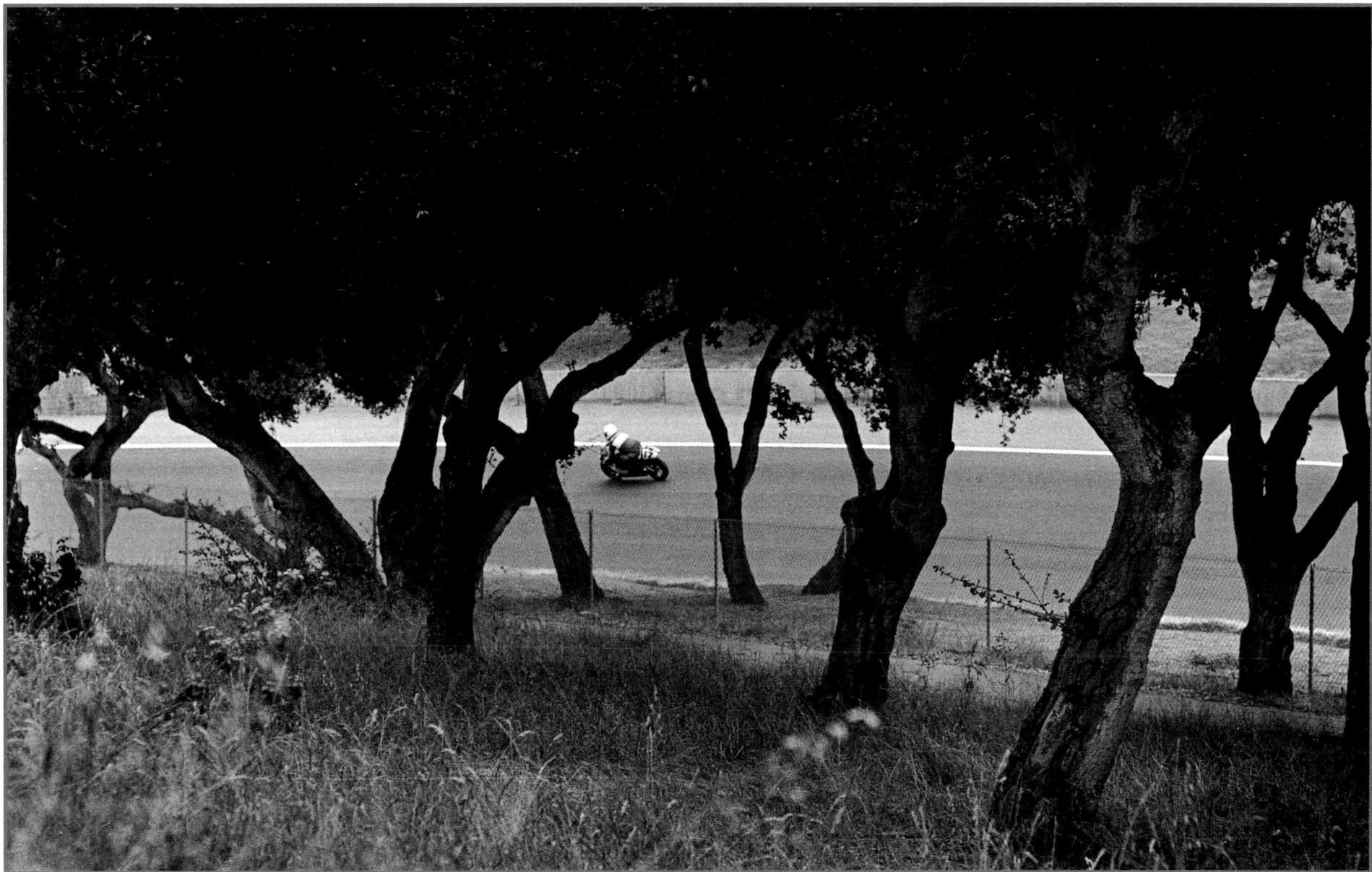

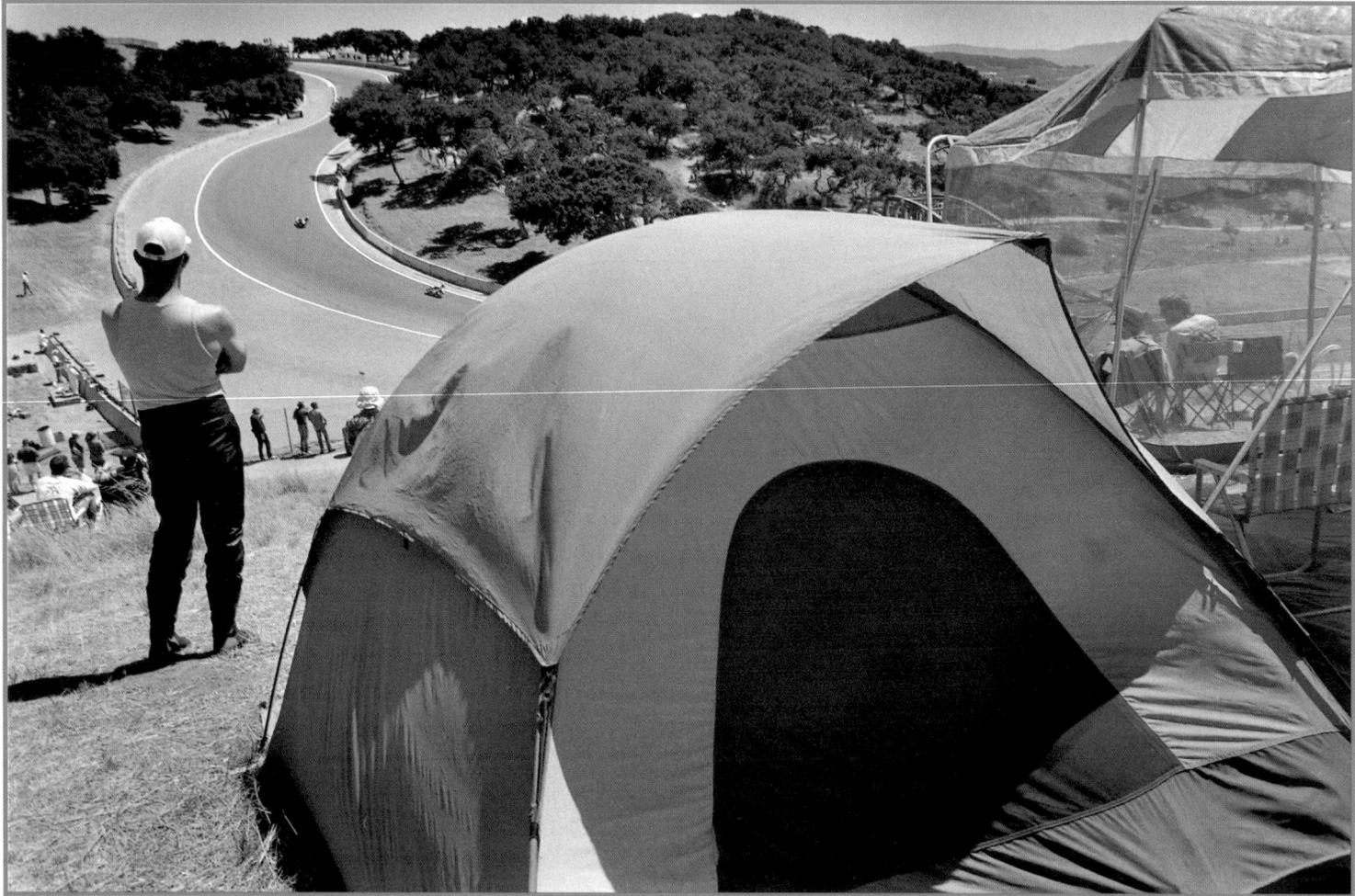

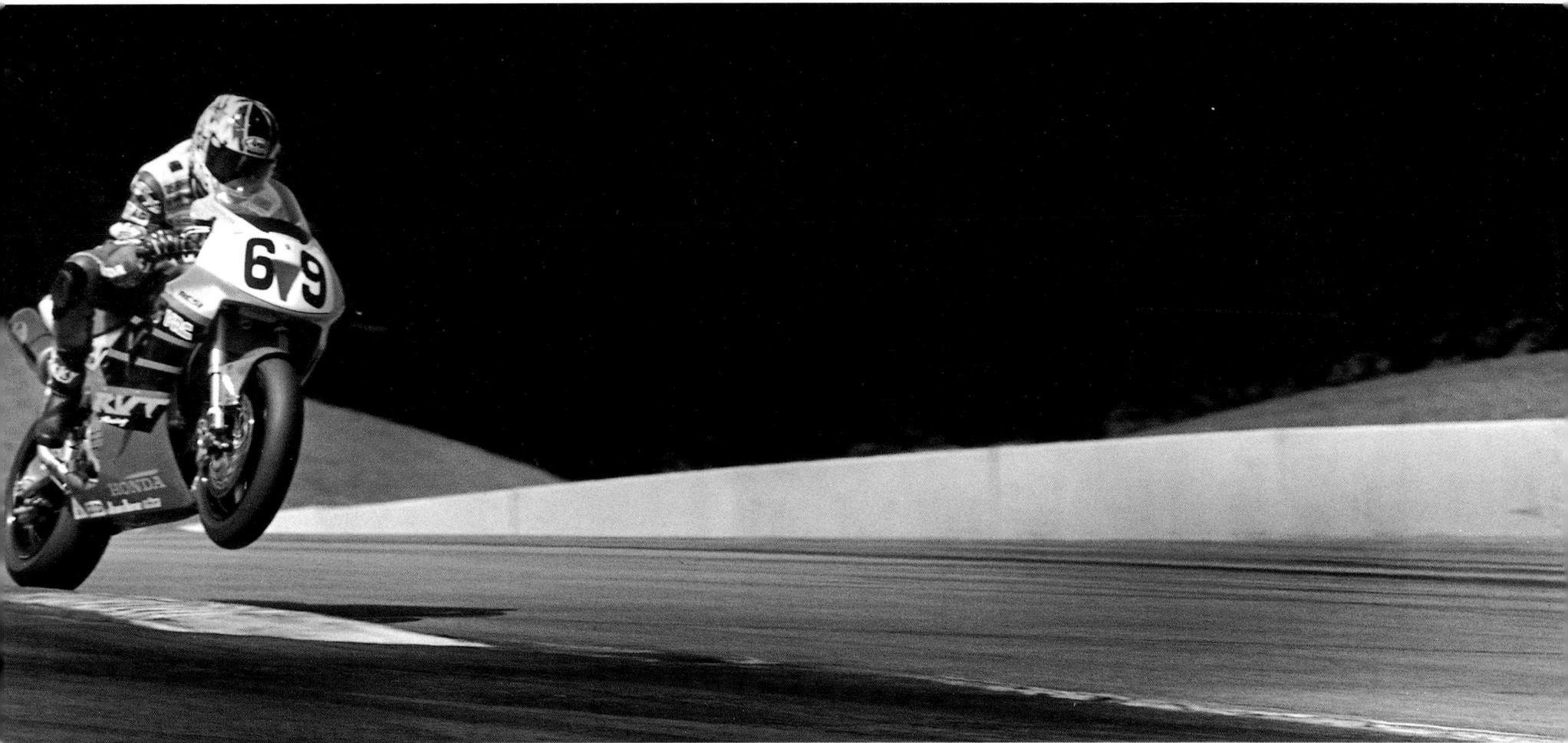

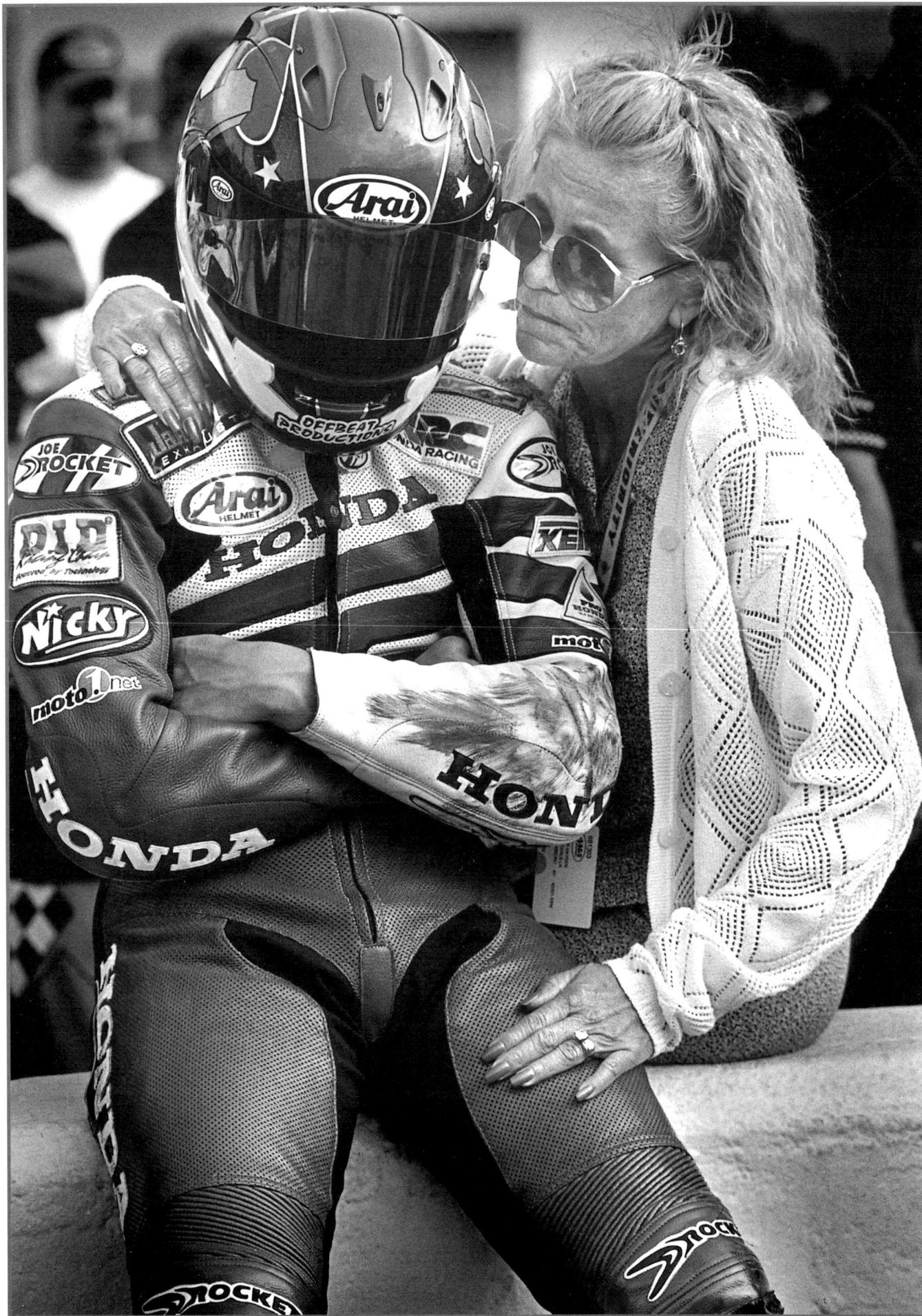

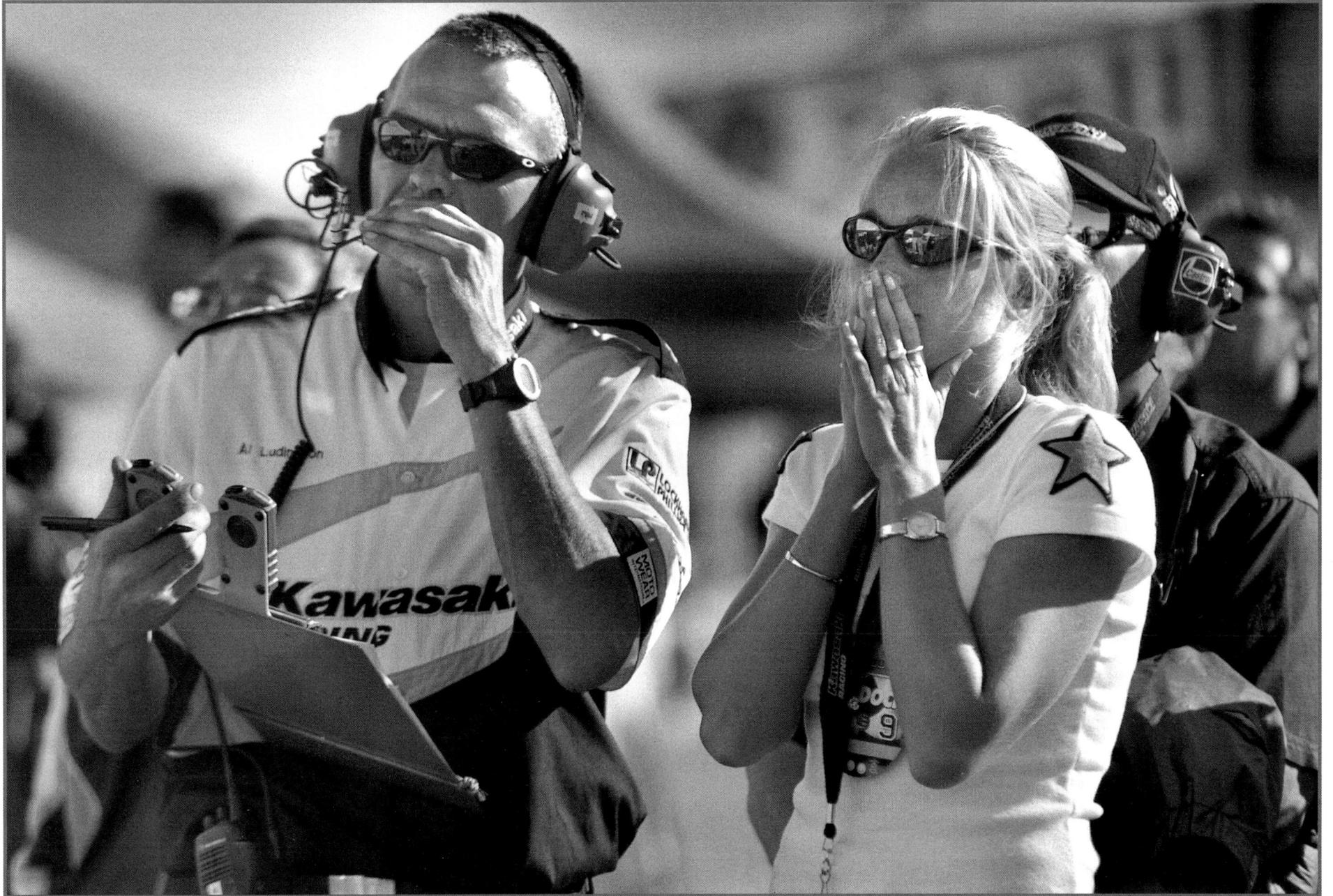

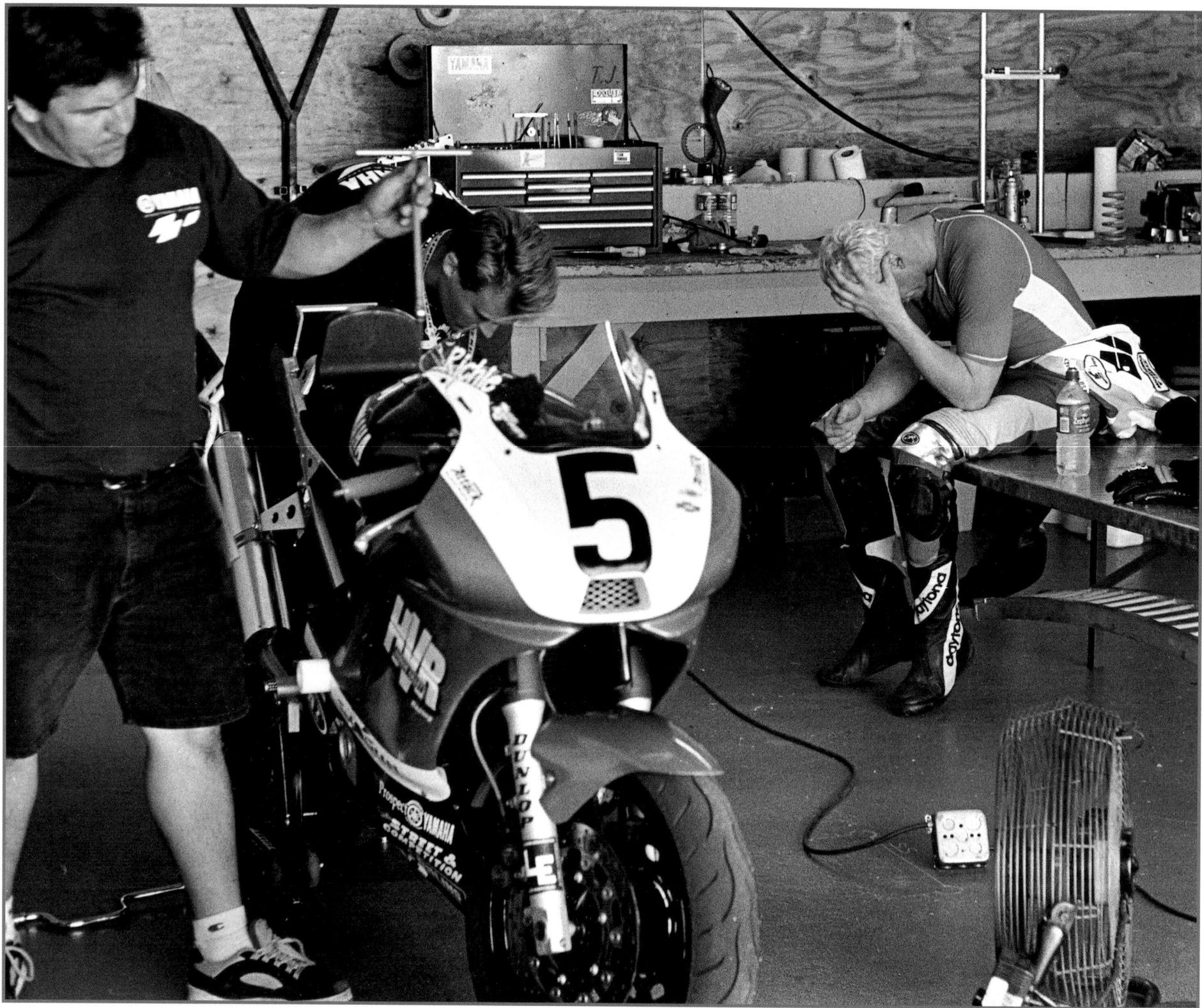

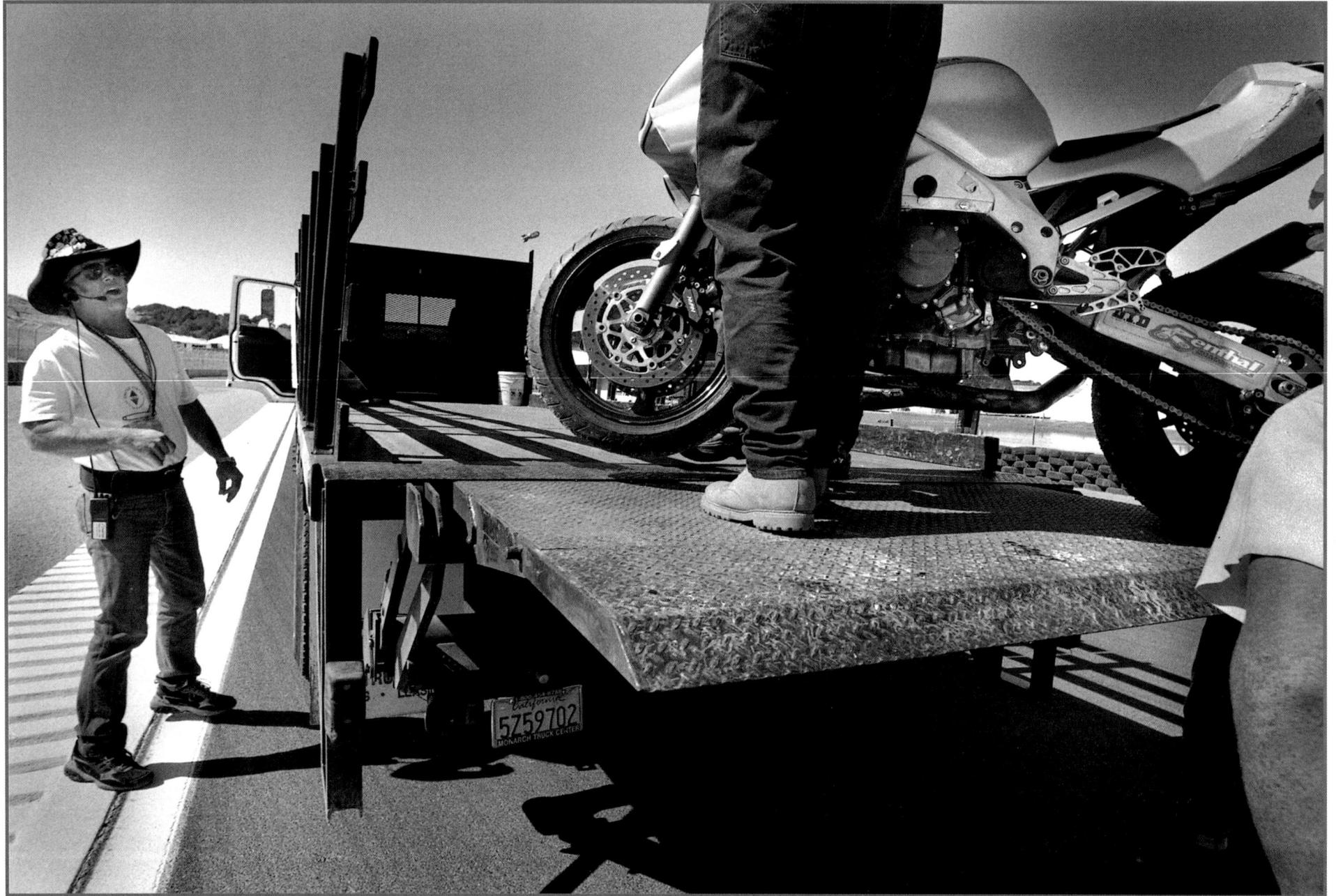

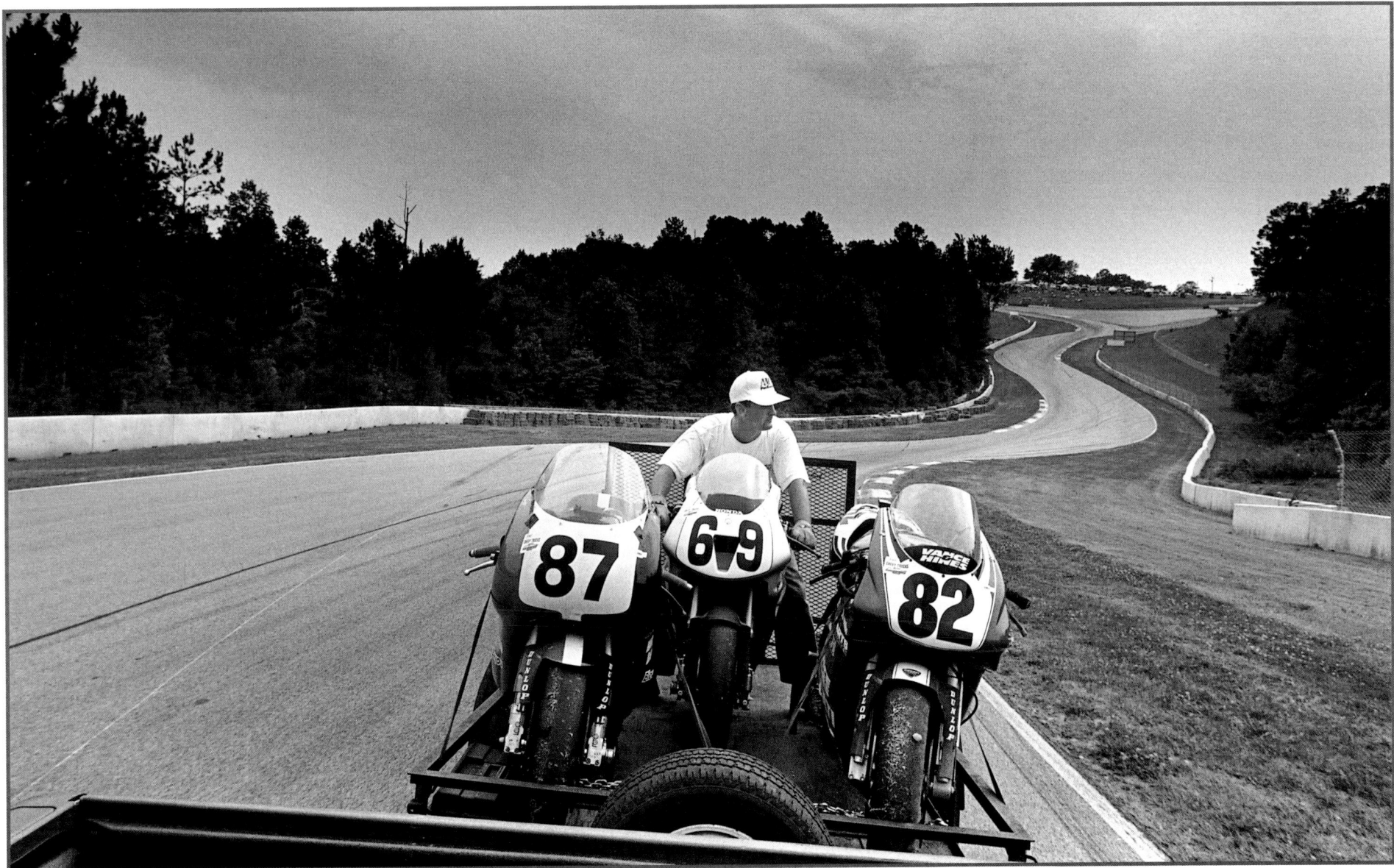

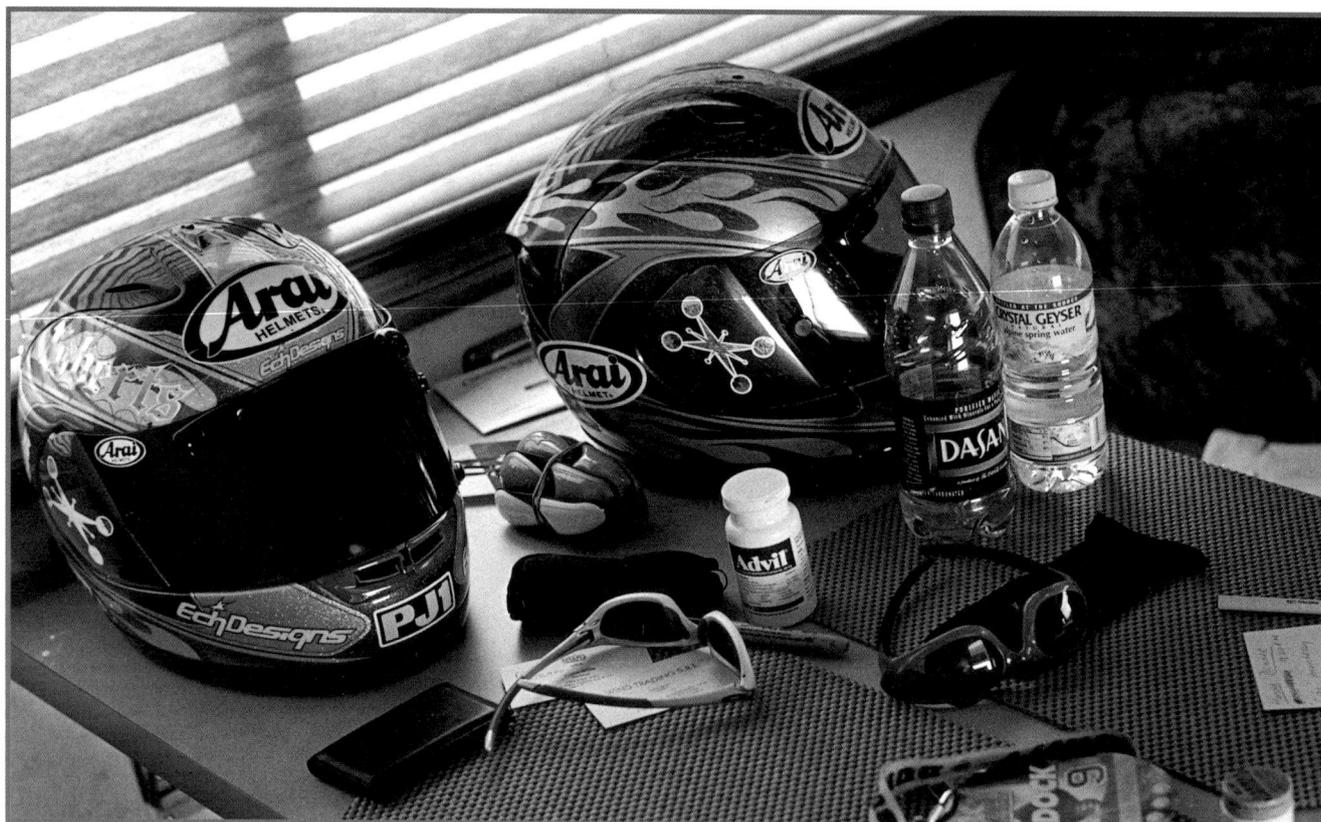

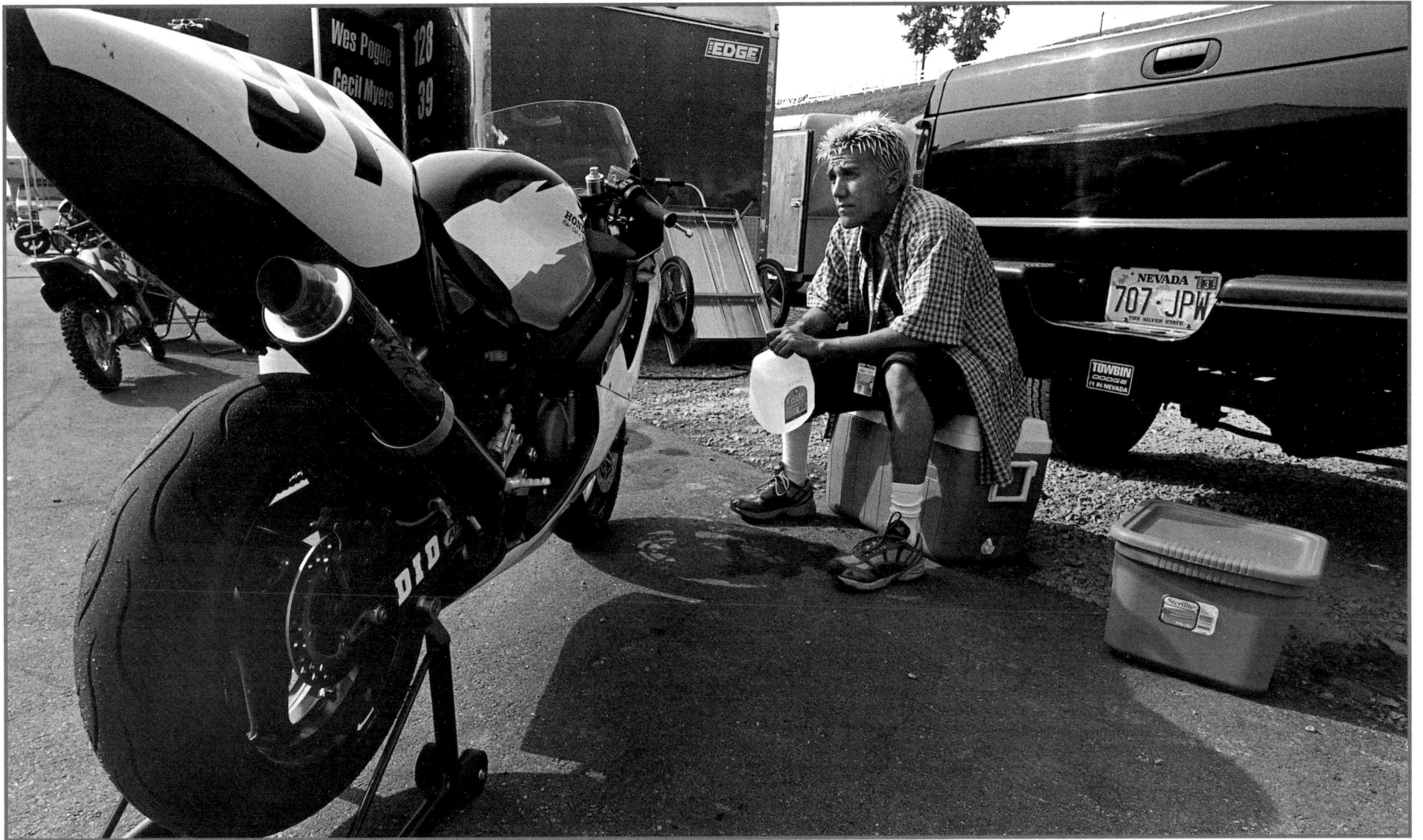

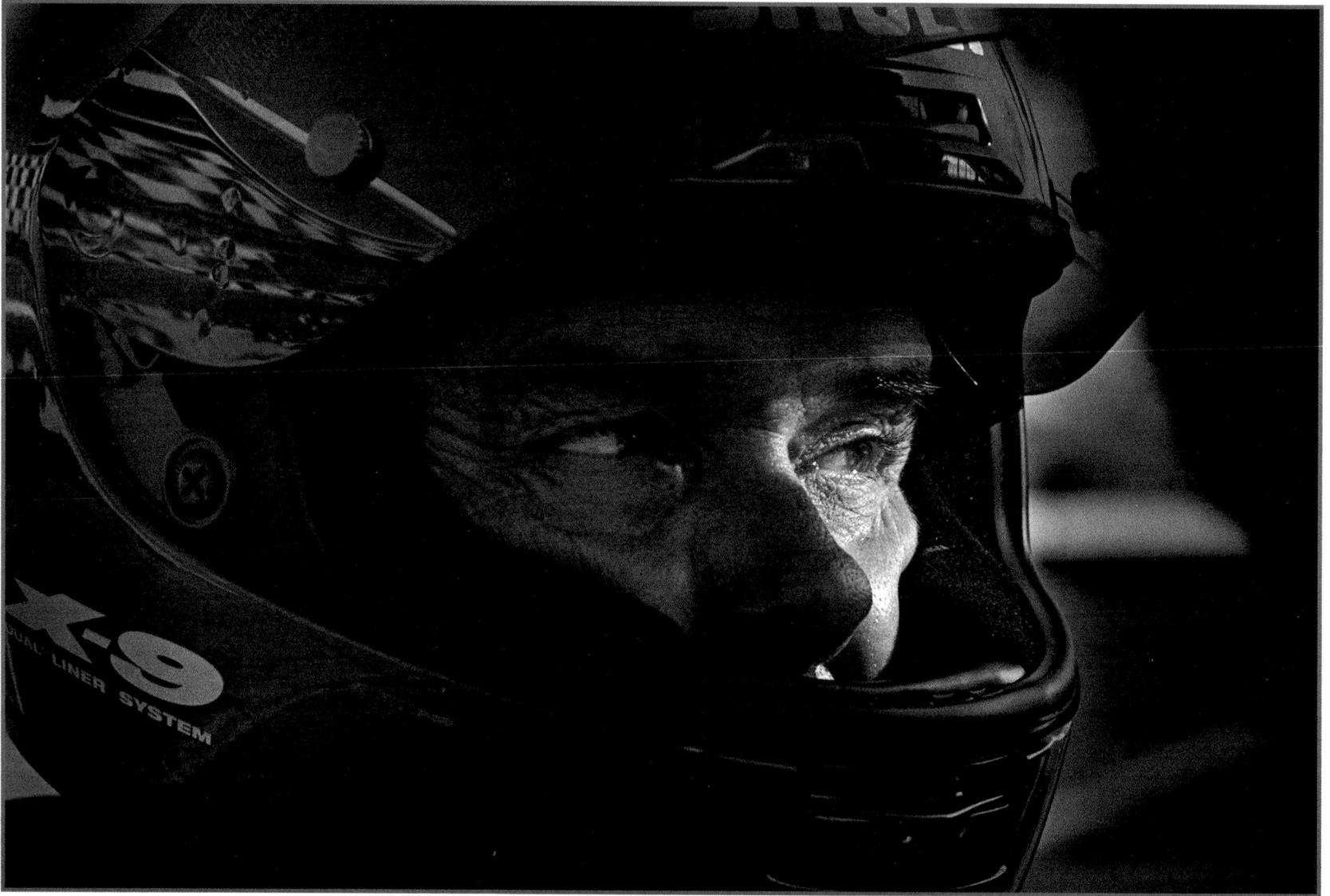

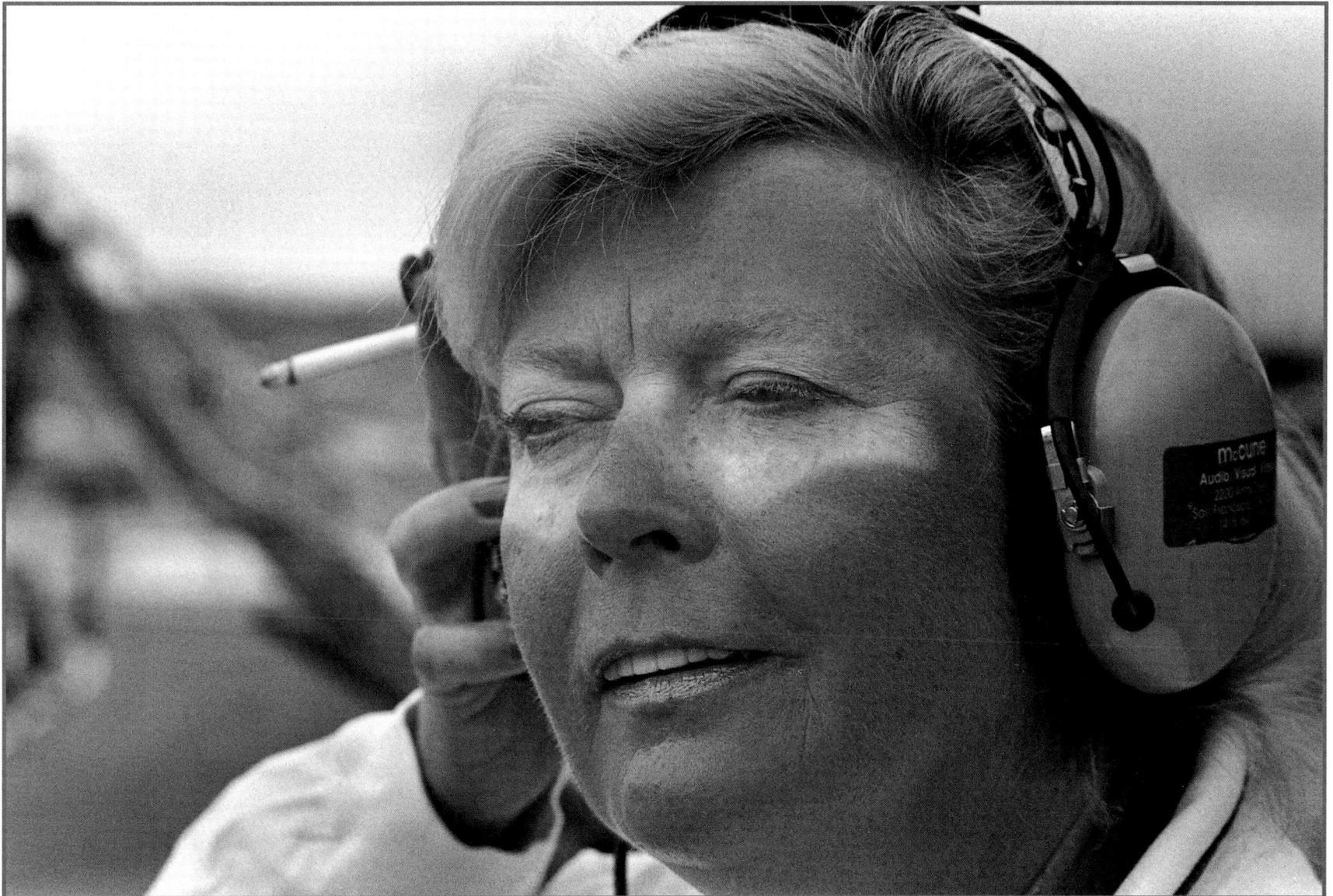

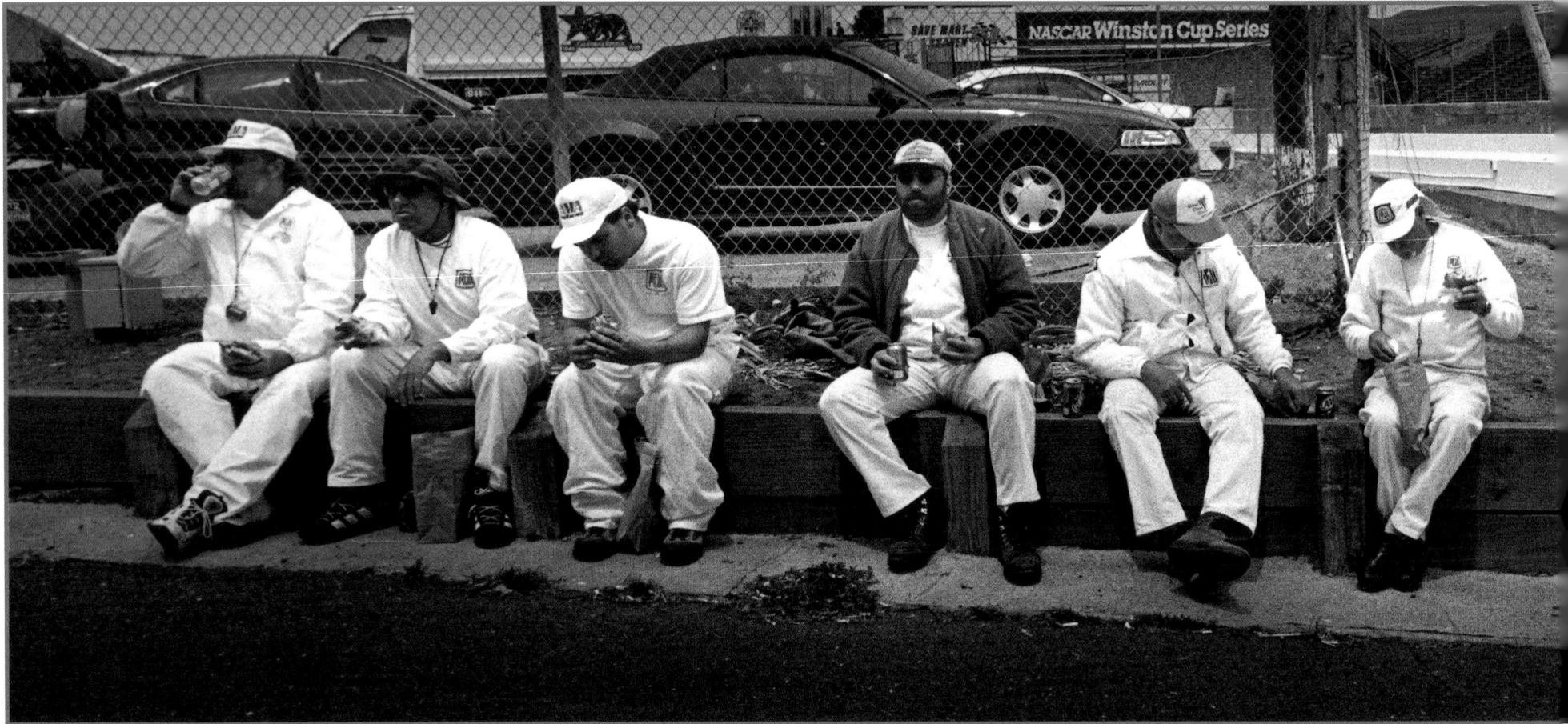

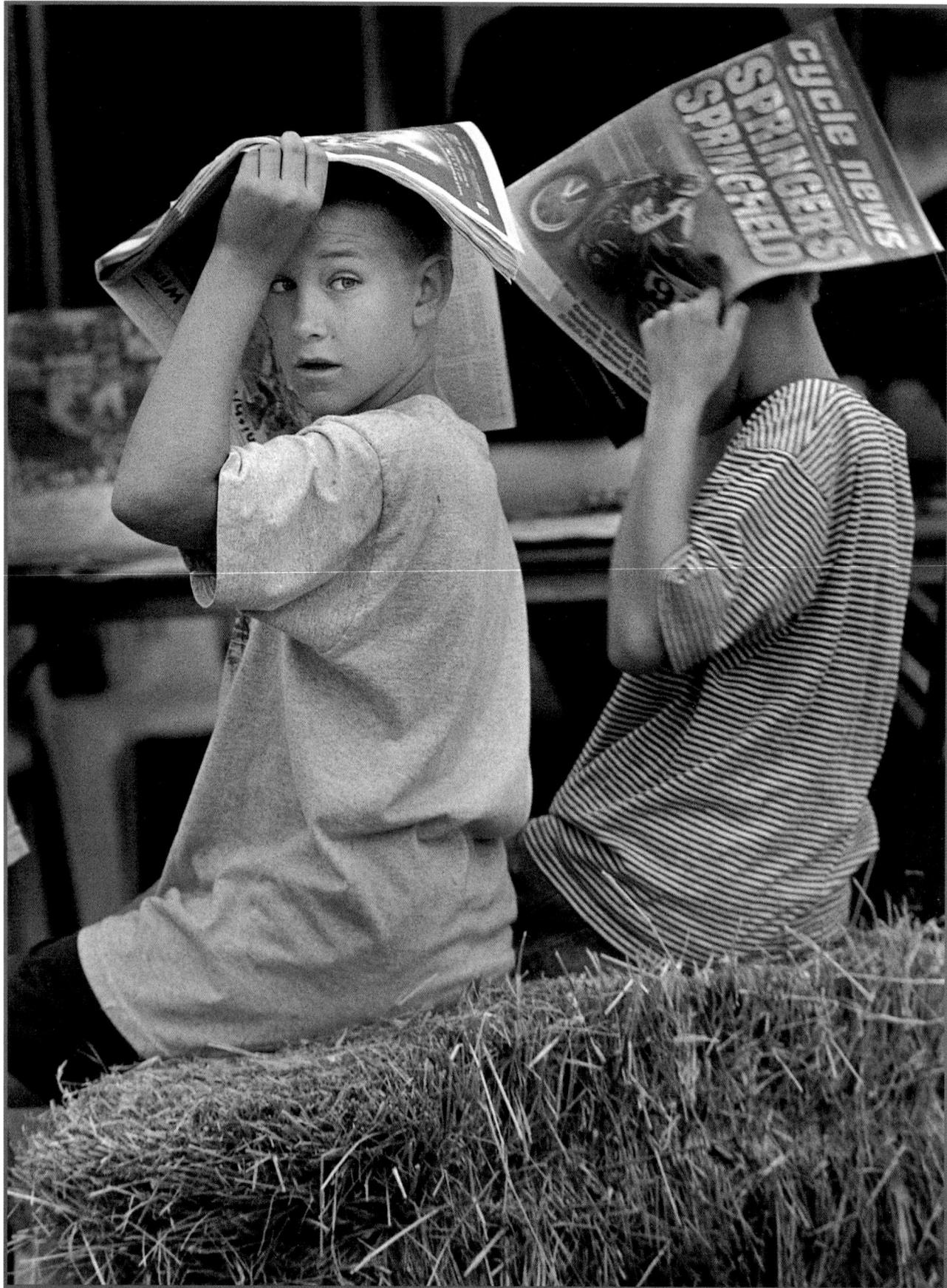

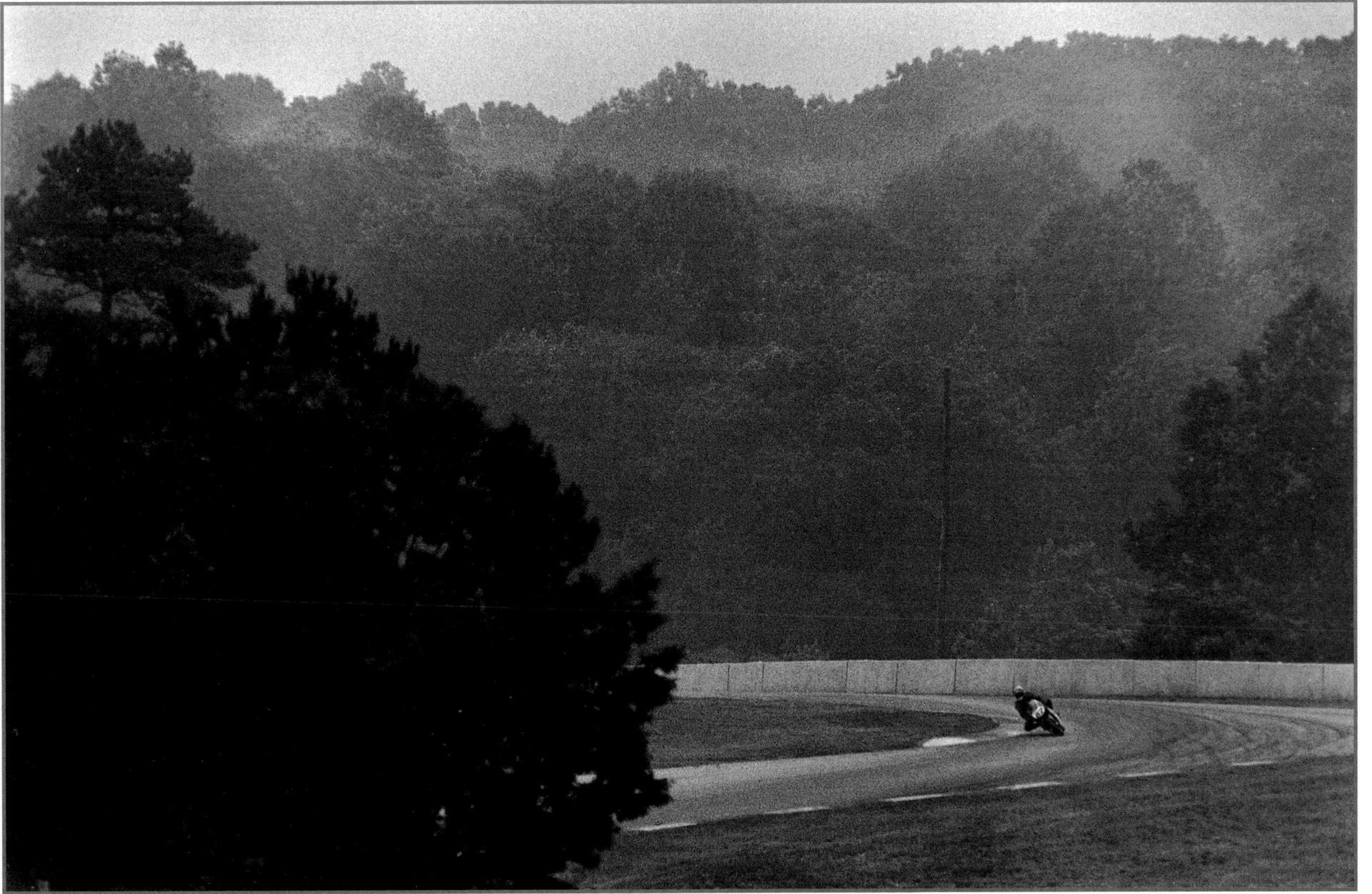

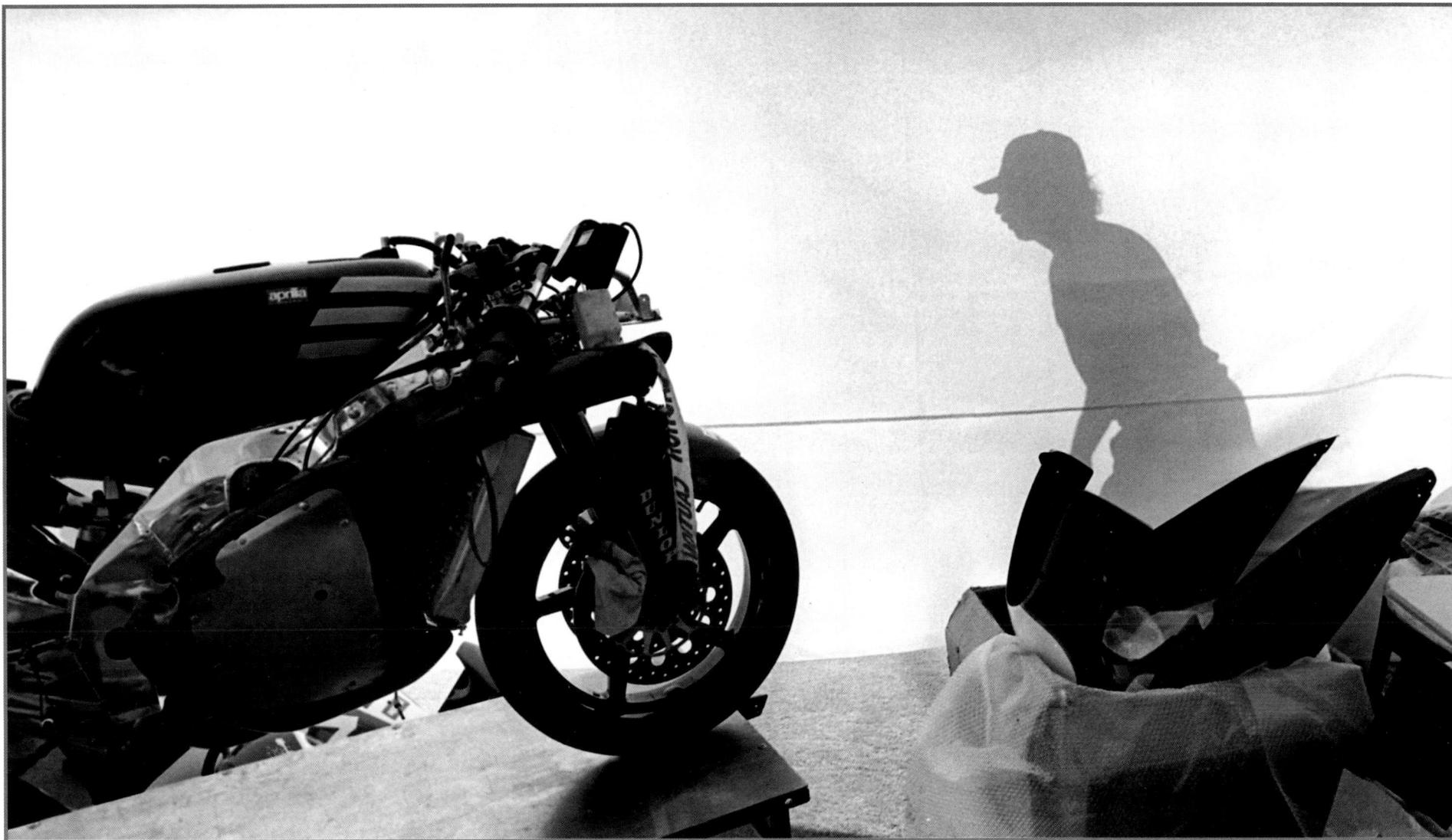

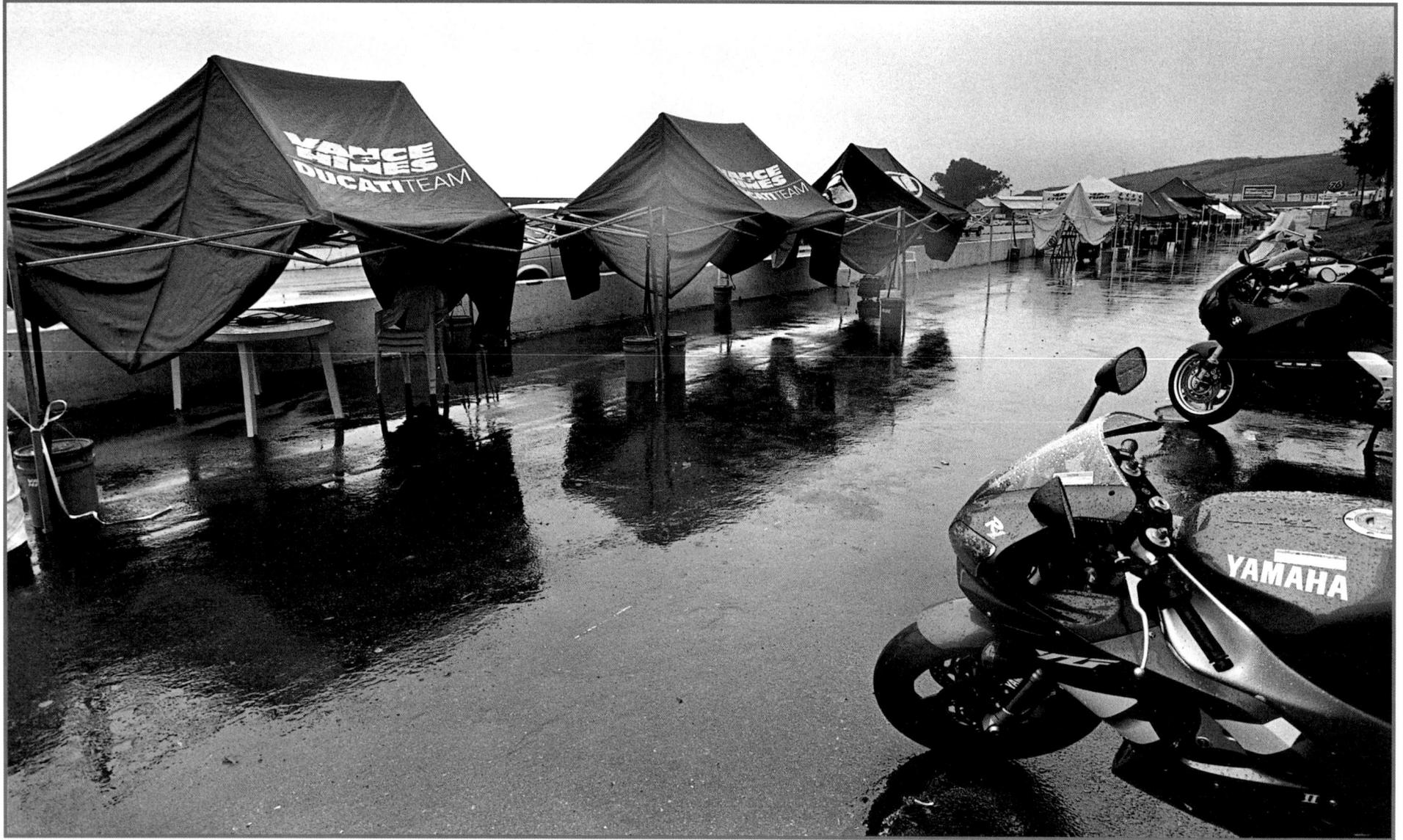

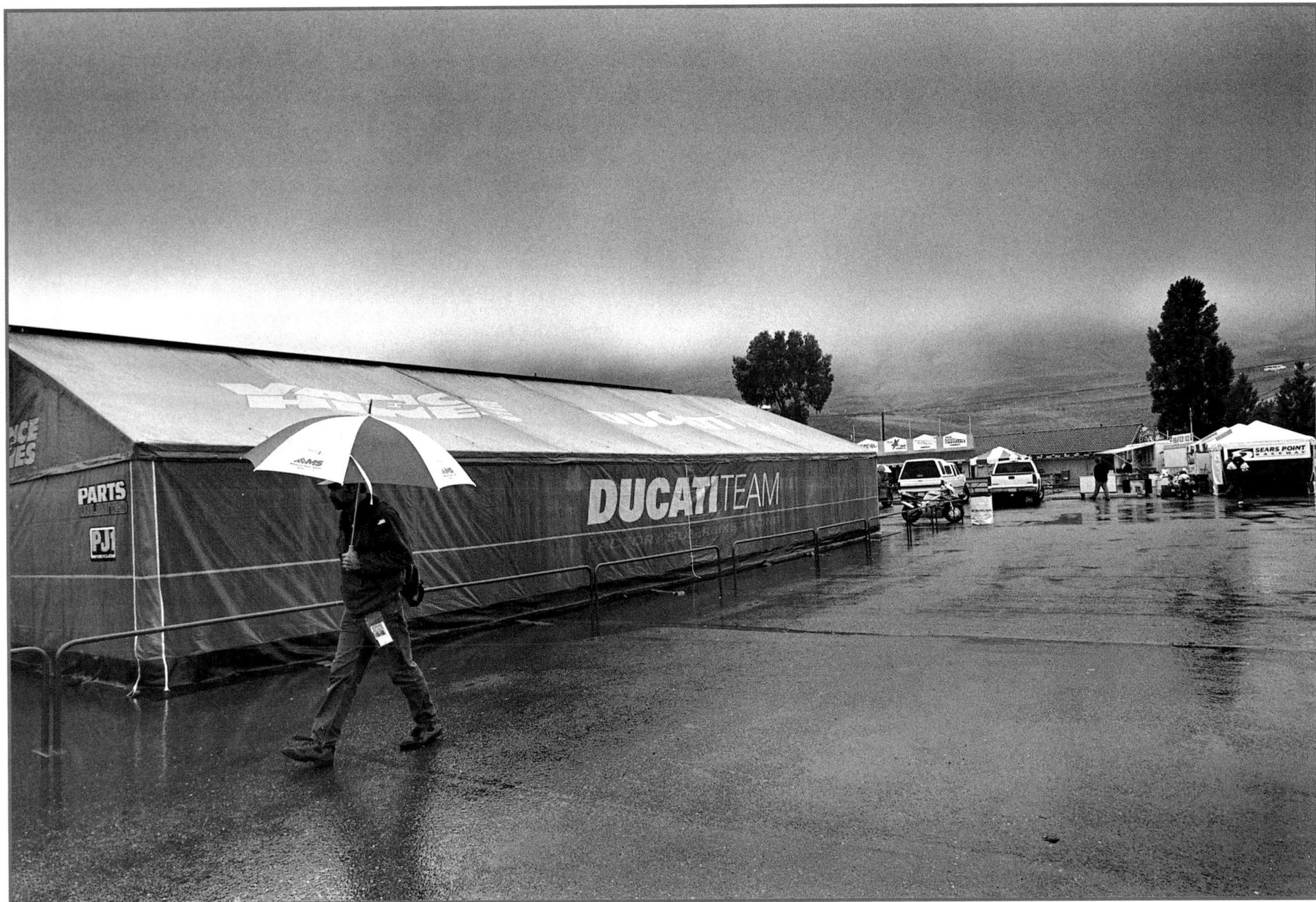

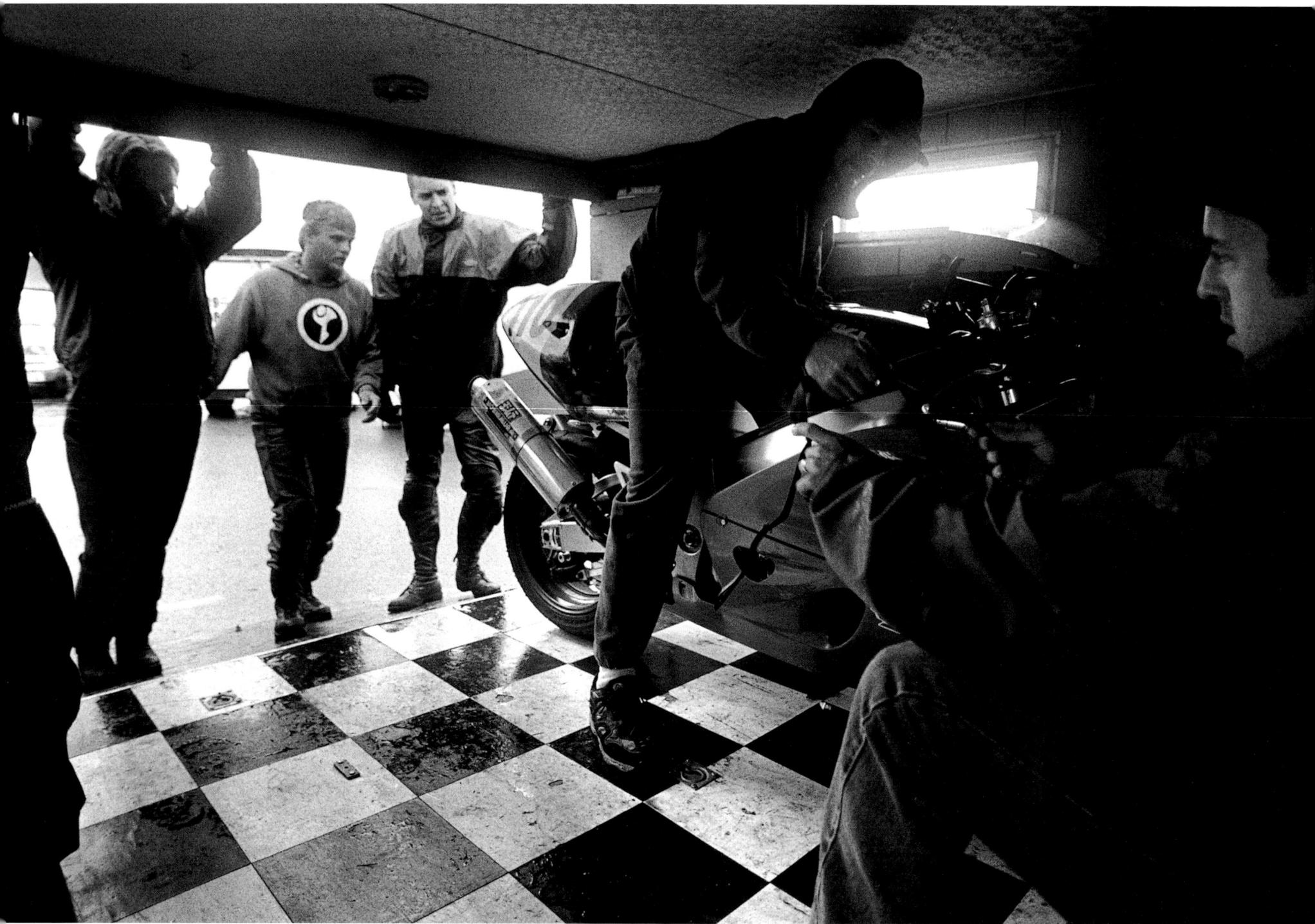

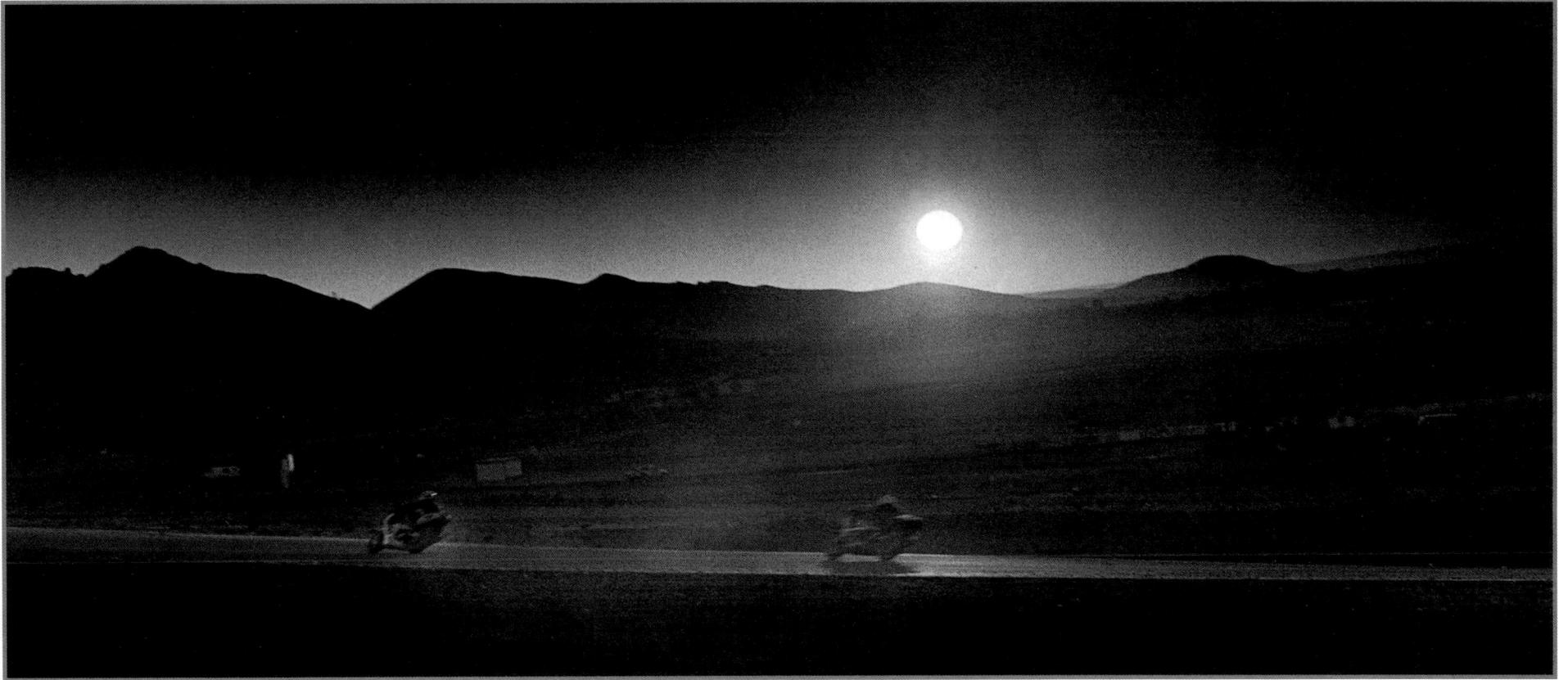

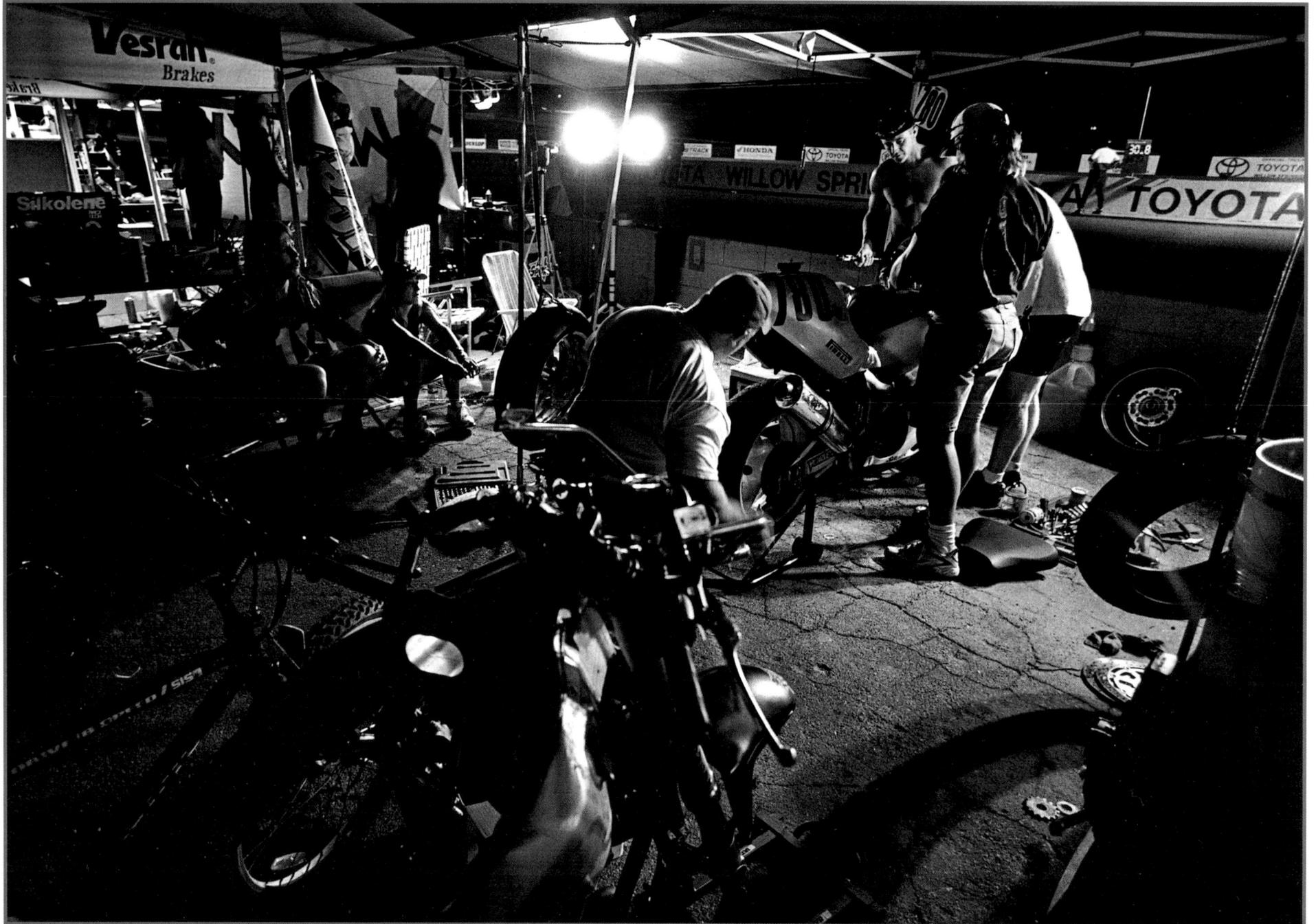

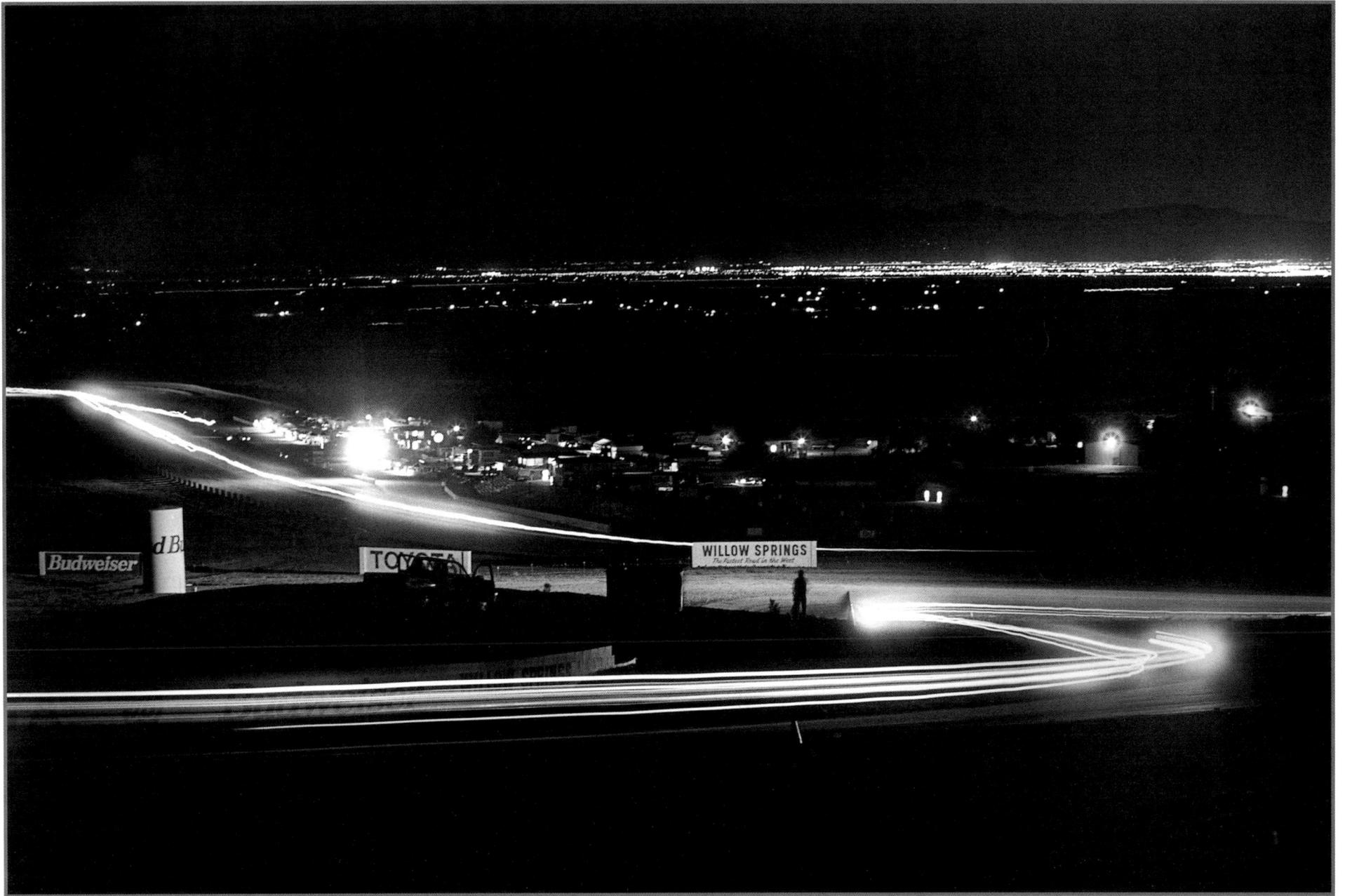

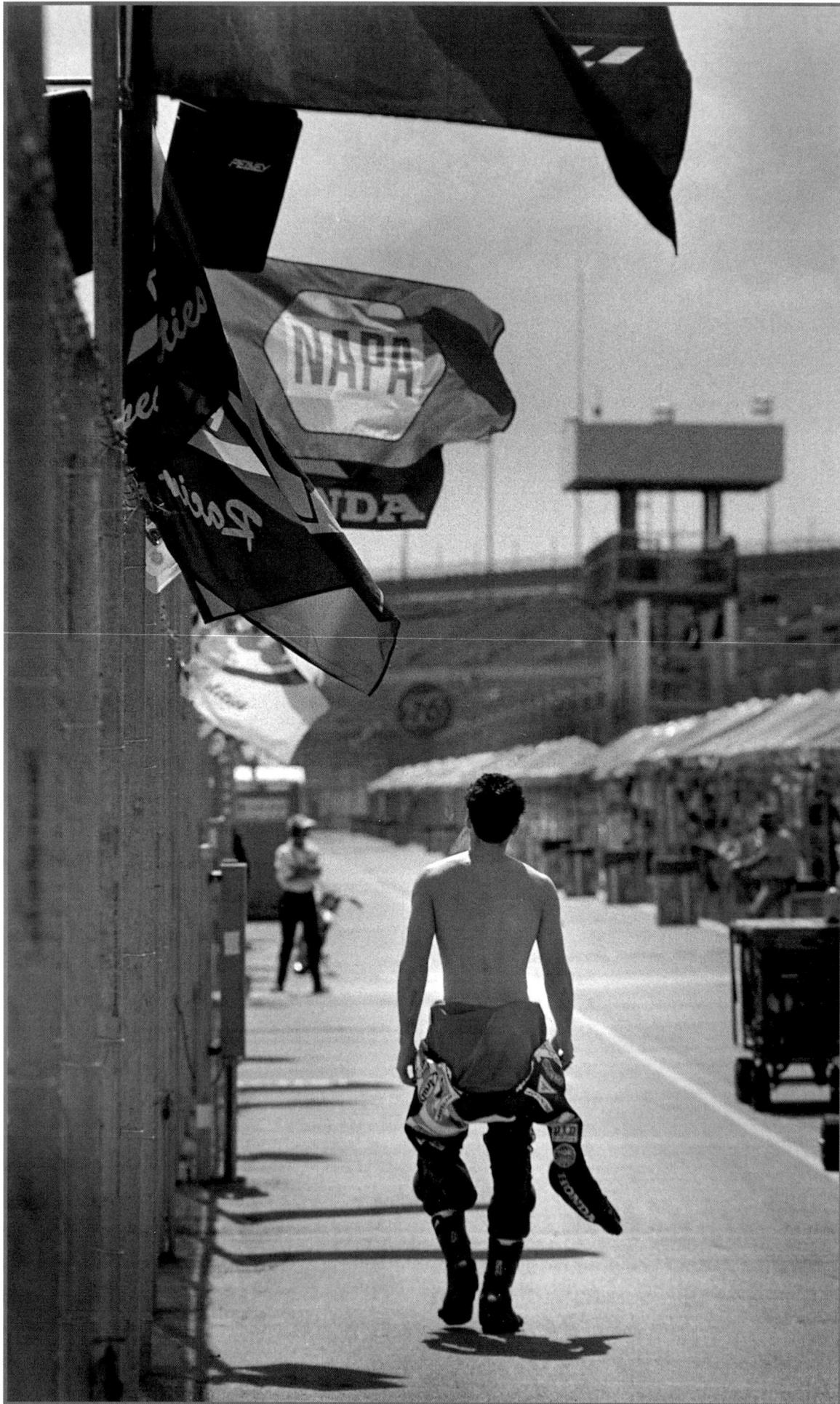

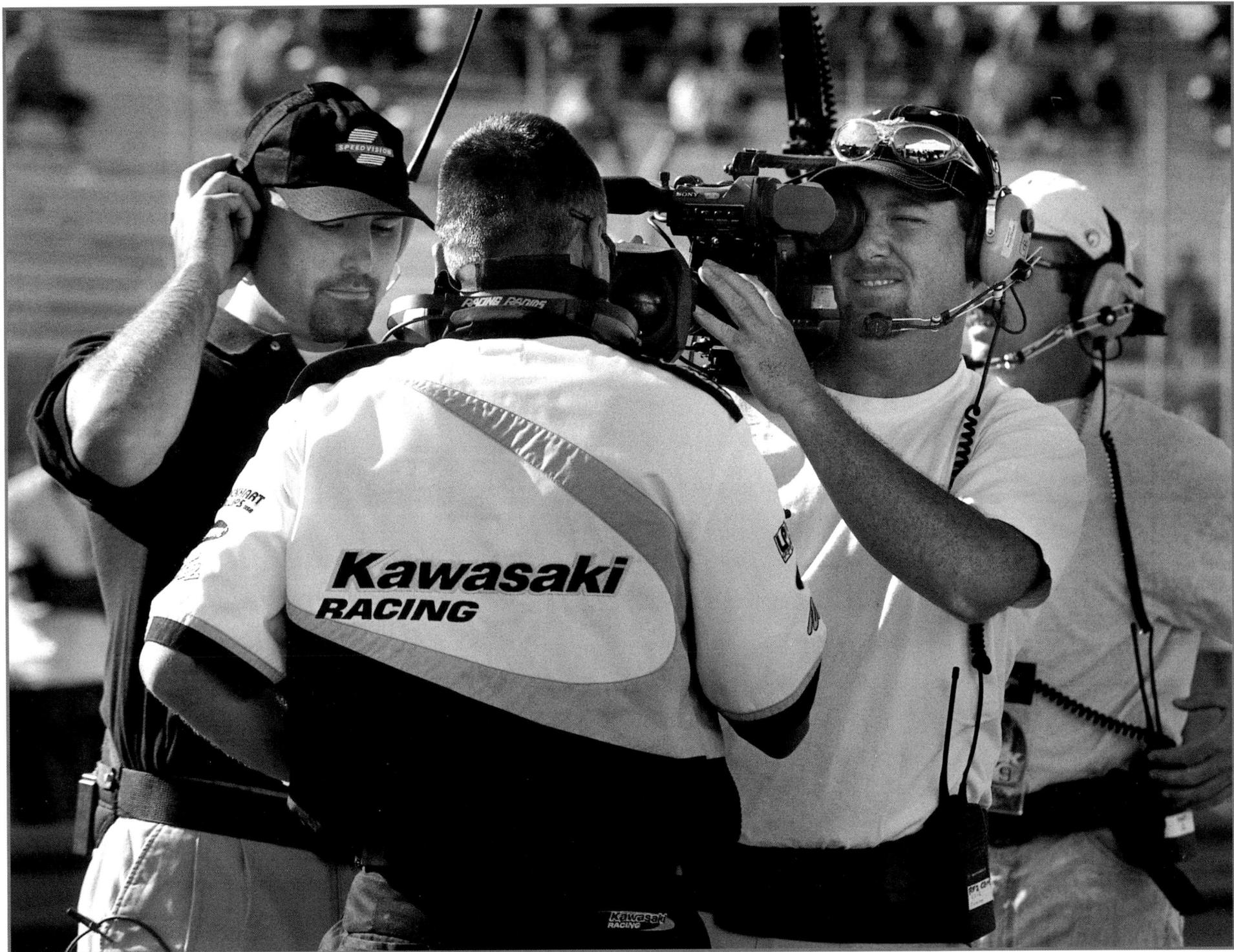

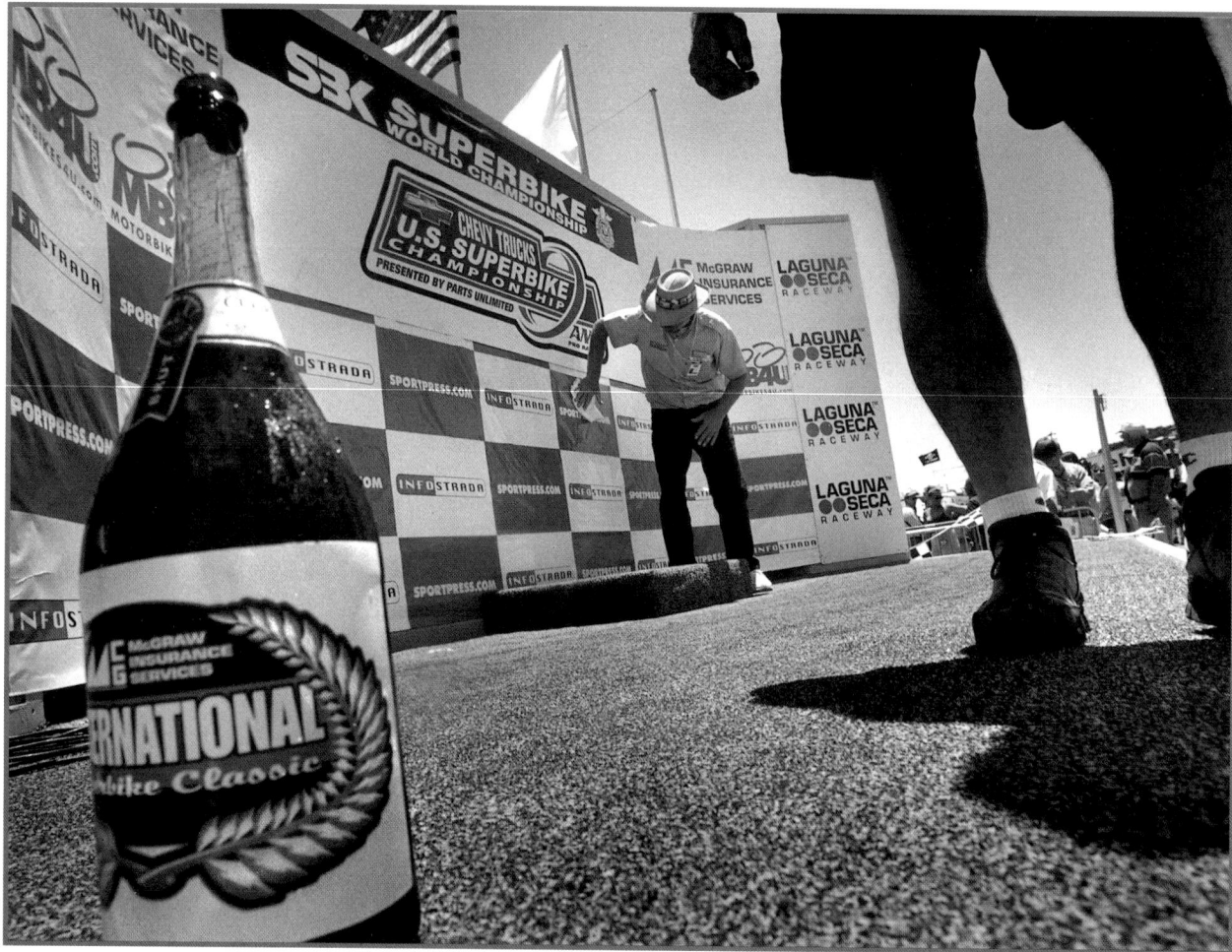

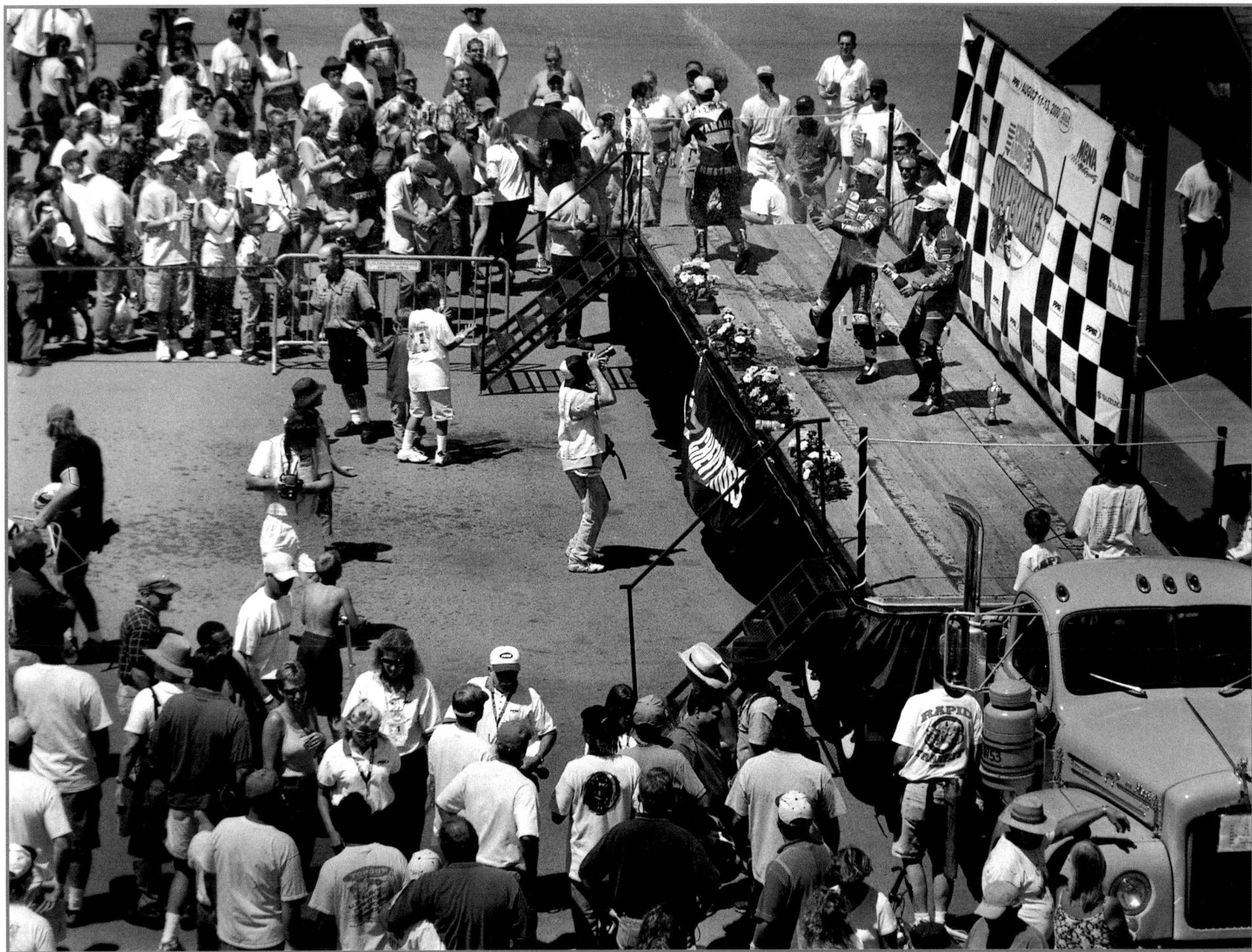

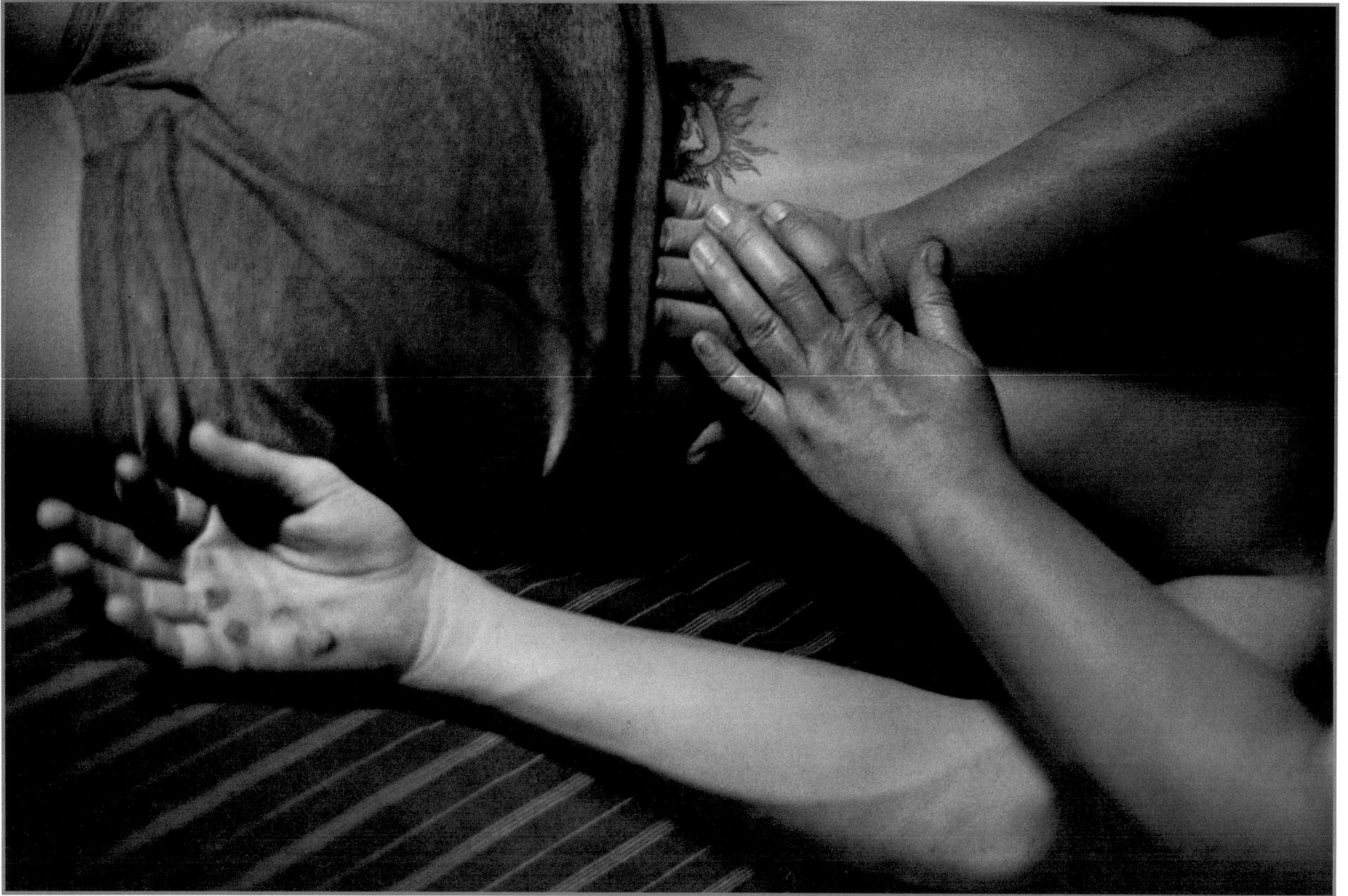

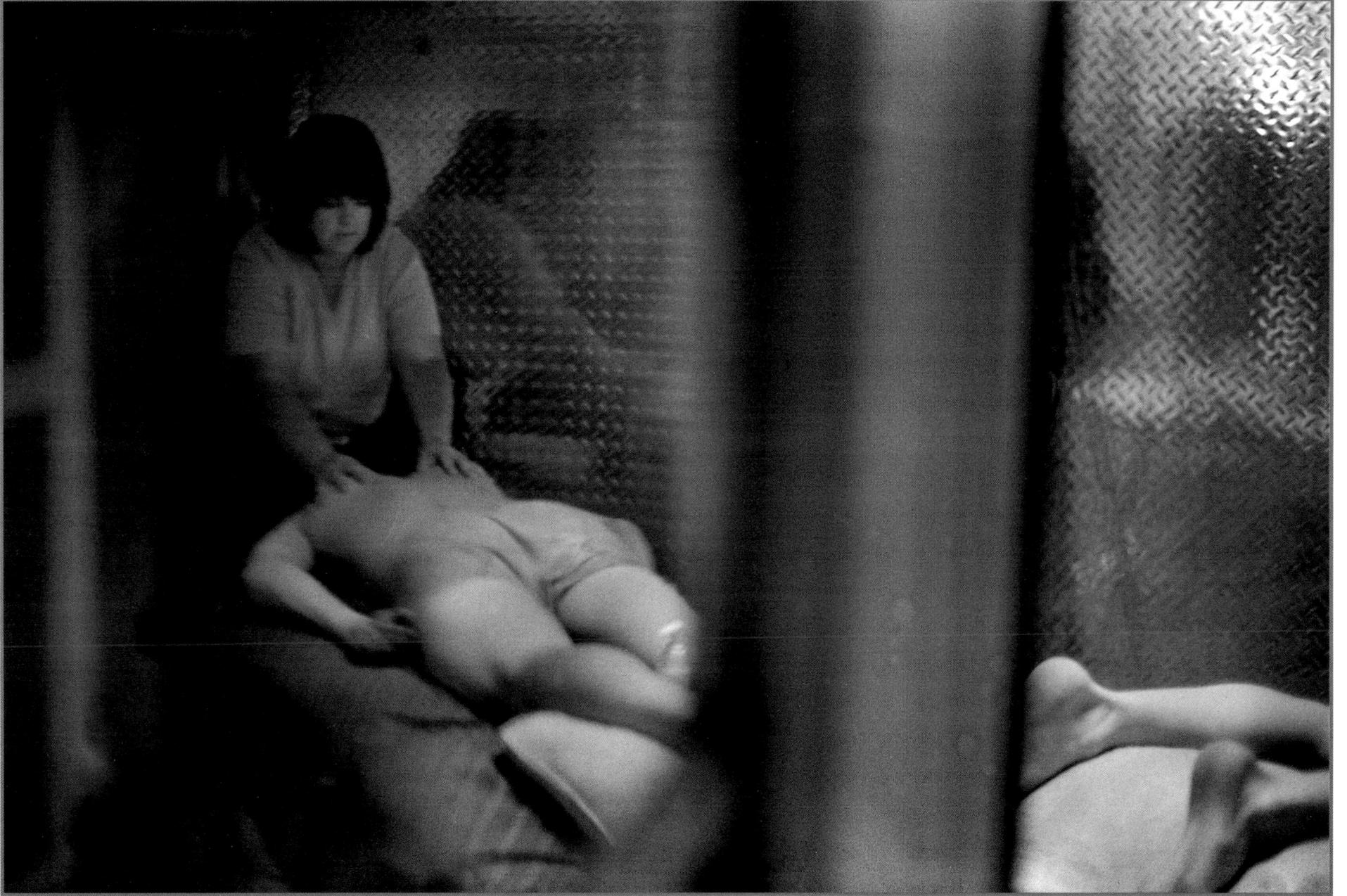

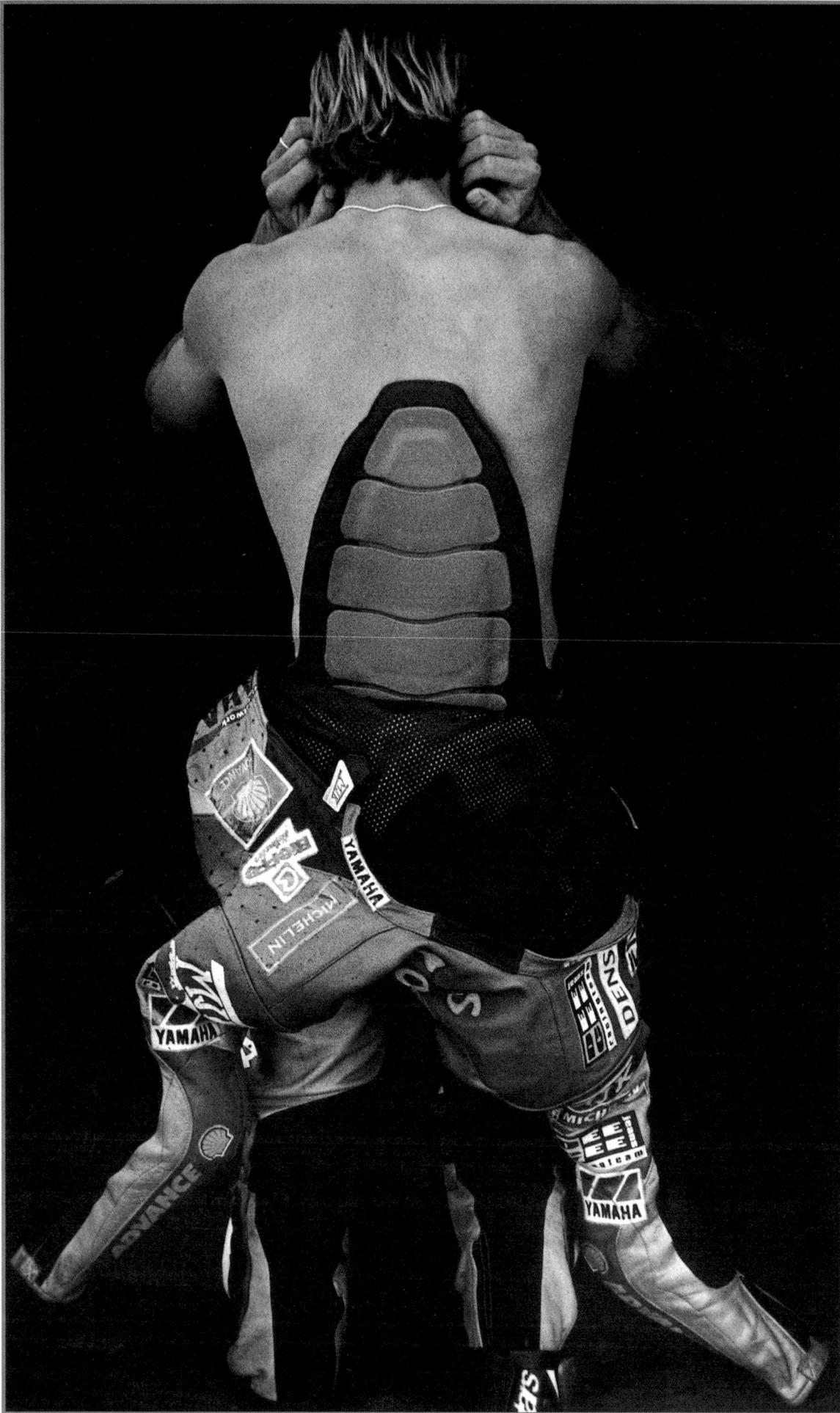

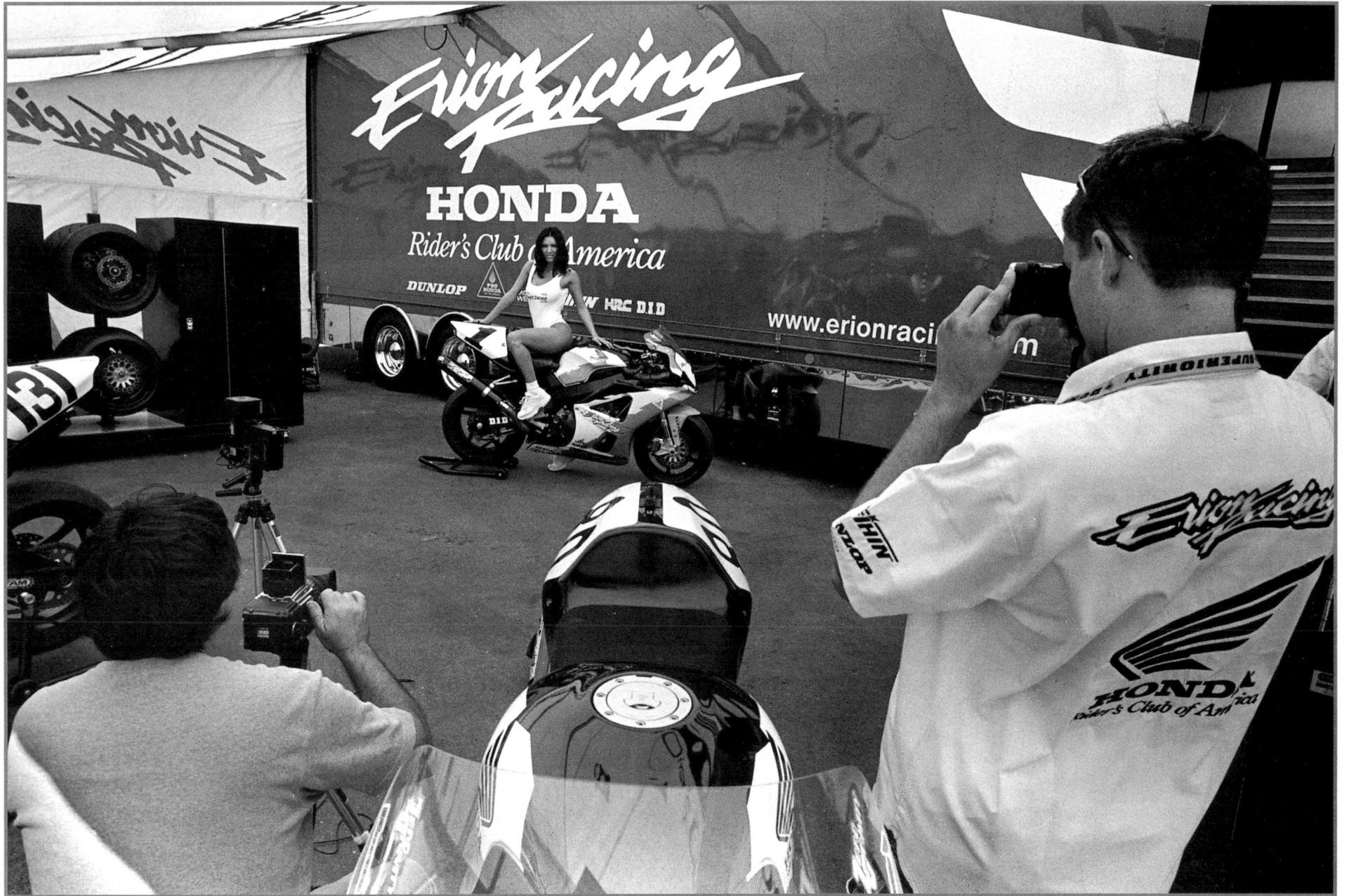

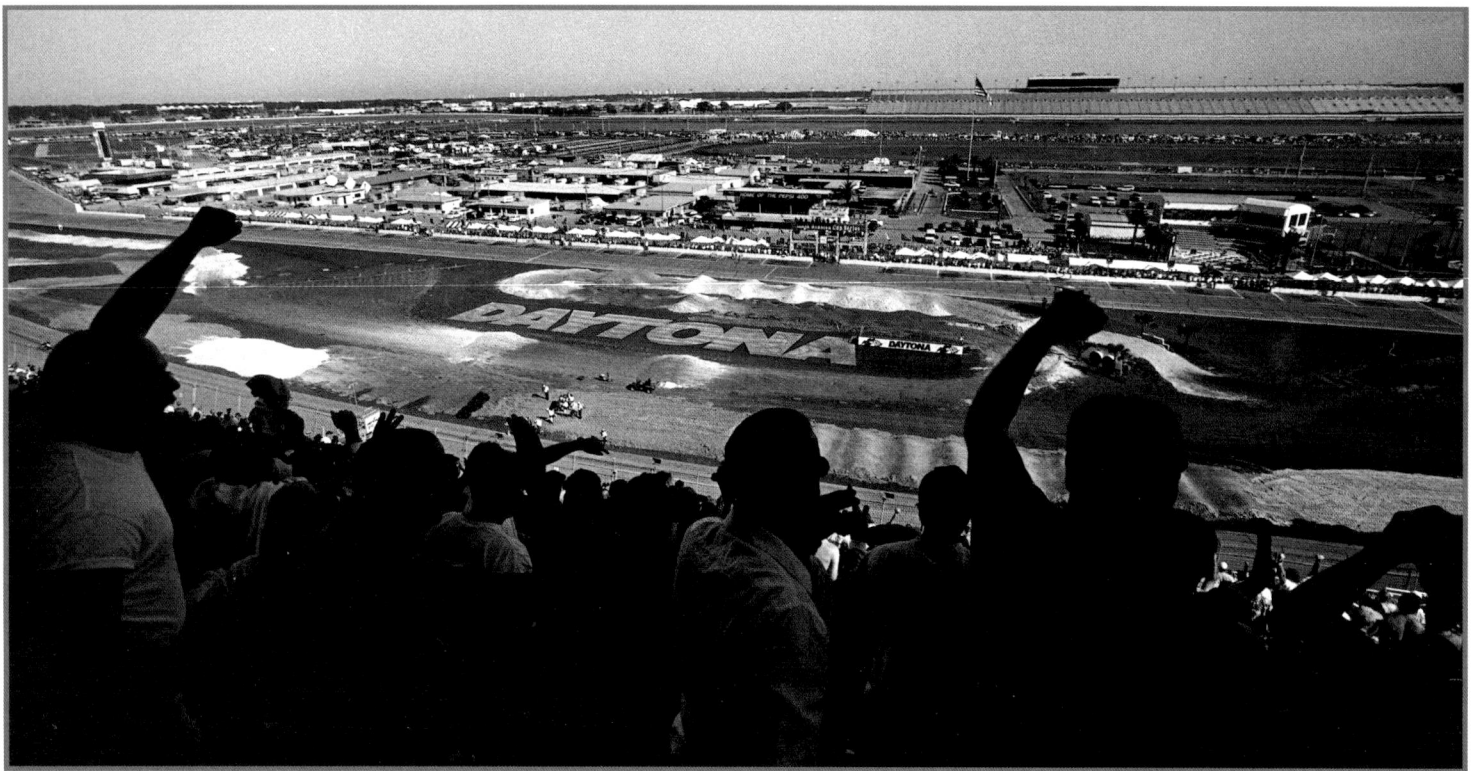

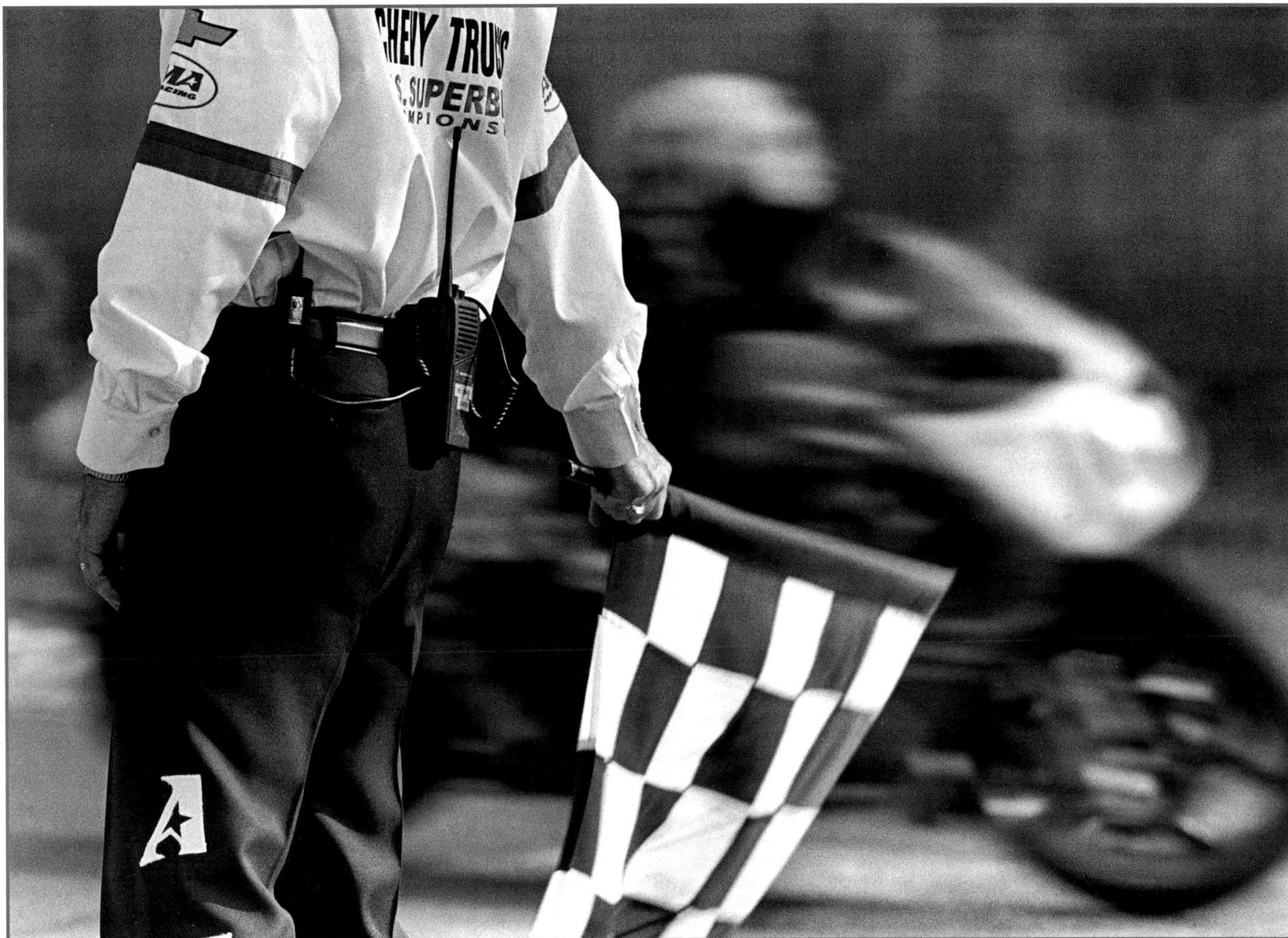

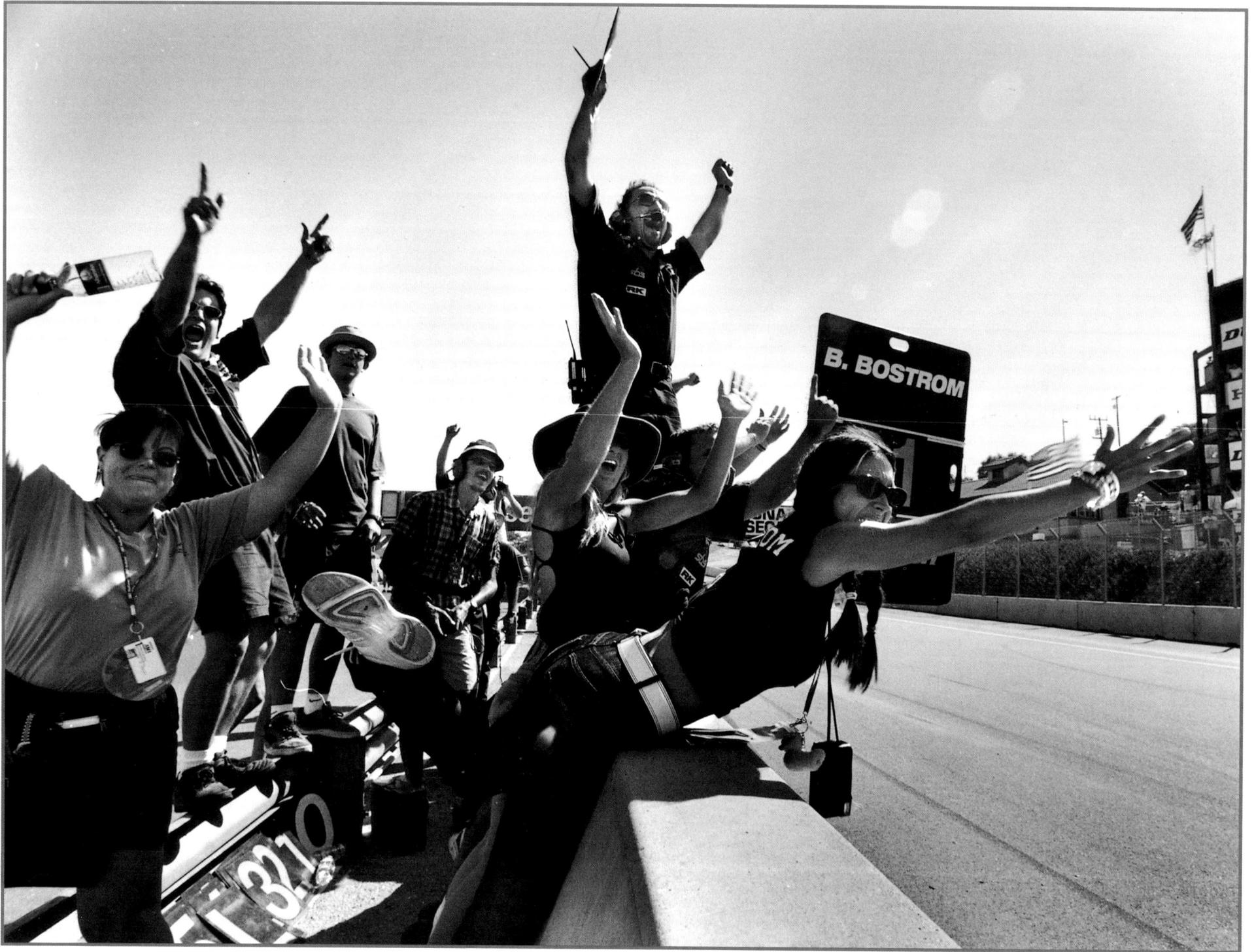

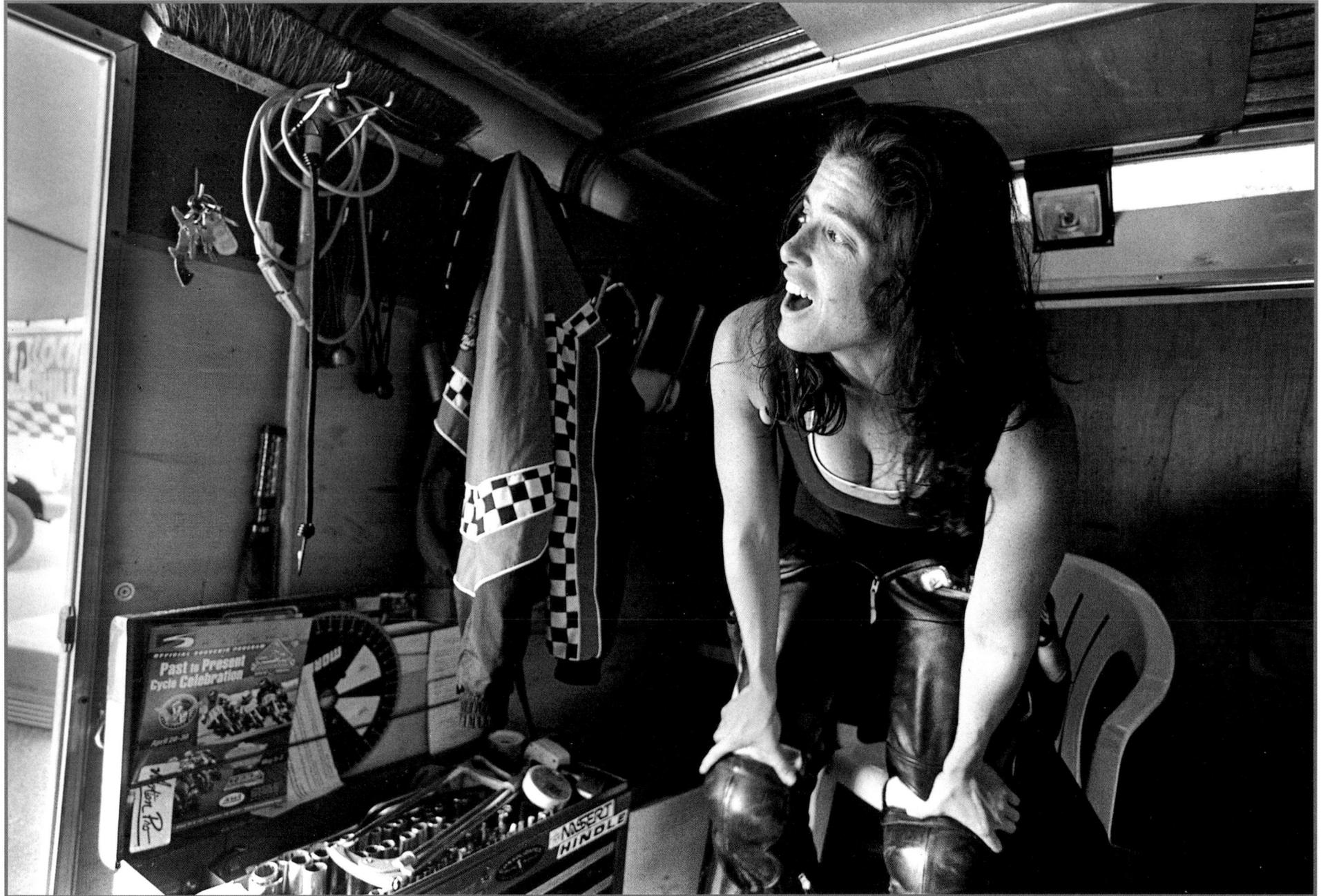

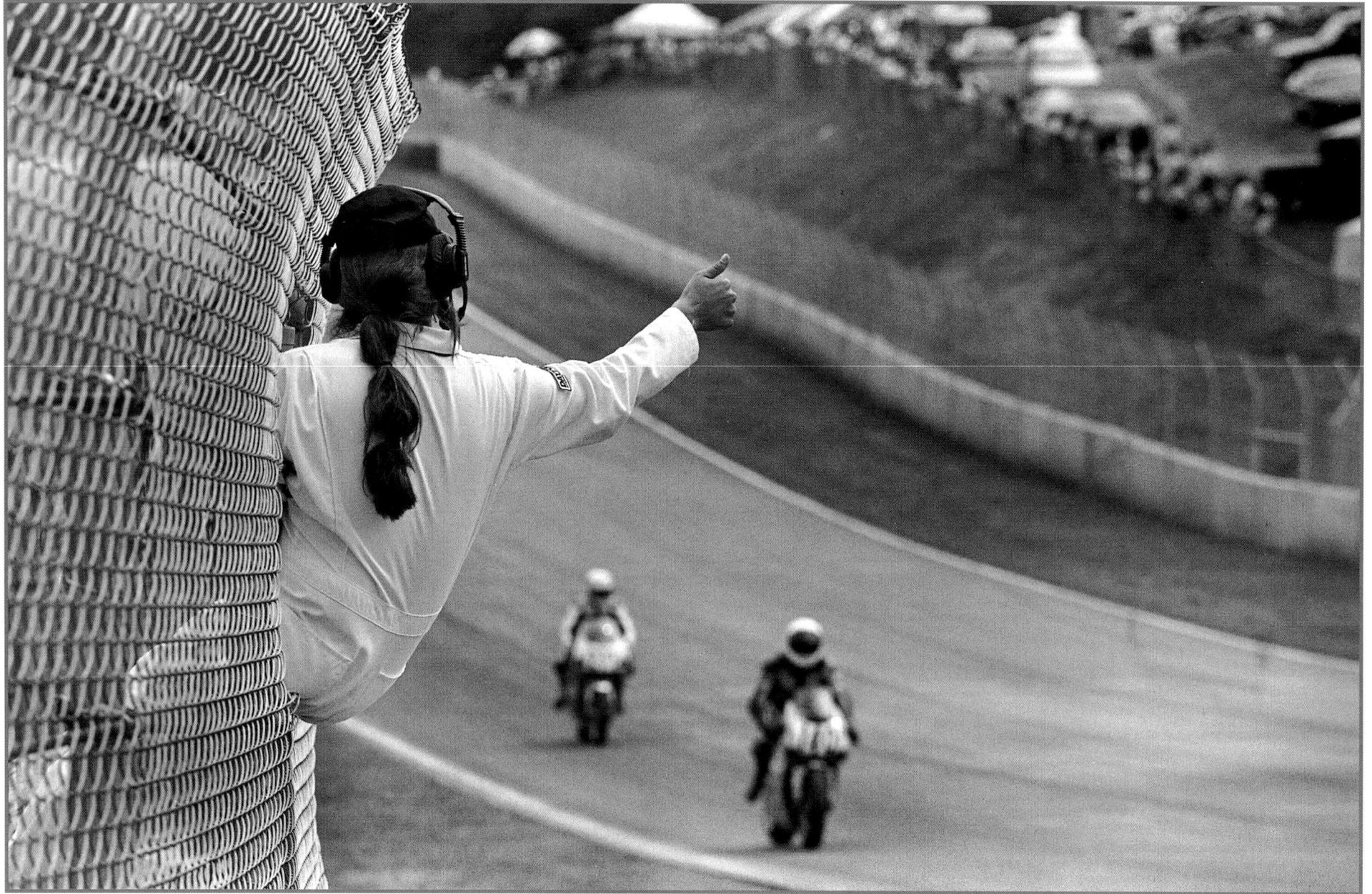

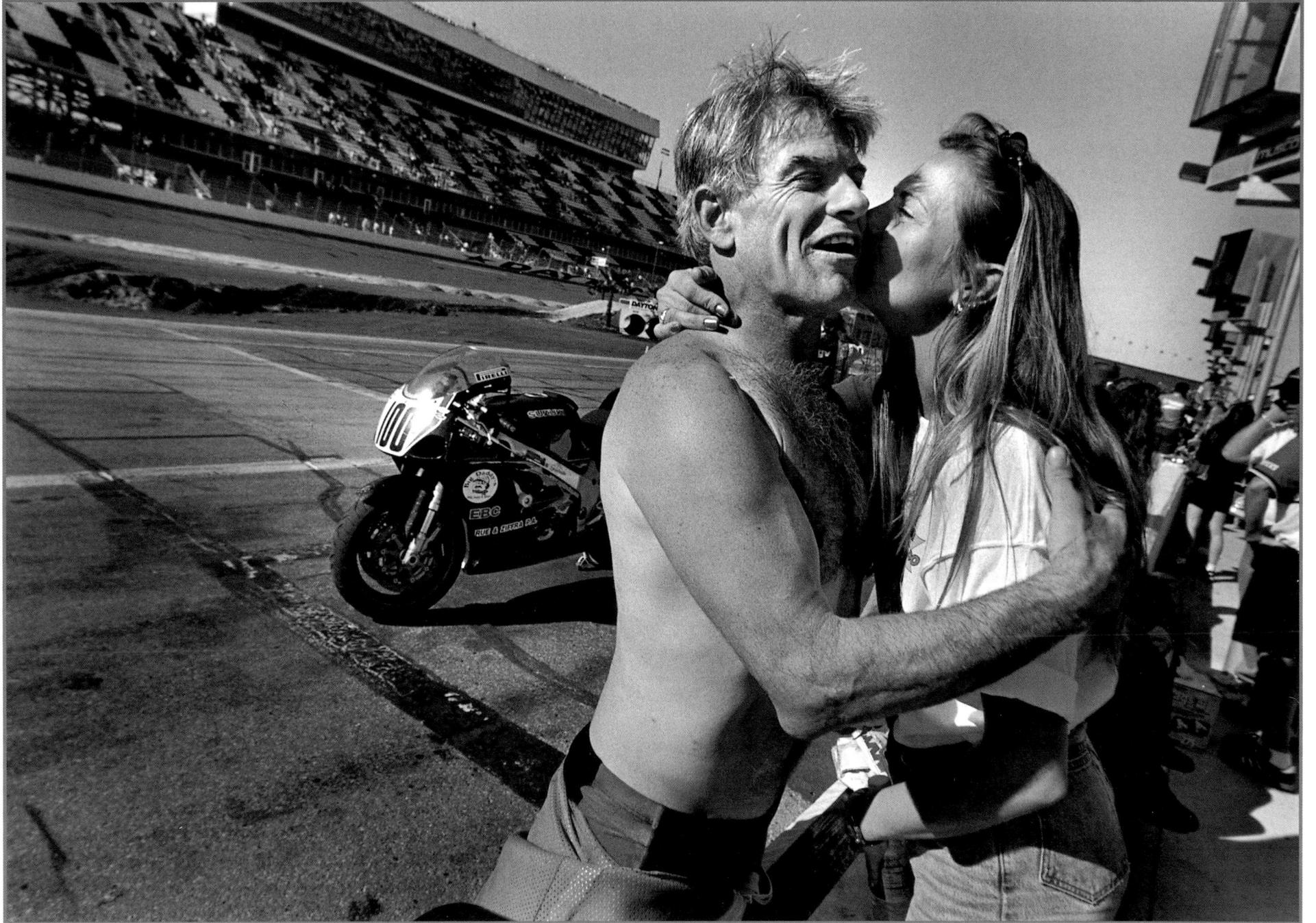

2. Renowned racer Miguel Duhamel showing pre-race intensity and "game face". Honda race team members Mitchell Leonard and Ken Vreeke make last minute adjustments to neck brace on his leathers. Daytona International Speedway.

5. Blurred cycle

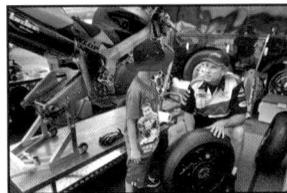

6. Honda factory mechanic Mitchell Leonard takes a moment to explain race strategy and how it relates to what he is doing, to his son, Austin (8), at Sears Point.

8. Dreamlike blurred vision of S-turns at RoadAtlanta.

9. Earl Hayden's "My Three Sons" stopwatch collection.

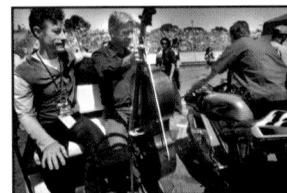

10. Singer and motorcycle enthusiast Lyle Lovett and cellist John Hagen en route to perform the national anthem at Laguna Seca Raceway's World Superbike event.

11. Sprocket change.

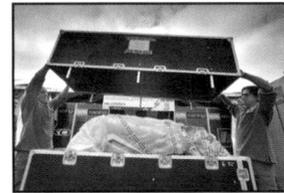

13. The Italian Aprilla team opens crate containing the race machines at the World Superbike event at Laguna Seca.

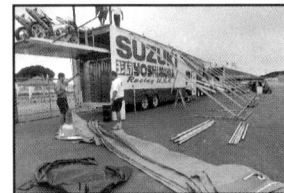

14. Yoshimura Suzuki's team setting up at Laguna Seca. Hiro Yamaguchi and Michael O'Rourke do the roofwork while Ammar Bazzaz and Hans Laske prepare the canvas.

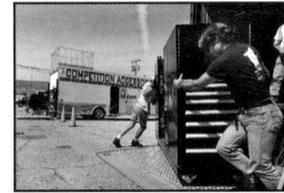

15. Erion Racing's Danny Hull and Mark Lucas roll one of the giant tool chests out of the transport at Daytona.

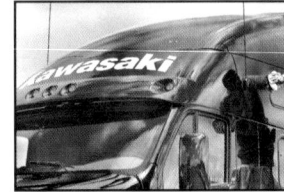

16. Making sure the corporate flagship looks good for the crowds at Laguna Seca.

17. In an image-driven world, there's no such thing as a small detail for Erion Racing's Steve Brousseau.

18. The California-based Erion Racing transport gets its usual pre-race washup at Crane Cams' campus in Daytona.

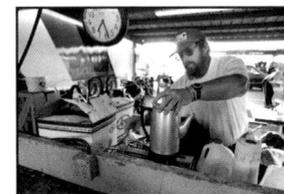

19. "Professor Mike" Copley fires up the hi-octane caffeine machine at Daytona, in the privateer paddocks.

20. Suiting up for qualifying, rider Bill Shore at Daytona.

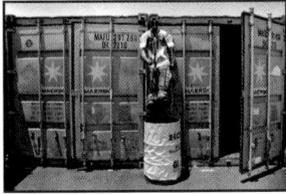

21. Massive steel storage units used by the World Superbike teams at Laguna Seca.

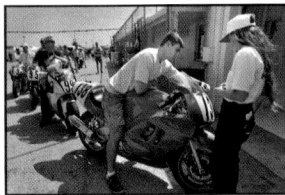

22. AMA official Laura Hardy checks in racer Justin Blake and his equipment at the inspection garage in the Daytona paddock.

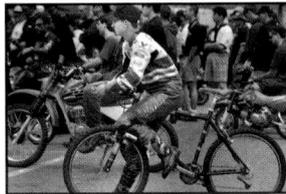

23. John Hopkins-powered two-wheeler at the pre-race rider's meeting. Sears Point.

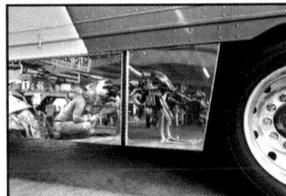

24-25. "Professor Mike" working his magic in the reflection of a transport belly box in the privateer paddock at Daytona.

26. The Aprilla team begins uncrating the custom units containing all of their gear and motorcycles, flown in from Europe for the World Superbike leg at Laguna Seca.

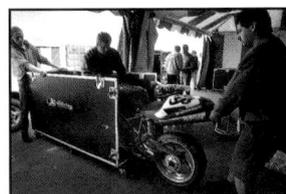

27. The Austrian "Gerin Racing" Ducati emerges from its protective shell after a transatlantic flight. Magloch Thomas, Fritz Schwarz and Hangoebl Erwin go to work at Laguna Seca.

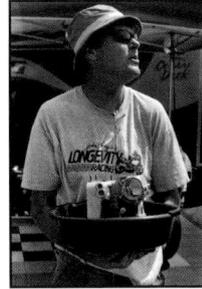

28. Legendary privateer John Long of Miami in the midst of heart surgery on his Ducati. RoadAtlanta.

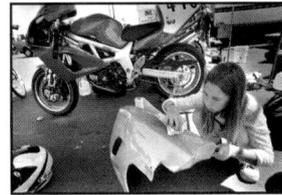

29. Polishing her daddy's fairing.

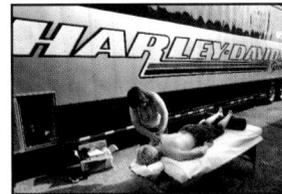

30. Massage therapist Karen Sotiriou ministers to Kurtis Roberts at her rubdown station in between transports at Daytona.

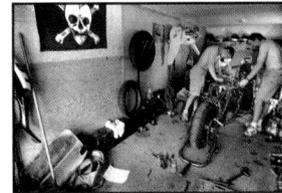

31. In the heat of the team trailer, Eric Braks and Mark Reynolds rebuild the Dow Transportation/ H-D of Boston race bike. Daytona.

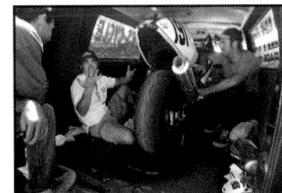

32. Curtis Adams congratulates privateer racer Frank Aragaki on his long drive from San Diego to Daytona to compete in the season opener. Tuner Evan Steel long ago stopped wondering why they do it.

33. Wrenches.

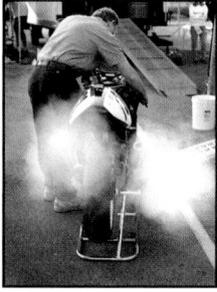

34. Rolande Cushway blowing smoke from his Honda 250.

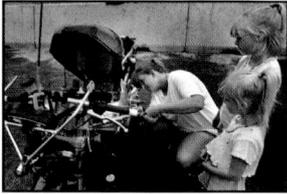

35. Kathleen (4) and Emily (7) learn the finer points of motorcycle mechanics from mom, Angie Steinhoff. RoadAtlanta.

36. Rider Jason Dave praying to the motorcycle gods at Laguna Seca.

37. Oblivious to the pre-race crowd, rider David Roy does his stretches in preparation for a run at Sears Point.

38. Conference.

39. Part of the mountain of tires used up at every major racing event.

40. Factory rider Josh Hayes gingerly suiting up at Sears Point. The recent scars were earned during a high-speed get off at Daytona.

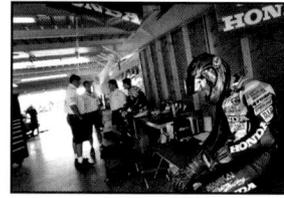

41. The mental game begins for Kurtis Roberts in the Erion Racing paddock at Daytona.

42. Part of the constant swirl of activity in the paddock area.

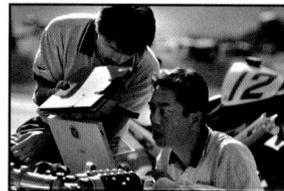

43. Team Yamaha technicians analyzing information pulled directly from onboard computers on their racebikes.

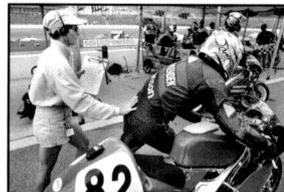

44. Crew chief Debbie Oprendek gives some friendly assurance to husband Bill after a practice round at Daytona.

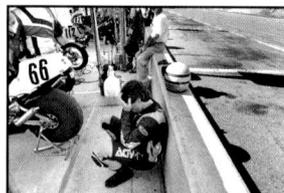

45. Heat and practice times take their toll. Daytona.

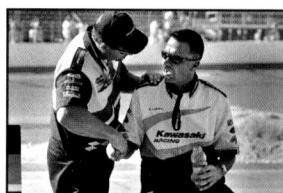

46. Honda's John Ethell greets friendly rival Al Ludington of Kawasaki at Daytona. Top racing mechanics rotate in a pool from manufacturer to manufacturer, giving rise to the industry slogan among the wrenches, when first greeting each other at the start of a new season: "Same shit, new shirt."

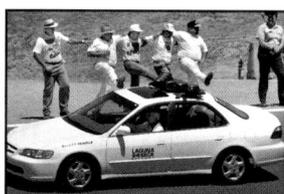

47. FIM officials of World Superbike racing insist on personally inspecting all American track personnel at a formal lineup before each race. Here, some California corner workers give their impression of the proper decorum. Laguna Seca.

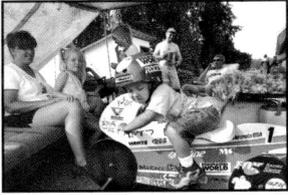

48. Practicing getting his knee down in a turn, three year-old Nicholas Marquez dreams of a lifestyle like those riders who have autographed his custom scooter. RoadAtlanta.

49. Redline Racing's Alan Jackson goes over the mental checklist at Laguna.

50. In the midnight glow of the pits, a relief rider waits for his turn in the 24-hour WERA endurance race at Willow Springs.

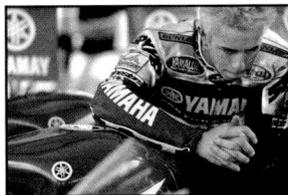

51. Tommy Hayden visualizing the checkered flag at Daytona.

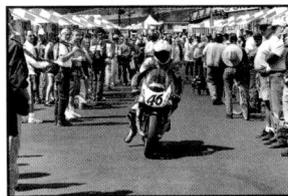

52. Rolling out of the paddock at Laguna.

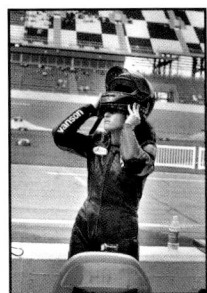

53. Jocylyn of TeamJocylyn prepares for a practice session at Daytona.

54. Checking out the pits.

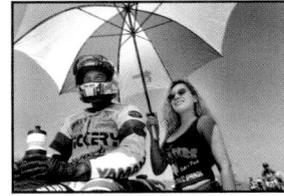

55. Both dressed to thrill, racer Marty Sims gets some shade from umbrella girl Darlene Hernandez. Pike's Peak International Raceway.

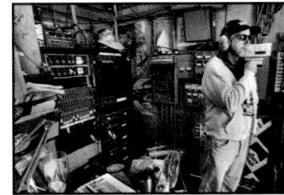

56, Communications tech Rory Walsh running pre-race sound checks in the audio shack at Laguna Seca.

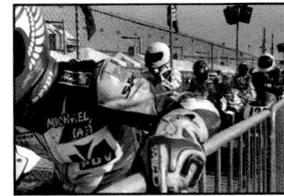

57. Lining up to get on grid for a practice session at Daytona.

58. Going into The Corkscrew after Turn 8 at Laguna Seca.

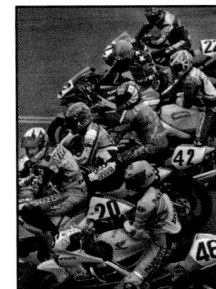

59. Crowding in to get the word on a rain delay at Sears Point.

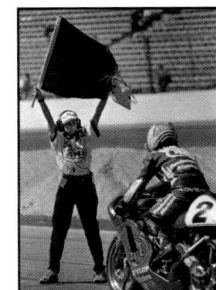

60. AMA official Laura Hardy gets 'em ready to run at Daytona.

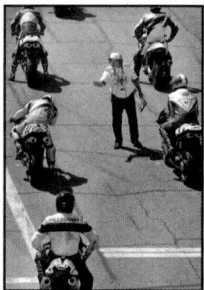

61. "Get it runnin' or get off the grid," the AMA official seems to be saying to an unfortunate competitor at Daytona.

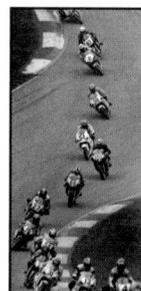

62–63. A threatening sky opened just at the flag of this Daytona race, seemingly giving Divine approval to the start.

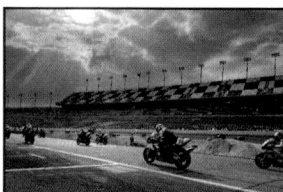

64. Richard Haas takes time to smell the roses with daughter Clara, 3, before his practice heat at Sears Point.

65. Burning into Turn 10b at RoadAtlanta, Kawasaki's Eric Bostrom buries a knee.

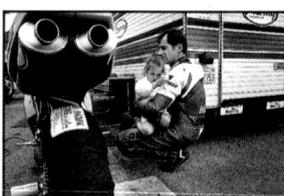

66. The Yamaha factory team studies track results at Daytona.

67. Track announcer Richard Chambers calls 'em as he sees 'em at Daytona.

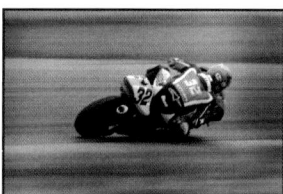

68. As racers hurtle by just yards away, mechanic Robert Zerbisias transmits vital lap information. Pike's Peak.

69. Warm-up lap through the esses at RoadAtlanta.

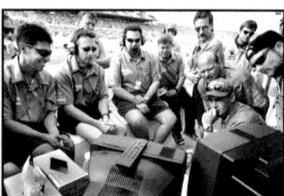

70. AMA timing shack at Laguna Seca.

71. Cornerworker works on her tan and watches the action move into Turn 4 at Laguna Seca.

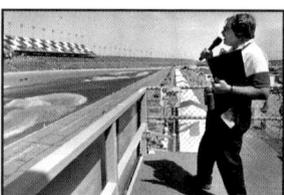

72. Yamaha factory mechanic at Daytona.

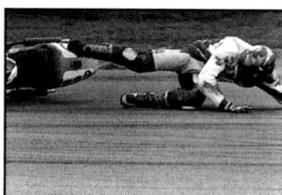

73. Blistering, on and off the track. Laguna Seca.

74a. Miami-based rider Quenni King makes a high speed dismount in Turn 10a at RoadAtlanta.

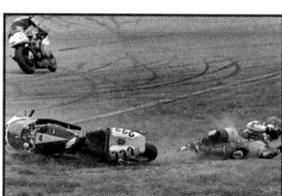

74b. King and bike sizzling through the apron grass.

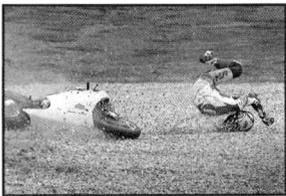

74c. Tumbling into the runoff pit's gravel, completely out of control.

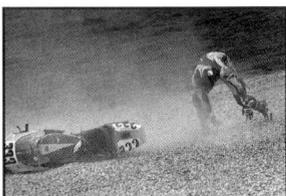

74d. Momentarily stunned, King gamely regains his feet near his downed bike.

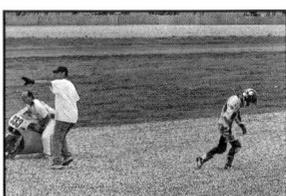

74e. Under the direction of the crash truck team, King dejectedly mushes off to safety behind the concrete barriers.

75. Quenni King analyzes what went wrong as pick-up team member Michael Marquez loads the damaged racer on the trailer. RoadAtlanta.

76. Members of the safety crew apply desiccant to the motorcycle fluids spilled on the Laguna Seca track in the aftermath of a crash.

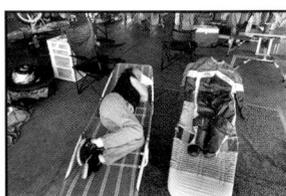

77. Tina Keesee and Mike, the Invisible Man, grab a few winks before the race in the Daytona privateer paddocks.

78. T.C. Christian's racehound Brandy guards the fort in the relaxed atmosphere at Sears Point.

79. Cleaning up the rumble strip in Turn 8 at Laguna Seca.

80. Heading into the dramatic elevation changes of The Corkscrew at Laguna Seca.

81. The Corkscrew, Laguna Seca.

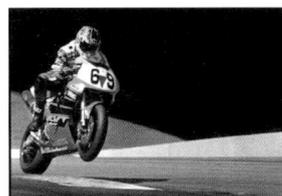

82. Nicky Hayden accelerating out of Turn 5 at RoadAtlanta.

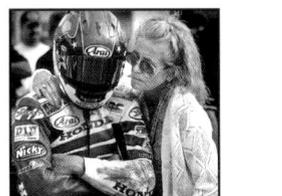

83. After a disappointing crash at Daytona, Nicky Hayden is comforted by his biggest fan, Mom.

84. Al Ludington and an onlooker convey the emotion of an exciting race.

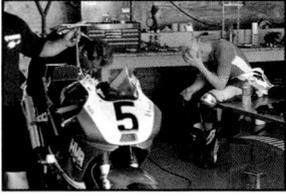

85. Steve Guinard goes to work on an exhausted Richie Alexander's ride. Daytona.

86. Why they wear leathers. Laguna Seca.

87. The Drag-On Wagon, Laguna Seca, and USARM driver William Brower.

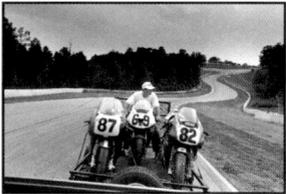

88. Todd Forgie having a busy day on the chase truck at RoadAtlanta, where dedicated safety team volunteers furnish their own trucks and trailers to use as crash recovery vehicles during the races.

89. Kurtis Roberts' mobile track office. Laguna Seca.

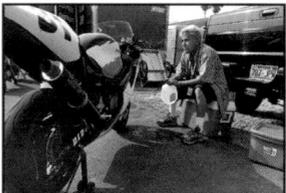

90. Showing the guts and "just gimme a shot" spirit common to most privateers, Frank Cesena drove from Las Vegas to RoadAtlanta with just his truck, bike and leathers. No mechanic, no tent, no trailer, and very few tools. Now, after a couple of practice runs, he has an oil leak.

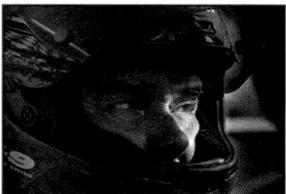

91. Holder of championships in three classes plus some Bonneville Salt Flat speed records, legendary privateer John Long steels himself for the next run at Daytona.

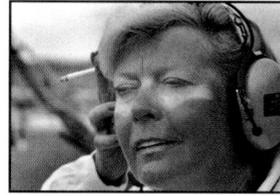

92. USARM team member Kati James surveys her domain from Turn 2 at Laguna Seca.

93-94. A rainy, overcast lunch break for the corner crew at Sears Point.

95. Rain break, RoadAtlanta. Pals Joseph Parks and William Winfree from Duncanville, AL wait it out.

96. Foggy morning run, Turn 3. RoadAtlanta.

97. Portable machine shop.

98. Aprilla paddock. Laguna Seca.

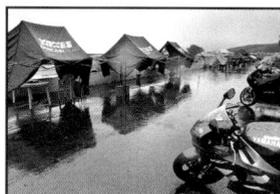

99. Quite literally, the pits. Called race at Sears Point.

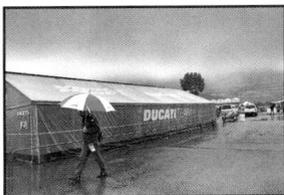

100. Vance and Hines paddock, hunkered down. Sears Point.

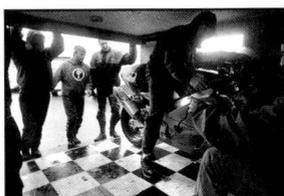

106 Champion tuner Al Ludington gives an expert opinion to Greg White and Doug Frankie of SpeedVision.

101. Disappointed privateer Kenyon Klage of "Terminal Velocity Racing" rolls it in after the Sears Point race was called for rain. Team members (L to R) LaWanna Taylor, Chad Arnold, Trampus Richmond and Jason Beren pack and plan for next time.

107. "Helluva waste of good champagne." Laguna Seca track worker David Howell mops up.

102. Sunrise, 18 grueling hours into a 24-hour WERA Enduro. Willow Springs.

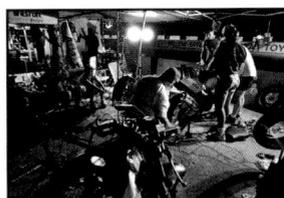

108. Winner's podium. Pike's Peak.

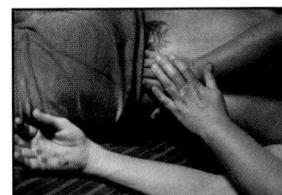

103. Emergency repairs at midnight. Willow Springs.

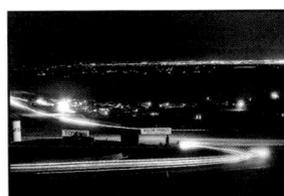

109. Roberts family crest. Laguna Seca.

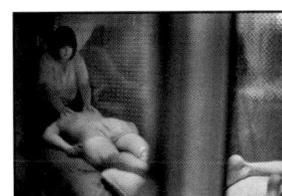

104. Corner worker glances at the distant lights of Lancaster, CA during the mind-numbing early morning hours of a WERA endurance race. Willow Springs.

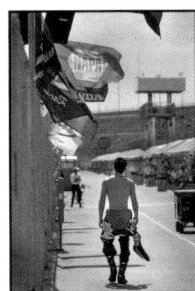

110. Massage therapist Karen Sotiriou works the post-race kinks out of Kurtis Roberts. Laguna Seca.

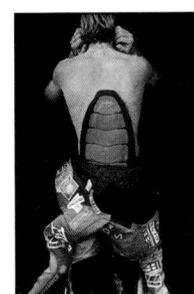

105. Dealing with the heat, Daytona.

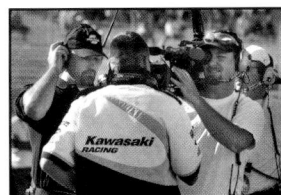

111. Back pad. Laguna Seca, 1999.

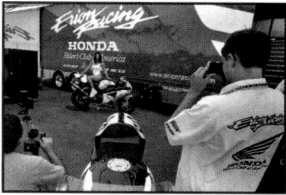

112. Rider Josh Hayes tries his hand at glamour work with calendar model Nina Kaczorowski.

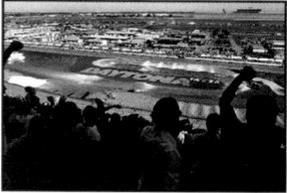

113. Big finish at the Arai 200, Daytona, 2000.

114. Veteran AMA flagman Bob Lemming at RoadAtlanta.

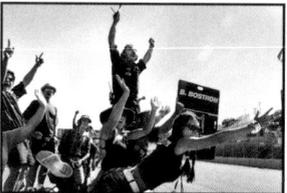

115. Pit crew and friends go crazy for Ben Bostrom win. Laguna Seca, 1999.

116. Christine "Wonder Woman" Demas, pleased with her practice run at Sears Point.

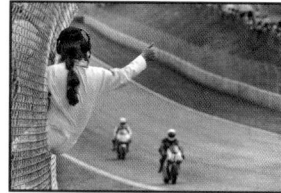

117. Corner supervisor Thomas Smith congratulates riders on another successful race at RoadAtlanta.

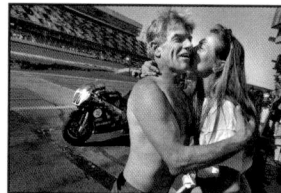

118. Back racing after a 5-year layoff, Oklahoma City resident Mike Harth gets reassured that, win, lose or draw, he's still Martha Cafarelli's hero. Daytona.